3D GRAPHICS

A Visual Approach

R. J. Wolfe

DePaul University

New York • Oxford

OXFORD UNIVERSITY PRESS

2000

Oxford University Press

Oxford New York
Athens Auckland Bangkok Bogotá Buenos Aires Calcutta
Cape Town Chennai Dar es Salaam Delhi Florence Hong Kong Istanbul
Karachi Kuala Lumpur Madrid Melbourne Mexico City Mumbai
Nairobi Paris São Paulo Singapore Taipei Tokyo Toronto Warsaw

and associated companies in
Berlin Ibadan

Copyright © 2000 by Oxford University Press, Inc.

Published by Oxford University Press, Inc.
198 Madison Avenue, New York, New York 10016
http://www.oup-usa.org

Oxford is a registered trademark of Oxford University Press

Library of Congress Cataloging-in-Publication Data

Wolfe, R. J.
 3D graphics : a visual approach / R.J. Wolfe.
 p. cm.
 Includes bibliographical references and index.
 ISBN 0-19-511395-0 (paper)
 1. Computer graphics. 2. Three-dimensional display systems. I. Title.
T385.W6448 1999
006.6–dc21 98-52158
 CIP

Printing (last digit) 9 8 7 6 5 4 3 2 1

Printed in the United States of America
on acid-free paper

3D GRAPHICS

To Alain

Contents

Preface

Knowledge of visual effects is essential for anyone in computer graphics. An artist needs to be familiar with the range of possibilities that computer graphics provides for creative expression. It is similar to knowing the techniques of the more traditional media. For computer scientists, knowledge of visual effects is essential for developing new algorithms and implementing existing ones. Programmers who are visually literate can spot many problems just by looking at the images produced by their programs.

A second benefit of visual literacy for both programmers and artists is increased communication skill, which is highly prized in today's job market. Working in the computer graphics industry means working in a team-oriented, multidisciplinary environment where good communication skills are essential for success.

While visual literacy is certainly not new to artists, it is a foreign topic in most computer science graphics courses. Instructors fluent in mathematics and algorithms become uneasy about discussing the visual aspects of computer graphics and may be tempted to avoid this essential aspect altogether. Furthermore, there are few resources for these instructors, because current texts spend minimal time on this topic.

This book fills the gap with a technique called Visual Analysis. Visual Analysis is the process of looking for a specific set of visual cues and using those cues to identify the algorithms that produced them. The book begins with cues that are visually very different from each other and thus easy to recognize. Such easy-to-spot cues include outlined polygons and the presence or absence of shadows. In subsequent chapters the text discusses progressively more subtle cues, which enable a student to identify a widening range of algorithms. Finally, Chapter 9 discusses "visual equivalencies," which are algorithms that produce similar effects in special contexts, and Chapter 10 discusses how these equivalencies can be used to advantage.

TERA

Essential to this text is TERA. TERA (Tool for Exploring Rendering Algorithms) is an interactive program designed to help identify algorithms visually and is the only program in existence that was created specifically to strengthen visual literacy. With TERA students can change the appearance of objects in a scene by clicking on a rendering option. Once they are familiar with the visual effects, they can test their knowledge by clicking on the "Self Quiz" button.

TERA provides visual examples that illustrate chapter topics and help reinforce key concepts in an enjoyable way. It contains a huge number of image combinations, totaling over 500,000, which constitute a rich resource of visual examples.

The software is extremely easy to use, taking about four minutes to install and less than a minute to learn. Students as young as eleven have installed and used it. TERA has been formally class-tested at three universities, and studies have shown that it increases visual literacy in computer science students.

I will be maintaining a FAQ list for questions involving TERA's installation and use. If you have need of this information, mail me at wolfe@cs.depaul.edu for the URL.

COMPUTER ART CLASSES

This book supports intermediate computer art courses whose goals are to use 3D graphics as a medium of expression. Students taking these classes will already have finished a basic computer art course and a 3D drawing or sculpture course.

The text clarifies the principles behind 3D rendering and imparts a basic understanding of techniques that can aid in communicating an idea or statement as an image. To make these principles as accessible as possible, it uses examples drawn from the physical world to illustrate concepts and deliberately steers away from the pseudocode found in technically oriented computer graphics books.

Topics appropriate for art classes include the fundamentals of Chapters 1–3, the discussion of basic shading types of Chapters 4 and 5, and the coverage of texture and bump mapping in Chapters 6 and 7. In addition, Chapter 8 discusses various approaches to lighting. Students interested in animation will benefit from the cost discussion in Chapter 10, which includes a section about how much time it takes to render animation and tips about cutting down that rendering time.

COMPUTER SCIENCE CLASSES

This text is useful in survey courses and also in courses where the emphasis is on programming. In a survey or service course in computer graphics, this book is appropriate as a main text, and in a programming course, it provides supplemental information not found in conventional computer science graphics texts.

For a survey course, this book provides a broad, nontechnical overview of the vast range of rendering techniques, and TERA demonstrates all of them visually. For this type of course, Chapters 1, 3–8, and 10 are most important. Chapters 3–5 cover the basics of the z-buffer and raytracing algorithms and Chapters 6 and 7 cover texture and bump mapping. Chapter 8 discusses lighting techniques. The "Doing It Yourself" sections will teach students how to use a freely available raytracer (POV-Ray) to create their own virtual worlds. If time permits, the instructor may elect to include the cost comparisons in Chapter 10 and discuss the speed issues presented there.

In computer graphics courses where the main thrust is algorithm implementation, this book serves well as a supplementary text. TERA teaches students an algorithm's visual

effects in much less time than it would take them to learn a rendering package. This gives students the opportunity to come in contact with a much wider range of algorithms than can be covered in lecture using traditional methods. In addition to the greater breadth of coverage, this minimal time investment in using TERA gives students an in-depth knowledge of an algorithm's visual effects before they implement it. As a result, they are able to debug their programs more effectively and with less help from the instructor.

For a course of this type, the discussions of visual cues in Chapters 3–8 are the most appropriate. The cost analysis presented in Chapter 10 is informal and qualitative and is based on a set of empirically gathered benchmarks. As such, the instructor may want to use a more rigorous analysis when discussing algorithms.

Acknowledgments

Many people generously gave of their time, experience, and resources, which aided in the metamorphosis of an Idea into Reality. It is a pleasure to mention them here.

First is a retelling of how this book came to be. The motivation for creating the Visual Analysis technique and the TERA software came from students in the computer graphics classes at DePaul University. It has been a privilege and a pleasure to have the opportunity to know and to learn from these hardworking, dedicated, and honest people. The idea for Visual Analysis formed itself while I was team-teaching a computer art course with Jenny Morlan of DePaul. Through eloquent descriptions she imparted many insights into how to use my eyes when viewing works of art.

Discussions about the approach with Steve Cunningham of California State University at Stanislaus and Judy Brown of the University of Iowa provided the courage to commit the requisite time and effort to develop an initial version of TERA. Andrew Sears of DePaul lent a hand in developing TERA's interface and helped set up the initial usability trials. He also gets credit for the TERA acronym. Scott Grissom and Tom Naps volunteered to test the approach in their graphics classes at University of Illinois at Springfield and Lawrence University and the happy result was a short series of papers.

Bill Zobrist of Oxford University Press read one of the papers and suggested that Visual Analysis might form the basis for a book. Discussions with Steve Cunningham, Stephen Spencer at the Ohio State University, Alain Chesnais of Alias/Wavefront, and Ed Allemand at DePaul helped form the contents of the prospectus that I sent to Oxford. The result is what you hold in your hands.

Steve Cunningham rightly should be called the "uncle" of this book as he has served with patience and perception as a reviewer, both formally and informally. In addition, he took on the responsibility of creating the CD master, which works successfully on a multitude of platforms.

While a student at DePaul, Dwight Luetscher ported the original Unix version of TERA to Microsoft Windows 3.1 and included a customizable setup package that he created on his own initiative. It has been a rock-solid, bug-free package that is extremely easy to install. Stephen Spencer also helped out on the multiplatform front by porting TERA to two SGI operating systems.

Many people spent time testing TERA and TERA's installation procedure. Olivier Buisard, Dena Eber, Scott Grissom, Bill Horsthemke, Tom Naps, David A. Roth, Stephen Spencer, and Alicja Stanczak responded with valuable feedback that helped improve both

the content and usability of TERA. In addition, Olivier tested all of the homeworks, so we know that they are possible to solve!

I am grateful to Dena Eber of Bowling Green State University, Parris Egbert of Brigham Young University, William B. Jones of California State University, Dominguez Hills, Chandra Kambhamettu of the University of Delaware, and William Shoaff of Florida Institute of Technology for their careful reading and substantive, constructive feedback on the contents of this book. I believe that the text was greatly strengthened from their suggestions for improvement.

Stephen Spencer, Virginia Weinhold, and Kevin Simon of the Ohio State University graciously contributed Figure 8-6, which demonstrates progressive radiosity. Many thanks to DePaul alumni Ronald Faulkner (Figure 6-3), John Schuchert (Figure 8-2), and Kevin Ferguson (Figure 6-18), who created images and textures for the book. DePaul alumna Hui-Lin Li created the image sets "Auction," "Dresser Top," and "Garden," which are found in TERA. Dan Farmer created the vase in Figure 5-6. Steve van der Burg's `dining.pov` created the dining room shots seen in Figures 6-8 and 9-2. Robert A. Mickelsen's butterfly suite was modified to create Figure 6-2.

Many of the images in this book were created with software that is available for free or for a nominal fee via the Internet, and it would have been impossible to create this book without these high-quality rendering and modeling packages. The rendering packages include Larry Gritz's BMRT [GRIT98], Craig Kolb's Rayshade [KOLB98], the POV Team's Persistence of Vision Raytracer (POV-Ray) [POVR98], and Greg Ward's Radiance [WARD98]. Modeling was carried out with Neville Richards' Breeze Designer [RICH98] and Stephen Chenney's Sced [CHEN98]. Sced, a most versatile package, did the lion's share of the modeling. The following table lists each package and the images they helped create.

Package	Images
BMRT	6-3, 6-5, 8-2
POV-Ray	1-3, 1-4, 1-5, 3-4(left), 3-5, 3-6(left), 3-25, 5-2, 5-3, 5-5, 5-6, 5-8, 5-9, 5-11, 5-12, 6-2, 6-4, 6-29, 6-30, 7-4, 8-7, 8-8, 9-2, 9-4(left), 9-5, 9-6(left) 9-7(left), 9-8, 10-8
Radiance	8-1, 8-3, 8-5
Rayshade	5-1, 5-4, 6-10, 6-12, 6-18, 9-3, raytraced part of 10-6
Breeze Designer	6-3, 8-2
Sced	1-5, 3-4, 3-5, 3-6, 5-1, 5-2, 5-4, 5-5, 5-6, 5-7, 5-8, 5-11, 5-12, 6-1, 6-4, 6-5, 6-6, 6-7, 6-9, 6-11, 6-13, 6-15, 6-17, 6-18, 6-19, 6-20, 6-22, 6-23, 6-24, 6-27, 6-28, 6-29, 6-30, 7-4, 8-1, 8-3, 8-5, 8-7, 8-8, 9-1, 9-3, 10-6, 10-8

Many, many thanks to the POV Team for graciously allowing me to put POV-Ray on the CD. I also appreciate Chris Young's willingness to tech-review the POV-Ray related sections. His suggestions were a great help.

Many of the objects appearing in the images are available for download via the Internet. One comprehensive site is Reflectually, http://surserver1.rz.uni-duesseldorf.de/ pannozzo/3ds.html, which features objects in Autodesk's 3DS format and is maintained by Dino Pannozzo. Also excellent is the catalog of VMRL objects at http://www.ocnus.com/models/

models.html, maintained by Ocnus' Rope Company. Also notable for its range of objects is the Aminet site at http://wuarchive.wustl.edu/pub/animnet/gfx/3dobj.

Credits for the objects used in this book are given here:

Object	Credit	Appears in	Found at
ape		5-2	Reflectually
apple		5-8	Reflectually
banana		6-11, 6-13, 6-15	Reflectually
barrel		7-4	Reflectually
baseball cap		6-18	Reflectually
bishop	Ron Brown	3-3,4-2,4-3	Reflectually
bud vase		3-6	Reflectually
camera		5-7	Ocnus
coffee maker	Jeff Costantino	5-1	Aminet (Kitchen.lha)
couch	Jim Graham	8-1, 8-3	Reflectually
dolphins		3-1	Reflectually
ketchup		9-1	Ocnus
mug		5-1	Ocnus
P51 Mustang		2-10	Reflectually
rose		5-10	Reflectually
saucer	Jeff Costantino	1-5	Aminet (Kitchen.lha)
sky vase	Dan Farmer	5-6	POV-Ray
table		8-1, 8-3	Reflectually
teapot	Martin E. Newell	3-2, 3-4,4-1, 6-6, 6-9, 6-10, 6-11, 6-12, 6-13, 6-15, 6-17, 6-19, 6-20, 6-21, 6-22, 6-23, 6-24, 6-27, 7-1, 7-2, 7-3, 8-2, 9-3, 9-4, 10-5, 10-6, 10-8	Reflectually
teapot2		8-1, 8-3	Reflectually
toilet		6-5	Reflectually

Information about the software and objects used in TERA's images is contained in the TERA package itself. To read it, select the desired image, click on "Help," and then on "Credits."

All of the folks at Oxford University Press showed patience and a willingness to work with a new author. Bill Zobrist, Krysia Bebick, Peter Gordon, Jasmine Urmeneta, and Karen Shapiro have been accessible and supportive during the entire process.

A special thanks goes to a special proofreader, Rosalie Nerheim. Also highly appreciated was the consultation with A. Glenn Nerheim regarding chemistry glassware for the TERA images. For help with my rough-hewn writing style, continual encouragement, constructive suggestion, and support through it all, the last and best thanks go to my husband, Alain Wolfe.

3D Graphics

1 Introduction

The explosive growth in 3D computer graphics has made a dramatic and positive impact on fields ranging from science, manufacturing, and medicine to art, advertising, and entertainment. No longer hampered by ferociously expensive equipment and cumbersome software, computer graphics has become prevalent in such richly varied forms as virtual reality, architectural design, medical imaging, animation, product design, and games. As more and more people come in contact with the wonder and excitement as well as the practicality of graphics, the demand for increasingly more sophisticated products and packages continues to grow unabated. As a result, companies are continually looking for well-qualified professionals who can push toward new breakthroughs, and job opportunities abound.

VISUAL LITERACY

Computer graphics is a visually oriented art and science, which means that an important part of being a professional in this field is having a visual literacy. This book defines *visual literacy* in computer graphics as the ability to analyze an image or animation and identify the graphics effects that were used to create it. Visual literacy is important not only to artists but to programmers as well because it forms a basis of communication between the diverse group of specialists who all call themselves graphics professionals.

The goal of this book is to foster your visual literacy in computer graphics through a technique called *visual analysis*. Visual analysis is a method of identifying graphics effects in images or animation by spotting specific visual cues. In Chapter 3, you will begin by learning about four basic techniques, and by the time you finish Chapter 9, you'll be familiar with all of the commonly used effects in 3D computer graphics. Chapter 10 concludes with a comparison of the effects and their associated costs.

But visual literacy is more than understanding and noticing technique; it also encompasses a broader understanding of how all the elements in an image work together to create an expression for a viewer. It includes both the understanding of images and what they represent. As Dena Eber says, "Just as letters form words that are symbolic of thought, digital effects form images that are representative of ideas." Communication of ideas hinges not only on picture composition, but also on the effects chosen by the artists and programmers who create the picture.

Advantages

Regardless of whether you're an artist or programmer, your knowledge of visual effects will help you as you learn more about computer graphics. If you are an artist, you know that when compared to more traditional media, computer graphics is new and sometimes considered controversial. But just as when you learn to use paint or chalk, you need to become familiar with the techniques that computer graphics affords you. Knowing the range of possibilities will help you reach your full potential for creative expression. In addition, visual literacy will help you learn to use computer graphics software more quickly.

An inherent effect of looking, re-looking, and analyzing an image is a deeper grasp of how a viewer will perceive it. This leads to a greater understanding of what a picture may say or how it may impact the people who see it.

On the other hand, if you are a programmer or computer scientist, you may find yourself in the role of facilitator to a creative process. If you are familiar with visual effects, you will be able to listen to an artist describing a scene and then be able to suggest ways of creating a desired effect. If the particular effect does not exist yet, your knowledge can help you modify an existing program to produce the desired results. Visual literacy also helps programmers when they debug initial revisions of graphics programs. If you know ahead of time how an image should appear, then you can quickly spot many problems just by looking at the image that your program produces.

A benefit for both artists and programmers is increased communication skills. Any career counselor will tell you that in today's high-tech market, being a good team player is a highly desirable characteristic in a potential employee, and a crucial part of being a team player is good communication skills. Today's exciting projects are often so large and require such a wide variety of skills that they require literally hundreds of artists and programmers to work together to bring them to completion. Knowing the proper term to describe an effect will help you be a better communicator both with those who are in your own specialty and with those who are in other areas of graphics.

Another benefit that enhances teamwork is having an appreciation or empathy for the tasks confronting other team members. Just as an artist needs to comprehend and accept that raytraced three-hour movies are beyond today's technology, a programmer must understand that creating the correct highlight or texture will greatly affect the meaning of an image, even if doing so requires a little more effort.

While not directly related to honing your job skills, the last benefit of visual literacy is a heightened sense of appreciation when you view computer graphics of any kind, from commercials to feature-length animations. You will find yourself thinking, "I know how they did that!"

TERA

TERA (short for Tool for Exploring Rendering Algorithms) is an interactive program designed to help you spot visual cues and is the only program in existence that was created specifically to help you identify graphics effects and strengthen your visual literacy. As intriguing as it is to look at a computer-generated image on paper, it is much more fun to experiment by changing it! You can use TERA to learn to look for crucial visual cues,

and after you are an expert, you can use TERA to associate the cues with the effects that made them.

With a single click of a button, TERA allows you to try out different effects, and you can decide on the one that looks best for any particular type of object. TERA gives additional visual examples of topics discussed in each chapter, and it helps to reinforce key concepts. TERA has so many image combinations that to print them all on paper, one per page, would require over 500,000 sheets or 1000 reams of paper!

Your textbook comes with a copy of TERA and also includes several exercises that were designed to help you to get the greatest possible benefit when using it. By using TERA, you will be able to answer the questions in the text or go off to explore on your own.

TERA has been class-tested at three universities and it not only helps you to spot graphics effects visually but also helps students who are writing graphics programs. It helps them while debugging because they already know what a graphics effect should look like. Students have consistently reported that it is easy and fun to use. We have found that it takes students about 15 seconds to figure out how TERA works (but don't tell your instructor.) So break open that envelope in the back of your book and pop that platter into your CD drive. It does not matter if you are using a PC, a Unix workstation, or a Mac running SoftWindows; TERA will work for you.

Details for installing TERA on your platform are given in Appendix D. The installation process has been tested thoroughly on each platform and users have reported that the installation takes about five minutes. When you run TERA, you have to put the TERA CD into your CD drive. To start a TERA session using a Mac with SoftWindows or a PC running Windows 3.1, open the program group labeled TERA. You will see a group of icons just as you do in Figure 1-1. Double-click on the icon you want.

For Windows 95, 98, or NT, select the **Programs** option from the **Start** menu and click on **TERA.** From the list that appears, click on the option you want.

If you are using TERA on a Unix workstation, you need to have an X Window session running. Mount the TERA CD and change to the subdirectory whose name best describes the brand of Unix you are using. At the command line prompt, type

tera

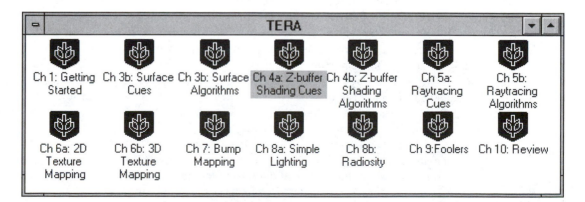

Figure 1-1 TERA program group.

```
                    color_xterm

/cdrom/linux:tera
DISPLAY environment variable is :0.0

Choose your option:
     1:   Getting Started
     2:   Surface Cues
     3:   Surface Algorithms
     4:   Z-buffer Cues
     5:   Z-buffer Shading Algorithms
     6:   Raytracing Cues
     7:   Raytracing Techniques
     8:   2D Texture Mapping
     9:   3D Texture Mapping
    10:   Bump Mapping
    11:   Simple Lighting
    12:   Radiosity
    13:   Foolers
    14:   Review
  or 'q' to quit.
```

Figure 1-2 TERA on Unix.

The list of options shown in Figure 1-2 will appear. Type the number of the option you want.

A TERA Session

Figure 1-3 is an annotated screen dump of TERA's main window. Depending on the system you are using, button sizes and font appearance may be slightly different. Take a look at Figure 1-3.

You select an object in the image by clicking on it. You will see the object's name appear in the *selected object* box that is located in the upper right portion of the window. To change the appearance of an object, first click on it and then click on one of the radio buttons in the *appearance* menu. Experiment by clicking on different radio buttons to see what they do to the picture.

You can always get a description of an object's appearance by clicking on the button labeled "Tell Me More." The descriptions point out the important features of a graphics effect or visual cue and they can help clarify and focus your observations. Think of them as being your tour guide through an image.

When you are finished exploring the current image, you can choose another one by clicking on the *image selection* menu. A drop-down menu will appear, and you can select another image by clicking one of the entries. In a second or two, you will see a new image.

Once you have explored various images, you may want to see how well you can do at identifying effects. For this you will need a new image, filled with a randomly chosen set

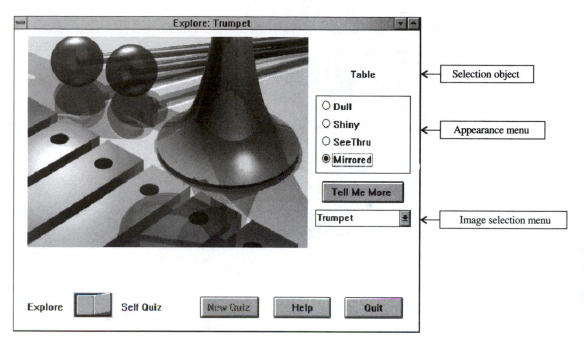

Figure 1-3 A TERA session.

of effects. To get this new image, click on "Self Quiz." When you do, the appearance of TERA's main window will change a bit, as you can see in Figure 1-4.

Notice that no radio buttons are filled in, and a new box, called the *feedback* box, appears above the *selected object* box. You guess the visual effect of a selected object by clicking on one of the radio boxes. If you answered correctly, the word "Correct!" appears in the feedback box, but if your guess is wrong, you will see the phrase "Try again." At this point, you can select another radio button or you can click on the "Tell Me More" button for a hint.

Sometimes two different effects can create appearances that are so similar that we call them "visually equivalent" and you will see the phrase "Close Enough" as a response to your selection. It means that while your selection was not correct, the effect you chose creates an appearance so similar to the actual one that no one would ever expect you to tell them apart. Another way to interpret this response is, "No one is ever going to ask you a question like this on the exam."

If you want further explanation of a "Close Enough" response, click on "Tell Me More." It will list the actual effect so you can compare it to the choice you made, and it also gives you a sentence or two that details the context that causes the two effects to create the same appearance.

Clicking the "Help" button gives a brief set of directions on using TERA and also presents you the option to list the credits, which acknowledges the people and software that helped contribute to the image in some way. If you see something you like, you can check the credits to see if it is available via the Internet.

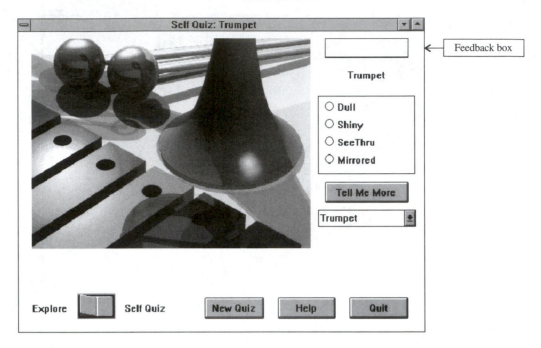

Figure 1-4 TERA in Self-Quiz mode.

Take TERA out for a test drive. Have fun!

EXERCISES: GETTING STARTED

These questions will help familiarize you with TERA.

1. Start the TERA session called "Getting Started." If you are using a Mac or a PC running Windows 3.1, you will double-click on the icon labeled "Getting Started." If you are using a Unix workstation, type "tera" at the command prompt and choose Option one. For Windows 95 or NT, select the **Getting Started** option from the **TERA** menu under **Programs** in the **Start** menu.
 a. What do you see in the first image? Click on various locations to find the names of all the objects, and list them.
 b. How many radio buttons are there? How are they labeled?
 c. How many images are in this first TERA session? List their titles.
2. Select the second image.
 a. The labels on the radio buttons are now different. Describe them.

 b. Click on "Self Quiz," select a chair and guess its color. After selecting a few different chairs, click on the "New Quiz" button. What does it do?

 c. Continue clicking on the "New Quiz" button until the wall appears bluish-green. First try guessing that the color is green. If you see "Correct" appear in the feedback box, click the radio button marked "blue." Once you see "Close Enough" appear in the feedback box, click on "Tell Me More." What does it say?

3. You can find out information about any picture by first clicking on the "Help" button followed by a click on the "Credits" button that is part of the "Help" pop-up window.

 a. Who created the chair and guitar in the first image?

 b. What program created the image?

 c. In the second image, what do the credits say about the chairs?

DOING IT YOURSELF: GETTING STARTED

TERA gives you a way to examine visual effects of rendering algorithms and provides an opportunity to observe and explore a wide range of computer graphics in a rich and varied set of contexts. Some of you may be interested in going beyond TERA to create your own computer-generated images. For you there is a section called *Doing It Yourself* at the end of each chapter. The activities in these sections are designed to give you hands-on experience in creating your own images and provide an opportunity to experiment further with the effects being discussed in the chapters.

In these sections you will learn a rendering package called the "Persistence of Vision Raytracer" or POV-Ray for short. If you carry out the activities described in these sections, you will have a working knowledge of how to use POV-Ray to create high-quality photo-realistic images. POV-Ray is a good place to start because its scene specification language is the easiest to learn, and it runs on almost any imaginable platform. Furthermore, it is free and available for download via the Internet. This first *Doing It Yourself* section will guide you through installing and using POV-Ray on your computer. When you have completed the list of activities described here, you will have created an image that looks like the one in Figure 1-5.

1. First, you set up the documentation for POV-Ray on your computer. It is compatible with your favorite Web browser and it will help you with both installing and using POV-Ray. There is a copy of the documentation on your CD in the `/povdoc` directory, and the table of contents is in `/povdoc/povray.html`. This is the documentation for version 3.02. If you download a later version, the sections of the newer version may not correspond to the sections mentioned in the text.

Figure 1-5 An image created by the POV-Ray program.

You can always access the latest version of the documentation via the POV-Ray Web site. To do this, point your Web browser at http://www.povray.org and click on "Resources." When the Resources frame appears, click on "Documentation archives," which is http://www.povray.org/ftp/pub/povray/Official-3.0/Docs.

Click on povhtml.zip, which is a zipped form of the documentation files. The zipped file is 1.5 megabytes, so it may take a while to download.

Create a subdirectory and move povhtml.zip into your freshly created subdirectory and unzip it. The uncompressed files take up about 2.5 megabytes of disk space.

The file holding the table of contents is called povray.html (or povray.htm). Load this file into your Web browser and answer the following questions.

a. According to the documentation, what is the program description of POV-Ray? The first sentence of the description will suffice.

b. On what platforms (computers) does POV-Ray run?

c. What computer are you using? For your platform, what files do you need to download?

d. What are INI files? Of what use are they?

2. Read Section 3.1, "Installing POV-Ray" in your on-line documentation. You can choose to install POV-Ray either from the versions on your CD or by downloading the latest version from the POV-Ray Web site. To install from your CD, look in the /povray subdirectory and change to a subdirectory corresponding to your system. Look at the README file for further hints on installation.

To get the latest version of POV-Ray, point your Web browser at http://www.povray.org and click on "Download." You will see the "Official Binaries"

page appear. Click on the link (Windows 95/NT, Linux, Macintosh) that describes your platform and follow the directions for downloading and installing the software.

Once you have finished the installation process, you will be ready to answer the following questions:

a. What is the main subdirectory name for POV-Ray?

b. What are the names of the directories directly underneath the main subdirectory?

3. Now you are ready to try running POV-Ray. Look in your POV-Ray subdirectories and find any file that ends in ".pov." This is a POV-Ray scene description file. Consult the documentation for exact details on running POV-Ray, and use POV-Ray to render (draw) the scene description file.

a. What is the name of the .pov file?

b. In what subdirectory did you find it?

c. What does the image look like?

4. You are ready to try creating the image you saw at the beginning of this section. You will find the scene description files on your CD in the directory `/yourself/ch1`. Copy everything from that subdirectory to your hard disk. (There should be four files called `gold.pov`, `goblet.inc`, `saucer2.inc`, and `mat2.inc`.) The files ending in ".inc" are helper files for `gold.pov`. Use POV-Ray to draw `gold.pov`. Did the image you created match the picture in this section?

There is a large community of people who use POV-Ray, and many of them use the Usenet newsgroup comp.graphics.rendering.raytracing to exchange ideas and to ask questions. The POV Team itself meets on CompuServe's GO POVRAY Forum. Another valuable resource is the POV-Ray Home Page at http://www.povray.org. Of special note is the Internet Ray Tracing Competition, which you can reach by clicking on "Competition" on the home page. It includes images from past competitions, and often you can download not only the image but also the scene description file that made it.

2 Basics

The four sections in this chapter explain some terminology used in computer graphics and most likely you will find that you are already familiar with some of it. The first section covers fundamental terms and concepts of computing while the second discusses the internal workings of computer graphics hardware. The third section takes a brief look at graphics file formats and the last explains some rendering concepts that will be useful to you regardless of whether you are using a commercial rendering package or you are writing a program of your own. The terms and concepts you will learn will be useful to you no matter what area of computer graphics you pursue, and you will see them again in subsequent chapters of this book.

FUNDAMENTALS

This section covers some extremely basic terms that are fundamental to all of computer science. If you are a programmer or a computer science student, you have already come in contact with this material.

An *algorithm* is a method or technique for completing a task and is basic to all computer programming. An algorithm can be thought of as a set of directions, like those on the back of a shampoo bottle or in a chocolate-chip cookie recipe.

A *program* is a set of computer instructions that completes a task. Another way of saying this is that a program tells a computer how to carry out one or more algorithms. Often we refer to a program or a group of related programs as a *software package* or *package*. Examples of common software packages include word processors, spreadsheets, and computer games.

A *model* is a computer representation of an object found in the real world. Models can depict anything from molecules, jet fighters, and human figures to mountain ranges and skyscrapers. In most cases models are made from simple geometric components such as triangles or spheres.

Rendering is the process of creating an image or picture from a model. For example, engineers can render a series of pictures of an engine to display its various components,

or an interior designer can render an image to show a client how a redecorated room will appear.

Rendering algorithms are algorithms that create images from models, and *rendering packages* are programs that implement rendering algorithms. Examples of commercially available rendering packages include Pixar's PhotoRealistic Renderman, Autodesk's 3DStudio, and Wavefront's SoftImage. High-quality rendering packages that are free or available at a very low cost include POV-Ray [POVR98], Larry Gritz's Blue Moon Rendering Tools (BMRT) [GRIT98], Craig Kolb's Rayshade [KOLB98], and Greg Ward's Radiance [WARD98]. For more information about obtaining these from the Internet, check the Bibliography of this book.

HARDWARE

One of the reasons that computer graphics has become so prevalent is due to the fact that high-quality images can be created on today's personal computers. This section focuses on personal computers because they have become so powerful that many artists, animators, and architects choose them for their rendering needs. Higher-priced workstations also contain the same components but may have additional hardware for faster rendering.

We begin our discussion of graphics hardware with the monitor. A computer monitor displays text and images by means of a cathode ray tube (CRT), which is similar to the picture tube in your television set. Figure 2-1 shows a black-and-white CRT, which has a large flat display surface or screen in the front and an electron gun in the back. When the monitor is turned on, electrons pour off the electron gun to form a beam that is aimed at the front display surface. The inside of the display surface is coated with phosphor, a substance that glows briefly when electrons strike it hard enough.

The beam from the electron gun crisscrosses the screen in a fixed pattern, and in most monitors sold in the United States, the beam retraces the pattern 60 times per second. Although the beam's pattern of travel is fixed, its intensity is adjustable and is under computer control. To create a visible spot on the screen, the computer raises the beam's intensity as it passes over the spot. As the beam passes over the screen, the computer raises

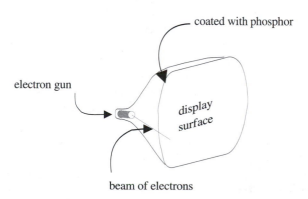

Figure 2-1 A cathode ray tube.

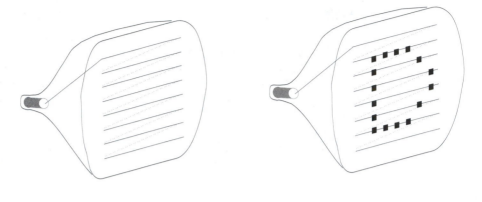

The beam travels across the
screen in a fixed pattern.

To make a visible spot, the beam
intensity is raised.

Figure 2-2 Drawing an image on a CRT's display surface.

and lowers its intensity, which results in a set of visible dots that we humans perceive as an image. Figure 2-2 shows both the fixed crisscross pattern and a simple image.

Each spot on the screen is called a *pixel*. The *resolution* of a monitor specifies the number of pixels that can be displayed on the screen. For a monitor, the resolution is usually given as the total number of pixels that can be displayed horizontally and vertically. Saying that a monitor has a resolution of 640 × 480 means that it can display a width of 640 pixels and a height of 480 pixels.

A digital form of the image is stored in special purpose memory called a *frame buffer*. Figure 2-3 shows the correspondence between the contents of the frame buffer and the image displayed on the monitor. There is one storage location in the frame buffer for each pixel on the screen and the value in a location determines the appearance of the corresponding pixel. Changing the contents of the frame buffer changes the image on the screen. To specify a location in a frame buffer or an image, we use *(x,y) coordinates*. A coordinate of (5, 3) specifies a location that is 5 pixels to the right and 3 pixels up from the lower left corner.

A frame buffer is usually located on a graphics board plugged into the computer's chassis. Also on the graphics board is a specialized chip called a *graphics controller* whose job is to send the frame buffer's image information to the monitor. In the United States, all but the cheapest monitors have graphics controllers that send the frame buffer's contents to the monitor 60 times per second.

Color is more fun than black and white, and most of today's computers come equipped with color monitors. A color CRT has a display surface whose inside surface is coated with three types of phosphor dots. One type glows red when struck by high-intensity electrons; the second type glows green and the last type glows blue. Figure 2-4 (see color plate section) shows how the phosphor dots are grouped into a pattern of triplets, where each triplet contains one red-glowing, one green-glowing, and one blue-glowing phosphor dot. A pixel on a color CRT contains one of these triplets. Varying the intensity of the red, green and blue dots will create color images.

0	0	0	0	0	0	0	0	0	0
0	0	1	1	1	1	0	0	0	0
0	0	1	0	0	0	1	0	0	0
0	0	1	0	0	0	0	1	0	0
0	0	1	0	0	0	0	1	0	0
0	0	1	0	0	0	0	1	0	0
0	0	1	0	0	0	0	1	0	0
0	0	1	0	0	0	1	0	0	0
0	0	1	1	1	1	0	0	0	0
0	0	0	0	0	0	0	0	0	0

 frame buffer

 image on computer screen

Figure 2-3 The contents of a frame buffer control the screen's appearance.

If you find it hard to believe that all colors on a CRT are created from mixing intensities of red, green, and blue, you can see for yourself by examining the picture on your color television set. The CRT or picture tube in your color television is similar to the ones found in computer monitors, but its phosphor dots are bigger. The next time you are watching the evening news, temporarily ignore your parents' warnings and walk up to the television and position your eye about 9 inches from the picture tube. At this short distance you will see red, green, and blue dots glowing on the screen. Now return to the couch.

Because monitors emit light, they follow a color-mixing scheme that is different from paint and print media. In the *additive color system*, the primary colors are red, green, and blue. In this system, mixing red and green yields yellow, green and blue together produce cyan, and a red-blue mixture creates magenta. As Figure 2-5 (see color plate section) demonstrates, mixing full intensities of red, green, and blue yields the color white.

A pixel on a color monitor contains three phosphor dots while a pixel on a black-and-white CRT contains only one dot, which means that color images contain more information than a black-and-white image with the same resolution. The frame buffer holding a color image must accommodate this larger amount of image information. The simplest way to do this is to store three numbers for each pixel. Figure 2-6 (see color plate section) demonstrates how three numbers can control the color of a pixel. The left number controls the red component, the middle number dictates the green component, and the last number controls blue. In this simple example, a value of zero indicates that the component is off, and a value of one means that the component is on. The numbers "1, 0, 0" mean that the red component is on, and the green and blue components are off. For the three components, there are eight combinations of on and off, which yields eight possible colors.

Today's graphics boards are not limited to eight colors. Most boards allow for 256 shades of red, 256 shades of green, and 256 shades of blue. To find the total number of possible colors, multiply the number of red, green, and blue shades. Multiplying 256 by 256 by 256, we get approximately 16.4 million. This range of expressiveness allows us to create high-quality images that have a realistic appearance.

As mentioned earlier, a frame buffer's contents will determine the image on the screen. Changing the information in the frame buffer will change the image on the screen. A user, such as an animator, has the power to change a frame buffer's contents, but the process is a bit indirect.

To create or change an image, an animator uses a keyboard or mouse to issue a "draw" command to a rendering package. Refer to Figure 2-7, which illustrates the hardware that

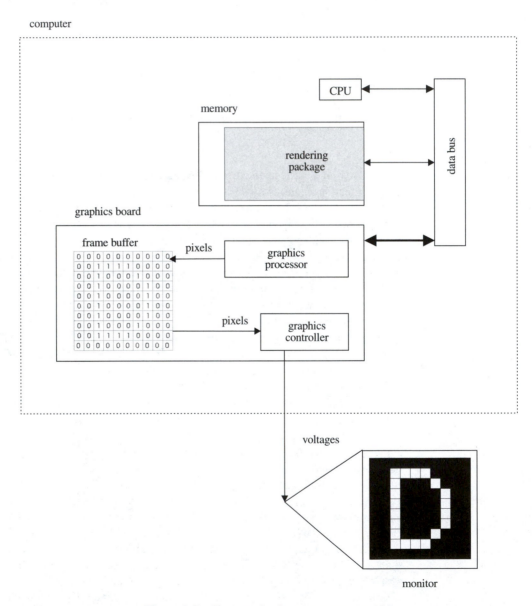

Figure 2-7 Computer hardware to support graphics.

displays an image. The software, which is sitting in the computer's main memory, responds to the command by instructing the CPU to send messages over the data bus to the graphics board. These messages contain new values for the frame buffer. Once they arrive at the graphics board, a chip called a graphics processor receives the messages and stores the new values in the frame buffer. The graphics controller chip then sends the newly changed contents of the frame buffer to the screen. Once this takes place, our animator will be able to see the resulting image.

FILE FORMATS

Most rendering packages allow a user to save the contents of the frame buffer as a file, making it possible to display it again at a later date. There are a huge number of image file formats, and the ones you will use will vary depending on the software package and application you have chosen. For example, image files commonly found on the World Wide Web include JPEG (Joint Photographers Expert Group) and GIF files (CompuServe's Graphics Interchange Format), while the POV-Ray rendering package produces Targa files. Publication companies generally prefer TIFF (Tagged Image File Format) files, and Microsoft-based products all accept Microsoft Windows Bitmap (BMP) files.

All of the file formats just mentioned are 2D formats that merely contain the contents of a frame buffer and are incapable of recording 3D information. To do that, there are a large number of 3D file formats, each of which is compatible with a limited number of rendering programs. Autodesk 3DStudio accepts 3DS or DXF files. Renderman Input Bytestream (RIB) files are what Pixar's Renderman and Larry Gritz's BMRT require. Consult the documentation that accompanies your rendering software to find out its list of acceptable 3D formats.

RENDERING CONCEPTS

Our physical world is three-dimensional, and if we want to capture realism in an image, we need to create and use three-dimensional models. To specify a point in *three-dimensional space*, we need three numbers, called *coordinates*. In a "Y is up" world, the first number, called the *x*-coordinate, quantifies "left–right." The second number, called the *y*-coordinate, quantifies "up–down." The last number, called the *z*-coordinate, quantifies "near–far." Figure 2-8 shows the coordinates for two points located in three-dimensional space.

There are actually three different coordinate systems that come in handy. The 3D coordinate system just discussed is the one that allows you to position objects in the world you are creating. This is why they are called *world coordinates*.

When you want to specify the location of a pixel in a frame buffer or in an image, you know that you have to specify an (x, y)-coordinate. An (x, y)-coordinate of (3, 2) tells you that the location is 3 pixels from the left edge and 2 pixels up from the bottom. When we refer to a position in terms of pixel location, we are using *device coordinates*.

Device coordinates are useful for specifying a position in an image, but if the resolution of the image should change for any reason, then they are no good. For example, if we are

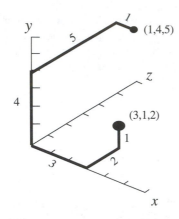

Figure 2-8 The 3D coordinate system.

working with an image having 1000×1000 resolution, we can use the location (500, 500) to specify the center of the image. If we increase the image's resolution to 2000×2000, a location of (500, 500) no longer specifies the center. *Normalized device coordinates* are a solution to this problem. Instead of expressing location as pixel counts, normalized device coordinates express locations as percentages. For example, the center of an image is 50% across the image and 50% up from the lower left corner and is expressed by the coordinates (0.5, 0.5). Regardless of image size, specifying a location in normalized device coordinates will take you to the position you want.

Creating a computer model of an object requires a list of points. Some rendering packages require a user to type in the points. This is tedious, time-consuming, and error-prone, because the user has to measure the object, enter the points, render, and look at the resulting image to see if the object's shape, position, and orientation are correct. Most likely, there will be something wrong and the user will be forced to look for the incorrect numbers, edit the list to fix the problem, and render another image. Typically a user repeats this "edit-test" cycle many times.

Other rendering packages come bundled with a *modeler*, which is a program with a graphical user interface that allows a user to modify the object interactively by moving a mouse while continuously displaying the object on the screen. Because the object is always visible, the user can immediately decide if the object's position, shape, and orientation are correct. If not, the user can correct the problem by moving the mouse. Virtually all commercially available rendering packages have some provision for interactive modeling. There are a few modeling packages available as freeware, including Neville Richards's Breeze Designer [RICH98] and Stephen Chenney's Sced [CHEN98], which are described briefly in Chapter 10. Check the Bibliography for details on how to obtain them.

The polygon could be called the most basic shape in computer graphics because all modeling and rendering packages accept them. A *polygon* has edges that connect its *vertices* to enclose an area. Figure 2-9 shows a polygon with each vertex labeled. Triangles are a type of polygon commonly found in computer models, and Figure 2-10 shows a model constructed entirely of triangles.

Computer graphics takes advantage of some terms and concepts that are already familiar to photographers. In photography, the visible area of a scene is recorded on film. In rendering,

Figure 2-9 A polygon.

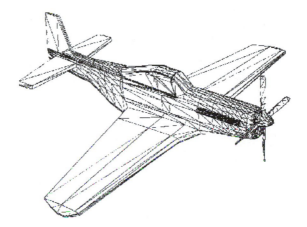

Figure 2-10 An object composed of triangles.

the visible area of a scene is displayed on a computer monitor. When taking a picture, a photographer must decide where to position and aim the camera. When you are creating a rendered image, it is just as important.

After positioning models to create a scene, you must decide where to put the camera and where to aim it. It is as if you are declaring, "I want to view the scene from HERE." In computer graphics, the position of a viewer is analogous to the position of the camera in photography and is called the *camera location* or the *viewpoint*.

In addition to positioning and aiming the camera, a photographer decides on the portion of the scene that will be visible and chooses an appropriate lens. Two photographs can have the same camera position and orientation, but in a close-up shot, you see less of the scene than in a wide-angle shot. Many rendering packages use a *field-of-view* angle to declare the visible area of a scene. As you can see in Figure 2-11, a wide (large) angle takes in more of the scene, while a narrow angle creates the effect of a telephoto lens.

FURTHER READING

For an excellent in-depth technical discussion of computer graphics architecture, read Chapters 1 and 4 of *Computer Graphics: Principles and Practice* written by Foley, van Dam, Feiner, and Hughes [FOLE90]. This is one of the major texts in computer graphics. For more

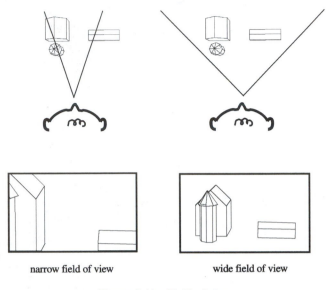

narrow field of view wide field of view

Figure 2-11 Field of view.

information about graphics file formats, take a look at the *Encyclopedia of Graphics File Formats* by Murray and van Ryper [MURR96]. Chapters 1 and 2 present a categorization of file formats and explain the purpose of each category. It continues by discussing each category in detail and listing the specifics of each format. This is a comprehensive volume, spanning the PC, Mac, and Unix platforms and their compatibility issues.

EXERCISES

Answer the following questions.

1. Which of the following are examples of algorithms?
 a. The novel *Oliver Twist*.
 b. Instructions on how to use your VCR to record.
 c. The activity of setting up your VCR to record.
 d. Directions to your friend's apartment.
2. Which of the following are programs?
 a. PhotoRealistic Renderman
 b. 3DStudio
 c. Rendering Packages
 d. Rendering algorithms
3. A rendering algorithm is a method of creating an _____ from a _____.

4. Which of the following are rendering packages?

BMRT POV-Ray SoftImage

FoxPro MSWord 3DStudio

5. You may want to review Figure 2-7 before answering the following questions.
 a. On which board does the frame buffer reside?
 b. What computer component is responsible for redrawing the image on the computer monitor?
 c. In what computer component will a rendering program reside?
 d. What component stores a digital representation of the image?
6. Consider the following points:

 (10, 3, 8) (16, 2, 7) (8, 4, 5)

Which point is the farthest to the right? Which point is highest?
7. In Figure 2-12 both scenarios will produce images in which all three objects are visible. In which scenario is the viewer closer to the objects? In which scenario does the viewer have the wider field of view? In general, if the viewer gets closer to the objects, what has to happen to the field of view to guarantee that the objects will still be visible in an image?

Doing It Yourself: Image Quality and Camera

In this section, you will learn how to

- Save an image file
- Adjust the quality and resolution of an image
- Manipulate the camera

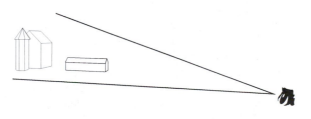
scenario A

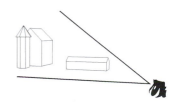
scenario B

Figure 2-12 Exercise 7.

You will want to save images that POV-Ray creates because it takes less time to display a preexisting image file than it does for POV-Ray to create the image from a .pov file. You can speed up POV-Ray by adjusting the resolution and image quality. By changing the camera properties you can create different views or "shots" of your scene.

Saving a File

Load the Table of Contents of your on-line documentation (povray.html) into your Web browser and read Sections 6.1.1, "Command Line Options," and 6.2.2.3, which includes "File Output Options," "Output File Type," and "Output File Name."

1. What is the command line switch that creates a Targa image file?
2. If you are working on Windows 3.1/95/NT, what is the command line switch that creates a Windows BMP image file?
3. If you are working on a Macintosh, what command line switch will create a Pict image file?
4. Give the command switch that would create an image file with the name "room.bmp."

Image Quality

When you are in the process of creating a scene, you want to see results quickly so you can make rapid adjustments. In this situation you are concerned with object and camera placement and will be making many more images before your scene is complete. For this purpose speed is so important that most people willingly sacrifice image quality.

One way to speed image generation is to reduce the resolution, which is covered in Section 6.2.2.1, "Height and Width of Output," in your on-line POV-Ray documentation. A second way is to use the "Quality Settings" as discussed in Section 6.2.6.1.

5. If you wanted a tiny image with a width of 100 pixels and a height of 75 pixels, how would you specify this with command switches?
6. If you wanted a high-resolution image with a width of 1200 pixels and a height of 800 pixels, how would you specify this with command switches?
7. What is the lowest quality setting that will produce shadows in the final image? What is the number of the highest image quality?
8. To complete this activity, copy all the files from directory /yourself/ch2 on your CD onto your hard disk. The files in that directory are room.pov, furnitur.inc, walls.inc, guitar.inc, ncc1701.inc, flooring.tga, and plane.tga. Next, find a watch that has a second hand.
 a. Use POV-Ray to draw room.pov with a resolution of 800 × 600 pixels. Use the watch to measure how long it takes your computer to complete the task. Now set the resolution to 100 × 75 pixels and record how long it takes your computer to draw a low-resolution image. What is the ratio of

 $$\frac{\text{Time to draw large image}}{\text{Time to draw small image}}$$

When you are in a hurry to see an image, what should you do to the resolution?

b. All the images you have drawn so far have been at the highest image quality. Try setting the image quality to 5 and redraw the image. What has changed? Set the image quality to 3 and redraw the image. What changed? Set the quality to the lowest possible setting, redraw the image, and compare it to the others you have drawn. What is different?

What you have experienced here are two different ways of reducing image quality to speed image production. Once you are nearing completion of a scene, you will want to boost the image quality. In addition to increasing the resolution, you can also turn on antialiasing, which is described Section 6.2.6.4 in your on-line documentation.

9. Set the resolution of the image to 400 × 300 pixels and draw the picture. Now use the command switch that turns on antialiasing and redraw the picture. Compare the appearance of the wallpaper in the first image and the second image. How do they differ?

Camera

Now you will start learning about the scene-building commands of POV-Ray. At this point, read through Section 4.1, "Our First Image," in the on-line documentation. In fact, you can try typing up the scene description listed in Section 4.1.6 and letting POV-Ray render it.

In the next set of activities, you will experiment with the camera command. Look at the contents of room.pov and find the camera command, which is listed here:

```
camera {
    location <4.31, 9.06, 19.8>
    direction <0, 0, 20>
    right <-8, 0, 0>
    up <0, 6, 0>
    look_at <-8.92, 2.92, -18.7>
}
```

The *location* clause, which positions the camera, and the *look_at* clause, which gives the center of attention in the scene, are described in Section 4.1 of the on-line documentation. The *direction* clause is one way of specifying the field of view in POV-Ray. As the last number in the direction clause gets smaller, the field of view widens. For wide-angle effects similar to what you see when you look through an apartment door peephole, change this last number to a value between 0.5 and 1. (Just don't make it zero.)

Another way of changing the field of view is through the *right* and *up* clauses. Notice that each of these clauses contains only one nonzero entry. The absolute values of these entries specify the area of the scene that a viewer can see. If you increase these, you will be able to see more of the scene.

The absolute values of these entries also give you the proportions of the final image. In this case, the absolute value from the right clause is 8 and the absolute value from the up clause is 6. The ratio of right to up is 4:3, which is the same as the ratio of the width to height of the final image.

For more information about the distance, right, and up clauses, consult Section 7.4.4, "Placing the Camera." For the next set of activities, you will be modifying the camera statement in the room.pov file.

10. Remember that the look_at clause specifies the point of interest for the viewer. To raise the point of interest, add a positive quantity to the y-component. To move the point of interest to the right, add a positive quantity to the x-component. Move the point of interest four units to the right and four units up from where it is now, and redraw the scene. What do you see?

11. Try moving the point of interest even farther to the right. What appears at the foot of the bed?

12. Restore the look_at clause to its original value of ⟨ −8.92, 2.92, −18.7 ⟩. Now try moving the camera location. To the x-component of the location clause, add 4. To the y-component, add 2 and to the z-component, add 12. This has the effect of moving the camera farther away from the bed. Rerender the picture. What has changed?

13. Again add ⟨ 4, 2, 12 ⟩ to the position clause and render the picture. Has anything else appeared? What is it? If you are not sure of what it is, repeat the process of adding ⟨ 4, 2, 12 ⟩ to the position clause and render the picture again.

14. If you wanted to take a shot that looks down on the bed, what component of the location clause would you change? Would you add to it or subtract from it?

15. Now restore the position clause to its original value of ⟨ 4.31, 9.06, 19.8 ⟩ and try reducing the z-component of the direction clause by half. Render the image. Do you see more or less of the scene? Continue decreasing the value of the z-component until you can see the entire scene. What is the value that allows you to see the entire scene?

3 Surface Algorithms

Suppose you are standing in front of a parked car. You can see the front license plate, but not the back one. To see the rear plate, you will need to walk to the other end of the car. From your experience, you know that an object's visibility depends on the position of the viewer. What is invisible in one view may become visible in the next, so a graphics practitioner has no choice but to supply a rendering program with complete three-dimensional information about an object. This makes the job of the rendering program quite complex, because it must face the question, "What objects are visible?" Algorithms that grapple with this question are called *surface algorithms*. In this chapter you will learn to identify surface algorithms by using a short list of visual cues, and you will also gain some insights into how different surface algorithms handle the visibility question.

Before you attempt to name a surface algorithm, you need to examine the image for visual cues. Spotting cues will be invaluable in determining the algorithm. You will begin by learning to recognize the following cues:

- Polygon appearance
- Visibility of far sides, backgrounds, and horizons
- Reflection, refraction, and shadows

POLYGON APPEARANCE

Whenever you are attempting to identify a surface algorithm, start by looking at the appearance of the polygons in the image. As Figure 3-1 demonstrates, they will either appear outlined or filled in. Polygons in the left image appear outlined, and they contrast with the filled-in or "solid" appearance of the polygons in the other two images. When you compare the center and right images, you will see that a filled polygon may have a single color or it may have multiple colors that change smoothly from one polygon to the next.

Using filled polygons can create a more true-to-life look, because foreground objects can hide background objects. The center and right images of Figure 3-2 demonstrate how filled polygons create an opaque cup, which hides part of the teapot. In contrast, the

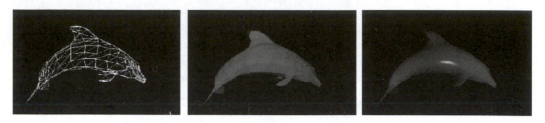

Figure 3-1 A comparison of outlined and filled polygons.

left image shows how outlined polygons give an object an artificial "Tinkertoy" look. Notice that the background is visible through the teapot, and the teapot is visible through the cup.

VISIBILITY

If you spot outlined polygons in an image, check the visibility of the horizon, background objects, and the far side of objects. Examine the image's horizon carefully. Does it run unbroken from left to right across the image, or does it disappear behind an object? If the image is an indoor scene, look for the far edge of a table or the line between a wall and a floor. Examine any background object located directly behind a foreground object. Is the object partially hidden by the foreground object, or is its structure visible through the foreground object? For example, in Figure 3-2a the teapot is visible through the cup in the foreground. When checking the visibility of far sides, use your commonsense knowledge about an object's shape. For instance, if a cup is positioned so its handle is on the far side of the cup and facing away from the viewer, is the handle visible? Contrast the visibility of the teapot in Figure 3-2a to the teapots in Figures 3-2b and 3-2c. Although the teapots in Figures 3-2b and 3-2c look different from each other, both of them obscure the background.

In the left image of Figure 3-3 the polygons comprising the back of the barn and silo are visible. The image has an unbroken horizon and you can see the barn in its entirety despite the fact that there is a silo in front of it. In contrast, the horizon in the right image

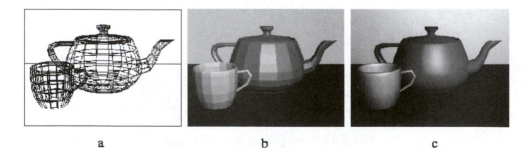

a b c

Figure 3-2 Visibility of horizons and background objects.

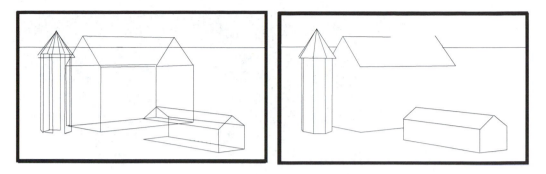

Figure 3-3 Visibility of outlined polygons.

disappears behind the barn. The silo obscures a corner of the barn, and the back of the barn and silo are missing.

SHADOWS, REFLECTION, REFRACTION

If you find filled polygons in an image, check for shadows, reflection, and refraction. *Shadows* add realism. Without shadows, objects seem to float above their supporting surface. In Figure 3-4 the left image has shadows, but the right does not.

Use your knowledge of the real world to help you spot *reflections*. Reflections found in computer imagery look like reflections in real life. If you find yourself describing an object as having a mirrored surface, then you have just found a reflective object. If you can see part of the scene in an object's surface, then that object has a reflective surface. Look again at Figure 3-4. Can you find a reflective surface?

Transparency is another naturally occurring phenomenon that can be simulated by computer graphics. An object is transparent if you can see through it. For example, Figure 3–5 shows a pencil that is visible through a water glass. If you find yourself thinking, "This object is made from glass," then you know that the object is transparent.

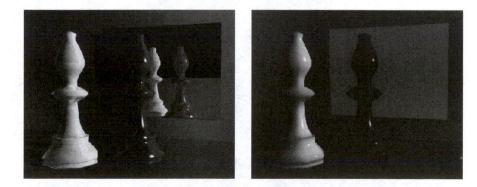

Figure 3-4 Reflections and shadows.

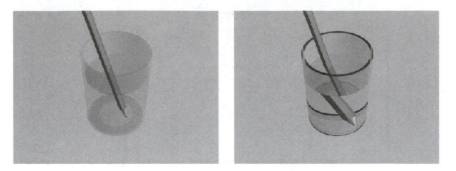

Figure 3-5 Transparency and refraction.

Look again at the right image of Figure 3-5. You know that a pencil is straight, but this pencil has a profile that appears to break as it enters the water. In your life experience, you have witnessed similar distortions when you looked through transparent objects. This is because light bends as it travels from air into such substances as glass or water. The term for this type of distortion is *refraction*.

As a study break, take a glass, fill it half full with water, and put a pencil or spoon in it. Compare the real-life glass to the images in Figure 3-5. Which one resembles your glass of water more closely?

In this book, the term *transparent* refers to objects that look as if they have been made from glass. Contrast the transparent object in the left image of Figure 3-6 to the objects in

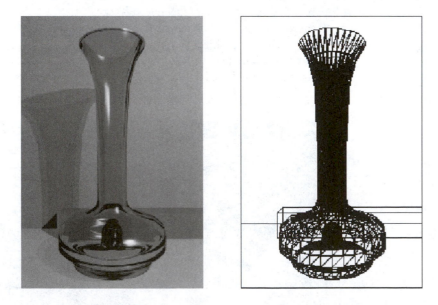

Figure 3-6 Transparency versus outlined polygons.

the right image. While you can see refraction in the transparent bud vase, what you see on the right are hundreds of visible polygon edges, which create a "Tinkertoy" look.

SUMMARY OF VISUAL CUES

Here is an initial checklist of visual cues that you should look for when you are examining an image. Chapters 4 through 9 will expand this list. Since we have just started, the current list is quite short:

- Polygon appearance
- Visibility of horizons, far sides, and background objects
- Shadows, reflection, and refraction

When searching for visual cues to help you determine the surface algorithm, your procedure for examining an image should be as follows:

1. Determine if polygons are outlined or filled.
2. If polygons are outlined, check visibility; if polygons are filled, look for shadows, reflections, and refraction.

EXERCISES: SURFACE CUES

To answer the following questions, you will need to use TERA. Install TERA if you have not done so already. Consult Appendix D for instructions on installing TERA on your computer and read Chapter 1 for tips on using it.

This set of exercises will help you spot the visual cues discussed in this chapter. In this session with TERA, you will be able to change the appearance of an entire image all at once, but you will not be able to change individual objects.

Start TERA and choose "Surface Cues." If you're using Windows 3.1, double-click on the icon labeled "Surface Cues." If you're using Windows 95 or NT, choose the "Surface Cues" option under the TERA entry in the **Programs** menu. Unix users will type "tera" at the prompt and choose Option 2 (Surface Cues).

1. Begin by selecting "Dolphins" from the image selection menu. Look at all four images and answer the following:
 a. In which image is the tail of the background dolphin visible through the post?
 b. In one of the images, the dolphins are made of outlined polygons, and they block parts of the horizon. Which image is it?
 c. In two images, it is possible to tell that the dolphins are a glistening light gray. Which two images are they?
 d. In which image is the post visible in the water surface?

2. Select "Herald" from the image menu, click on the various radio buttons, and answer the following:
 a. Are there any reflective objects? In which image do they occur?
 b. In which image can you see the far side of the trumpets?
 c. In which images are the far sides invisible?
3. Explore the "Sphere World" images before answering the following:
 a. Two images contain outlined polygons. Which contains fewer lines?
 b. Are there any shadows? If so, in which image are they?
 c. Which objects exhibit reflection?
 d. Do any objects exhibit refraction? If so, name them and the corresponding radio button.
 e. Which image allows you to verify the statement, "The smallest sphere is closest to the viewer? " Why?
4. Look at the "Chess" images, then answer the following:
 a. In which images do foreground objects obscure parts of the back wall?
 b. Which image has a mirror?
 c. Are there any shadows? If so, what objects cast them?
5. The following questions are about the "Sphere Flake" images.
 a. This shape does not correspond to any actual object in real life, so it is a little more difficult to decide what a far side might be. Still, when looking at the "SeeThrough" image, you will notice one visual cue that is useful. What is it?
 b. Are there any reflections? Refractions? Shadows? If so, specify where you saw them.

THE ALGORITHMS

There are four basic types of surface algorithms: *wireframe*, *hidden-line*, *z-buffer*, and *raytracing*. Before delving into their particulars, however, this part of the chapter will cover several key concepts that are useful not only for determining surface visibility but also for creating other effects that you will encounter in later chapters. These concepts have to do with the meanings of "far," "behind," and "away" as they relate to computer graphics.

The concept of "far" has to do with distance. Remember from Chapter 2 that the z-value of a point (x, y, z) in three-dimensional space gives an indication of how far away the point is. For our purposes, the greater the z-value is, the farther it is from the viewer. It is similar to comparing travel distances to cities. If Indianapolis is 200 miles away, and New York is 900 miles away, then New York is farther away than Indianapolis, because 900 is greater than 200.

The concept of "behind" is a relationship between two polygons or two objects. Suppose a viewer is looking at a scene that has two polygons, and the polygons overlap when drawn on a computer screen. Figure 3-7 shows a triangle and a square that overlap. The square is behind the triangle in the overlap area if its z-values are greater than the triangle's z-values. Figure 3-8 demonstrates the spatial relationship of the two polygons.

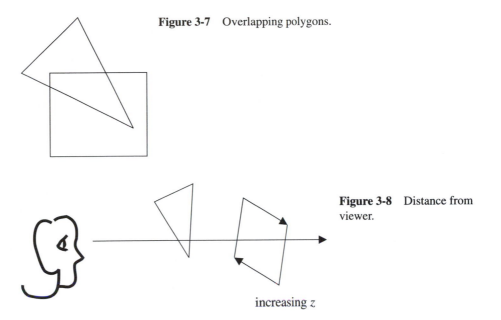

Figure 3-7 Overlapping polygons.

Figure 3-8 Distance from viewer.

increasing *z*

The concept of "away" has to do with a polygon's orientation relative to a viewer. Orientation information for polygons is expressed by using a special type of *vector*. Think of a vector as an arrow pointing in some direction. Only the direction and length of a vector are important and its position does not matter. Figure 3-9 shows two vectors, one pointing toward the sun and the other pointing toward a viewer. The first vector supplies information about the direction of the sun, and the second vector has information about how to find the viewer. To simplify matters, all the vectors in this book will have a length of one, so from now on, we will only be interested in a vector's direction.

A *polygon normal* is a vector that tells you which way a polygon is facing. To understand what a polygon normal is, think of a nail that has been pounded through a board so that it sticks out on the other side. Figure 3-10 shows the board turned upside down so the nail points up. Imagine that the nail was hammered through the wood so perfectly that it meets the board at right angles as you walk around the nail. No matter where you position an imaginary carpenter's square, you will find that the nail meets the board at a right angle. No matter where you measure it, a normal meets its polygon at right angles, so it sticks "straight out" of the polygon.

Figure 3-9 Two vectors.

Figure 3-10 A polygon normal.

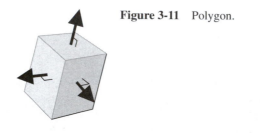

Figure 3-11 Polygon.

 Because it sticks straight out, a normal points in the same direction that the polygon is facing. As Figure 3-11 demonstrates, we can use a polygon normal to tell us the direction or orientation of a polygon. A normal pointing upward means that its polygon is facing upward.

 Mathematicians will tell you that a polygon actually has two normals, and they are correct. Figure 3-12 shows the two normals for one side of a cube. One normal points toward the outside of the cube, and the other points toward the inside. In computer graphics, we are only interested in the normals that point toward the outside, so from now on, the term "polygon normal" will refer to the normal that points outward.

 Figure 3-13 shows another extremely useful type of normal called *vertex normal*. In the figure the vertex labeled P is shared by polygons A and B. The normal of polygon A points straight up, while the normal of polygon B points to the right. The vertex normal of vertex P points in a direction that is halfway between A's polygon normal and B's polygon

Figure 3-12 Outer normal.

outer normal

Figure 3-13 Vertex normal.

normal. More precisely, a vertex normal is the average of the normals of those polygons that share the vertex.

Rendering algorithms need information about polygon orientation in order to make decisions about visibility and illumination. Polygon normals supply orientation information, and in Chapter 4 you will learn how vertex normals supply additional information that is useful when lighting the object.

The concept of "away" makes use of polygon normals to describe the orientation of a polygon relative to the viewer. Figure 3-14 shows a box with two of its sides facing away from a viewer. If a polygon faces away from the viewer, its normal will also point away from the viewer. A polygon whose normal points away from the viewer is called a *back face* and in the real world, back faces of opaque objects are always invisible.

Armed with knowledge of "far," "behind," and "away," you are ready to meet the four surface algorithms. After discussing their details, this chapter will conclude with a discussion of how the cues you have learned will help you identify each of these algorithms.

WIREFRAME

This algorithm takes a very simple approach to answering the question about surface visibility. It doesn't bother. A rendering package using the wireframe algorithm simply draws the outline of every polygon of every object in the scene and makes no tests for visibility.

Figure 3-14 Back faces.

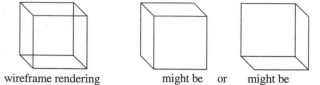

wireframe rendering might be or might be

Figure 3-15 Ambiguities in
wireframe rendering.

Advantages of this algorithm are that it is simple to implement and runs quickly. It is
fast because it has no capacity for determining the visibility of a polygon, so it spends no
time on deciding if a polygon is visible. However, the images it produces are not realistic
and in fact can be downright confusing. In Figure 3-15, the cube on the left was rendered
using the wireframe algorithm, and it is not clear at all which polygon is in front. The other
two cubes in the figure demonstrate the two possibilities.

HIDDEN-LINE

A hidden-line surface algorithm [APPE67] draws the outlines of polygons, just as the
wireframe algorithm does, but it removes some of the ambiguities of a wireframe rendering.
It draws only the parts of the polygon outline that are visible to the viewer.

The algorithm begins with a process known as a *back face cull*, which throws out
all polygons that face away from the viewer. It then attempts to draw the edges of the
remaining polygons. To find the visible portions of a polygon's edge, the algorithm com-
pares it to the other polygons in the scene and draws only the portion that does not have
polygons overlapping it. To find the parts of an edge that are not covered by overlapping
polygons, the algorithm records information about an edge's relative position as an *over-
lap count*.

If the edge passes behind a polygon, the algorithm computes the point at which the
edge disappears behind the polygon and adds one to the overlap count. When an edge comes
out from behind the polygon, the algorithm computes the point of the edge's reappearance
and since there is one less polygon covering the edge, the algorithm subtracts one from the
overlap count.

Figure 3-16 shows an example of an edge passing behind a polygon and reappearing
on the other side. The overlapping polygon divides the edge into three pieces. The middle
piece, drawn as a dashed line, has an overlap count of one and is invisible. The two pieces
on either end have an overlap count of zero and are visible. Figure 3-17 shows a more
complex example where two polygons simultaneously overlap an edge. The edge is invisible
whenever its overlap count is greater than zero.

Figure 3-16 Overlap counts.

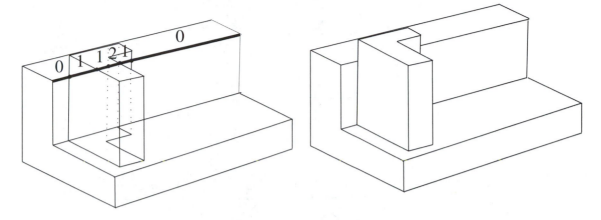

Figure 3-17 Hidden-line surface algorithm.

Z-BUFFER ALGORITHM

Rendering programs that use the z-buffer algorithm [CATM75] can create more realistic images than the wireframe or hidden-line methods because they fill a polygon's area with color. A program using the z-buffer algorithm needs a lot of memory. The algorithm got its name from the fact that in addition to the frame buffer, it requires extra memory to store what is called a *z-buffer*.

A z-buffer has the same resolution as a frame buffer. As you recall from Chapter 2, information stored at location (x, y) in a frame buffer dictates the color of pixel (x, y) on a computer's screen. In other words, the polygon that is visible at pixel (x, y) has color information stored at location (x, y) in the frame buffer. Instead of storing color like the frame buffer, the z-buffer stores distance information. For the polygon visible at pixel (x, y), the z-buffer stores the polygon's distance at location (x, y).

Figure 3-18 shows the relationship between frame buffer and z-buffer. A viewer is looking at a triangle and a square, and the square is closer to the viewer. The left image shows you the display on the computer monitor. The square is entirely visible and it partially obscures the triangle behind it. Compare the appearance of the screen to the contents of the frame buffer. Locations occupied by the square are marked with the letter S and locations containing a T are occupied by the triangle. Now look at the values in the z-buffer. Since the triangle is farther from the viewer, its z-values are greater than those belonging to the square.

To draw an image, the z-buffer algorithm begins by setting all locations in the frame buffer to the background color and all the locations in the z-buffer to a special value. The special value means "a distance farther away than any polygon could possibly be." In an example that we will discuss later, we will choose the value 99 to represent this huge distance.

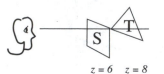

$z = 6 \quad z = 8$

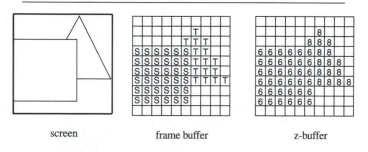

Figure 3-18 Frame buffer and z-buffer.

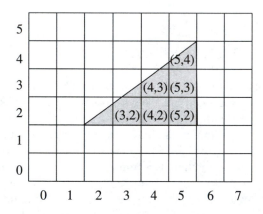

Figure 3-19 A polygon overlaps pixels.

The z-buffer then proceeds to process one polygon at a time. First, the algorithm identifies the pixels that lie inside the polygon's area. These are the pixels that the polygon would occupy if the polygon were entirely visible. Look at Figure 3-19. If the polygon were entirely visible, it would occupy locations (5, 4), (4, 3), (5, 3), (3, 2), (4, 2), and (5, 2) in the frame buffer. The algorithm must now decide if this polygon is in fact visible at any of these locations.

Suppose that the polygon currently being processed would like to occupy the pixel at (3, 2). The algorithm needs to decide if this new polygon is closer to the viewer than any previous polygon that occupies pixel (3, 2). If the z-value of the new polygon is less than the z-value stored in location (3, 2), then the new polygon is closer to the viewer, and the new polygon should obscure the previous one. In this case, the algorithm stores the color of the new polygon at location (3, 2) in the frame buffer and stores the z-value of the new polygon at location (3, 2) in the z-buffer.

The z-buffer algorithm can handle any polygon shape and can correctly process polygons that pierce one another. Figure 3-20 shows an example where a triangle pierces a square. In this example, the algorithm first draws the square. Because it is the very first polygon being processed, the square will occupy all pixel locations that fall inside its area. The algorithm stores the square's color in the frame buffer and its distance in the z-buffer. Figure 3-21 shows the frame buffer and the z-buffer after the square has been processed.

Look again at Figure 3-20. The triangle's right side is farther from the viewer than the square, so the square obscures the triangle where they overlap near the right side of the screen. However, the left tip of the triangle is closer to the viewer than the left side of the square. When the z-buffer algorithm processes the triangle, it determines the locations where the triangle is closer to the viewer than the square. For those locations, the algorithm will store the triangle's color in the frame buffer and the triangle's z-values in the z-buffer. The algorithm also changes some locations that had not been occupied by a polygon until the triangle overlapped them. Figure 3-22 shows the contents of the frame buffer and the z-buffer after the algorithm processes the triangle.

 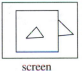

Figure 3-20 A triangle pierces a square.

screen

```
b  b  b  b  b  b  b  b  b  b  b  b  b  b  b  b  b
b  b  b  b  b  b  b  b  b  b  b  b  b  b  b  b  b
b  b  s  s  s  s  s  s  s  s  s  s  b  b  b  b  b
b  b  s  s  s  s  s  s  s  s  s  s  b  b  b  b  b
b  b  s  s  s  s  s  s  s  s  s  s  b  b  b  b  b
b  b  s  s  s  s  s  s  s  s  s  s  b  b  b  b  b
b  b  s  s  s  s  s  s  s  s  s  s  b  b  b  b  b
b  b  s  s  s  s  s  s  s  s  s  s  b  b  b  b  b
b  b  s  s  s  s  s  s  s  s  s  s  b  b  b  b  b
b  b  s  s  s  s  s  s  s  s  s  s  b  b  b  b  b
b  b  s  s  s  s  s  s  s  s  s  s  b  b  b  b  b
b  b  s  s  s  s  s  s  s  s  s  s  b  b  b  b  b
b  b  s  s  s  s  s  s  s  s  s  s  b  b  b  b  b
b  b  s  s  s  s  s  s  s  s  s  s  b  b  b  b  b
b  b  s  s  s  s  s  s  s  s  s  s  b  b  b  b  b
b  b  s  s  s  s  s  s  s  s  s  s  b  b  b  b  b
b  b  s  s  s  s  s  s  s  s  s  s  b  b  b  b  b
b  b  s  s  s  s  s  s  s  s  s  s  b  b  b  b  b
b  b  b  b  b  b  b  b  b  b  b  b  b  b  b  b  b
b  b  b  b  b  b  b  b  b  b  b  b  b  b  b  b  b
```

```
99 99 99 99 99 99 99 99 99 99 99 99 99 99 99 99 99 99
99 99 99 99 99 99 99 99 99 99 99 99 99 99 99 99 99 99
99 99 10 10 10 10 10 10 10 10 10 10 99 99 99 99 99 99
99 99 10 10 10 10 10 10 10 10 10 10 99 99 99 99 99 99
99 99 10 10 10 10 10 10 10 10 10 10 99 99 99 99 99 99
99 99 10 10 10 10 10 10 10 10 10 10 99 99 99 99 99 99
99 99 10 10 10 10 10 10 10 10 10 10 99 99 99 99 99 99
99 99 10 10 10 10 10 10 10 10 10 10 99 99 99 99 99 99
99 99 10 10 10 10 10 10 10 10 10 10 99 99 99 99 99 99
99 99 10 10 10 10 10 10 10 10 10 10 99 99 99 99 99 99
99 99 10 10 10 10 10 10 10 10 10 10 99 99 99 99 99 99
99 99 10 10 10 10 10 10 10 10 10 10 99 99 99 99 99 99
99 99 10 10 10 10 10 10 10 10 10 10 99 99 99 99 99 99
99 99 10 10 10 10 10 10 10 10 10 10 99 99 99 99 99 99
99 99 10 10 10 10 10 10 10 10 10 10 99 99 99 99 99 99
99 99 10 10 10 10 10 10 10 10 10 10 99 99 99 99 99 99
99 99 10 10 10 10 10 10 10 10 10 10 99 99 99 99 99 99
99 99 10 10 10 10 10 10 10 10 10 10 99 99 99 99 99 99
99 99 99 99 99 99 99 99 99 99 99 99 99 99 99 99 99 99
99 99 99 99 99 99 99 99 99 99 99 99 99 99 99 99 99 99
```

b: background color
s: square's color

frame buffer z-buffer

Figure 3-21 Storing a square.

```
b  b  b  b  b  b  b  b  b  b  b  b  b  b  b  b  b  b  b          99 99 99 99 99 99 99 99 99 99 99 99 99 99 99 99 99 99
b  b  b  b  b  b  b  b  b  b  b  b  b  b  b  b  b  b  b          99 99 99 99 99 99 99 99 99 99 99 99 99 99 99 99 99 99
b  b  S  S  S  S  S  S  S  S  S  S  S  b  b  b  b  b  b          99 99 10 10 10 10 10 10 10 10 10 10 99 99 99 99 99 99
b  b  S  S  S  S  S  S  S  S  S  S  S  b  b  b  b  b  b          99 99 10 10 10 10 10 10 10 10 10 10 99 99 99 99 99 99
b  b  S  S  S  S  S  S  S  S  S  S  S  b  b  b  b  b  b          99 99 10 10 10 10 10 10 10 10 10 10 99 99 99 99 99 99
b  b  S  S  S  S  S  S  S  S  S  S  S  b  b  b  b  b  b          99 99 10 10 10 10 10 10 10 10 10 10 99 99 99 99 99 99
b  b  S  S  S  S  S  S  S  S  S  S  S  b  b  b  b  b  b          99 99 10 10 10 10 10 10 10 10 10 10 99 99 99 99 99 99
b  b  S  S  S  S  S  S  S  S  S  S  S  T  b  b  b  b  b          99 99 10 10 10 10 10 10 10 10 10 10 16 99 99 99 99 99
b  b  S  S  S  S  S  S  S  S  S  S  S  T  b  b  b  b  b          99 99 10 10 10 10 10 10 10 10 10 10 16 99 99 99 99 99
b  b  S  S  S  S  T  S  S  S  S  S  T  T  b  b  b  b  b          99 99 10 10 10 10  9 10 10 10 10 10 15 16 99 99 99 99
b  b  S  S  S  T  T  T  S  S  S  S  T  T  T  b  b  b  b          99 99 10 10 10 10  8  9 10 10 10 10 14 15 16 99 99 99
b  b  S  S  T  T  T  T  S  S  S  S  T  T  T  b  b  b  b          99 99 10 10  7  8  9 10 10 10 10 10 13 14 15 99 99 99
b  b  S  T  T  T  T  S  S  S  S  b  b  b  b  b  b  b  b          99 99 10  6  7  8  9 10 10 10 10 10 99 99 99 99 99 99
b  b  S  S  S  S  S  S  S  S  S  S  S  b  b  b  b  b  b          99 99 10 10 10 10 10 10 10 10 10 10 99 99 99 99 99 99
b  b  S  S  S  S  S  S  S  S  S  S  S  b  b  b  b  b  b          99 99 10 10 10 10 10 10 10 10 10 10 99 99 99 99 99 99
b  b  S  S  S  S  S  S  S  S  S  S  S  b  b  b  b  b  b          99 99 10 10 10 10 10 10 10 10 10 10 99 99 99 99 99 99
b  b  S  S  S  S  S  S  S  S  S  S  S  b  b  b  b  b  b          99 99 10 10 10 10 10 10 10 10 10 10 99 99 99 99 99 99
b  b  S  S  S  S  S  S  S  S  S  S  S  b  b  b  b  b  b          99 99 10 10 10 10 10 10 10 10 10 10 99 99 99 99 99 99
b  b  b  b  b  b  b  b  b  b  b  b  b  b  b  b  b  b  b          99 99 99 99 99 99 99 99 99 99 99 99 99 99 99 99 99 99
b  b  b  b  b  b  b  b  b  b  b  b  b  b  b  b  b  b  b          99 99 99 99 99 99 99 99 99 99 99 99 99 99 99 99 99 99
```

b: background color
S: square's color
T: triangle's color

frame buffer z-buffer

Figure 3-22 Storing a triangle.

RAYTRACING

To understand how raytracing works, think of the screen as a grid [WHIT80]. The viewer looks through the grid to observe the scene, and each square in the grid represents a pixel in the image. For each square, the raytracing algorithm answers the question, "What can the viewer see through this grid square?" Figure 3-23 shows the relationship of the scene, the viewer, and the grid.

To find what is visible through one of the squares on the grid, the raytracing algorithm starts at the eye position, aims at the grid square, and fires a ray. The ray starts at the eye, passes through the grid square, and travels into the scene. If the ray strikes an object, then the grid square receives a color from the object. If the ray misses, the grid square receives the background color.

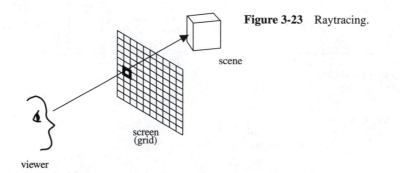

Figure 3-23 Raytracing.

scene

screen
(grid)

viewer

If a ray strikes an object, the algorithm determines the position of the impact. After computing the intersection of the ray with the object, the raytracer has the capacity to further follow the ray as it bounces off reflective objects or passes through transparent objects. Because a ray's path can be traced through the scene, it is easy to implement such visual effects as reflection and refraction. We will talk more about this in Chapter 5.

CUES TO THE ALGORITHMS

Whenever you analyze an image, always begin by identifying the surface algorithm because it is the most fundamental part of the rendering process. In the vast majority of cases, an image is created using only one surface algorithm. In all examples in this book, a rendering program will use only one surface algorithm to generate an entire image. For this reason, do not limit your observations to any one object or portion of an image when you are looking for cues to identify a surface algorithm. Look everywhere!

The list below pairs visual cues with the surface algorithms that create them:

Outlined polygons, unobstructed horizons and backgrounds, visible back faces	Wireframe
Outlined, opaque polygons	Hidden-line
Solid polygons with reflection, refraction, or shadows	Raytracing
Solid polygons without refraction, reflection, or shadows	z-Buffer

FURTHER READING

For a discussion of all four types of surface algorithms, consult Chapter 15, "Visible Surface Determination," from *Computer Graphics: Principles and Practice* by Foley et al. [FOLE90]. This text is a major reference for many types of graphics algorithms. As you read through the chapter, you will notice that there are multiple algorithms that carry out hidden-line and hidden-surface removal. Each variation was developed to address a specific situation. The algorithms are presented in sufficient detail that you can implement them in a program, if you are so inclined.

EXERCISES: SURFACE ALGORITHMS

You will need to use TERA to complete these exercises. Choose the "Ch. 3b: Surface Algorithms" session. This is Option 3 for Unix users.

1. The first questions examine the "Frank Lloyd Wright" images. Frank Lloyd Wright was an architect who championed the Prairie style. He designed the furniture to complement the interiors of the private homes he created.

 a. In the raytraced image, what surfaces are reflective? Which objects cast shadows? Are there any transparent objects?

 b. Match the algorithm and the effect it creates:

The wallpaper is visible in the table	Wireframe
The tabletop is solid brown	Hidden-line
The tabletop is made from two triangles	z-Buffer
You can see through the table	Raytracing

 c. Compare the books in the z-buffer rendering to the books that were raytraced. If you looked at just the books, would you have enough evidence to make an informed choice between the z-buffer and raytracing surface algorithms? Why would this give credence to the rule, "Look at the whole image when determining the surface algorithm."

2. Choose "Decision" from the image selection menu.

 a. Select the "Wireframe" radio button. Since there's no horizon in this image, what other cues can you find that confirm that this is a wireframe rendering?

 b. Compare the z-buffer and raytraced versions. Do any objects have the same appearance in both renderings? If so, what are they?

3. Move to the "Coffee Cup" images.

 a. In which rendering(s) do you find opaque objects?

 b. In what renderings are all objects opaque and made from filled polygons?

 c. Match the surface algorithm with the effects it can create.

Wireframe	Solid polygons, no shadows
Hidden-line	Outlined polygons; can see entire cup
z-buffer	Outlined polygons; spoon hides part of saucer
Raytracing	Shadows, reflection

4. Use the "Candy" entry in the image menu for the next questions.

 a. Which rendering has a mirror in it?

 b. What surface algorithm leaves the sticks visible inside the lollipops?

 c. What surface algorithm creates filled polygons but no transparency?

5. For the last questions, choose the "Fruit" entry in the scenes pull-down menu.

 a. What rendering algorithm(s) created apples made of outlined polygons?

 b. What rendering algorithm created a green pear that's entirely visible?

 c. What objects have a different appearance when rendered with the z-buffer and raytracing algorithms? Which of these objects cast shadows? Which of the objects are refractive? Which of the objects are reflective?

DOING IT YOURSELF: SHAPE, SIZE, POSITIONING

In this section, you will learn about

- Orienting, sizing, and positioning objects
- The rich assortment of primitive shapes available in POV-Ray

Begin by reading about planes, spheres, and boxes in Section 4.3, "Simple Shapes," and Section 7.5.2.9, "Sphere," of the on-line documentation for POV-Ray. Follow this by reading about *rotation* (orienting), *scaling* (sizing), and *translation* (positioning) in Section 7.3.1, "Transformations."

Copy the files `chess.pov` and `pawn.inc` from the subdirectory `/yourself/ch3` on your CD to your hard drive.

1. Examine the contents of `chess.pov` and answer the following questions.
 a. How many lights are there?
 b. What is the color of the plane? What is the color of the sphere?
 c. Where is the center of the sphere located?

Render an image of `chess.pov`. You will see a board that contains checks, and each check is one unit square. You can think of each check as being 1 inch on a side, if you wish. Traveling left and right on the board corresponds to changes in the *x*-coordinate. Traveling forward and back corresponds to changes in *z*.

2. Add another pawn to the scene. Give it a green color and add a translate statement to position it one unit to the right and one unit back from the blue pawn. What is the translate statement you used?
3. Now make another pawn and color it aquamarine. Place it two squares to the left and two squares forward of the blue pawn. Scale it so that it is twice as tall as the blue pawn, but it still occupies a single square on the board. What scale and translate statements did you use?
4. Create yet another pawn and color it magenta. Rotate it so it falls over to the right, and translate it to the right and forward of the blue pawn. Start with the following object statement for the pawn:

```
object { pawn
        texture { pigment { color Magenta}
                  finish { Shiny }
        }
        rotate <-90, 0, 0>
        translate <1, 0, -2>
}
```

Render an image and compare this version to the last version you created. Is this what you expected? Can you explain what happened? Figure 3-24 gives you a hint.

Figure 3-24 Side view of checkered board.

5. What will you have to do to the translate statement to cause the magenta pawn to appear on the board?
6. Review Section 4.3 on simple shapes. What additional commands would give you an image that looks like Figure 3-25?

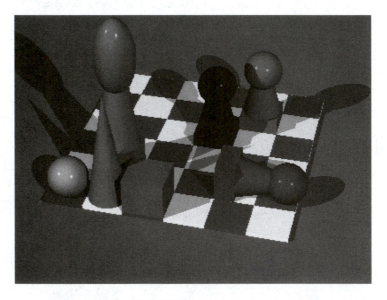

Figure 3-25 Exercise 6.

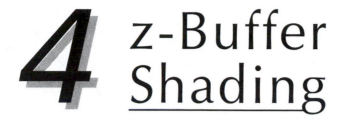 z-Buffer Shading

Shading algorithms determine the color or colors that each polygon will have. Sophisticated shading algorithms can add realism to an image because they help create the illusion of three dimensions in a two-dimensional image. Your choice of a surface algorithm limits the range of shading algorithms you can use because shaders are designed to work with specific surface algorithms. For the wireframe and hidden-line surface algorithms, there is little choice in shaders. However, for the z-buffer and raytracing algorithms there is a rich assortment of shading algorithms capable of myriad visual effects.

The shading algorithms or *shaders* compatible with the z-buffer algorithm make it a versatile and effective algorithm for a wide number of applications. With one set of shaders, it can create architectural renderings that have a high degree of realism. With another set, it becomes so fast that it remains the algorithm of choice for virtual reality applications, where an image must change in real time to keep up with the head movements of a user.

This chapter covers the four basic shaders for the z-buffer algorithm, namely, constant, faceted, Gouraud, and Phong.

VISUAL CUES

In this chapter you will learn two new visual cues to help you identify z-buffer shaders. You look for these once you have decided that the surface algorithm for the image is z-buffer. Multiple shading techniques can appear in an image, but each object will have only one shading algorithm applied to it. It's important, therefore, that you concentrate on a single object at a time and search it for shading cues. The new cues are:

- Transitions from light to dark
- Highlight shape

Transitions

The pattern of light and dark on an object will tell you a lot about the shader that was used to render it. There are three basic patterns of transitions that you should learn to spot. The

first pattern is no transition at all, and the object has a single color. As you can see in teapot 1 of Figure 4-1, a lack of lighter or darker shaders makes an object appear flat, as if it had been cut from paper.

Teapot 2 shows the second pattern of transition, which does have shades of light and dark. It does not look flat in the way that the first one did, but it still is not very realistic. The polygons that make up this teapot are readily apparent because each polygon has a single color.

The last pattern is a smooth transition from light to dark, as can be seen in teapots 3 and 4 of Figure 4-1. When a transition is smooth, the individual polygons that comprise the teapot's structure are not apparent.

Highlight Shape

If an object has a highlight, examine it. The highlight in teapot 4 of Figure 4-1 is elliptical, bright, and compact. It looks similar to the highlight on any real-life object that is made from shiny plastic. Figure 4-2 shows four more objects that have compact, elliptical highlights.

In contrast, the highlight in teapot 3 of Figure 4-1 is not as realistic in appearance. The highlight is star-shaped and not as prominent as the highlight in teapot 4. From your real-life experience, you know that it is odd that a star-shaped highlight would appear

Figure 4-1 Visual cues for z-buffer shaders.

Figure 4-2 Compact highlights.

on a smooth object. Figure 4-3 shows four more objects that have this less-than-perfect highlight. This type of highlight crawls along a polygon edge and does not seem to be very bright.

SUMMARY OF VISUAL CUES

Once you have determined that an image was rendered with the z-buffer surface algorithm, you are ready to look for visual cues for shading. Various shading algorithms may appear in an image, but each object will have a single shader.

When you are searching for shading cues in images created with the z-buffer surface algorithm, your examination of an object should answer the following questions:

Figure 4-3 Smeary and star-shaped highlights.

1. Are the transitions from light to dark
 a. nonexistent?
 b. permitting the underlying polygon structure to show?
 c. smooth?
2. If transitions are smooth and a highlight is present, is it
 a. star-shaped or running along polygon edges?
 b. bright, compact, curved along the perimeter?

EXERCISES: z-BUFFER SHADING CUES

Start TERA and choose the session called "Ch4a: Shading Cues," which is Option 4 for Unix users. In this session, you can use TERA to change individual objects. Click on the object in the picture, and then click on one of the radio buttons to change the object's appearance. You will notice that the radio buttons are labeled with the following terms:

OneColorOnly: One color per object

OneColorPolys: An object may have different shades of color, but each polygon has exactly one color

SmoothShading: Transitions from light to dark are smooth; any highlights will be star-shaped or smeary

GoodHighlights: Transitions from light to dark are smooth; highlights are bright and compact and may be elliptical

1. The first image you see is called "Bowling."
 a. Which visual effect appears "flat" or two-dimensional?
 b. Which visual effect lets you see the underlying polygon structure of the object?
 c. Which visual effect includes highlights whose perimeters follow polygon outlines?
2. Choose the "Living Room" image.
 a. Which effects allow you to see a line where the two walls join to form a corner?
 b. Which effects let you see the seat cushions on the couch and chair?
 c. Which objects have highlights?
3. Continue by choosing the scene entitled "Ducks."
 a. Which objects change appearance under all four effects?
 b. Observe the ducks' highlights under the "SmoothShading" effect and under the "GoodHighlights" effect. How do the highlights differ under these two effects?

4. The last set of questions concern the "Chess" images.
 a. Which effect can appear like shiny plastic?
 b. Compare the dark bishop's highlights under the "SmoothShading" effect and under the "GoodHighlights" effect. What changes?
 c. Where is there a starker difference, in the shading of a dull, flat object, or in the shading of a shiny round object? Explain.

THE ALGORITHMS

Before discussing the specifics of shading algorithms, we need to spend a little time on the phenomena of light and color. Light is an essential ingredient in computer graphics. When you look at a scene, light reflecting from surfaces will strike your eyes, and you will perceive the reflected light as color. The exact physical description of the interaction of light with a surface is very complex, and physicists have spent several centuries studying it. The interaction of light, the eye, and the brain is equally complex and forms the basis for the fields of colorimetry and color perception.

It is not practical to use computers to reproduce Nature's way of creating colors. Instead, we use approximations whose appearances make an acceptable impression on viewers. It is the same approach that filmmakers use when they are shooting scenes on a movie set located on a back lot. When building the set of a town from the Wild West, technicians construct only the fronts of buildings that line the street. When movie fans see the sheriff walking down the street, the buildings look real, even though they are not.

One of the most important approximations has to do with representing white light. In real life, white light contains all the colors of the rainbow. In computer graphics, however, white light contains just three colors—red, green, and blue. It is the same approximation that your color television uses. As you know, properly mixed shades of red, green, and blue can simulate most of the colors that the human eye perceives.

PHONG LIGHTING MODEL

Computing color in computer graphics relies on approximations, and one of the most commonly used ones is called the *Phong lighting model* [BUIT75]. Many commercially available rendering packages use this method for approximating colors in a scene.

Computing color begins with light. Light is necessary to illuminate a scene and our eyes cannot see without it. Objects that generate light, such as electric lights and the sun, are called light sources. Most objects are not light sources but reflect it instead.

For our purposes, we can categorize light sources into two different types, called *directional* and *ambient*. Directional light comes directly from a light source. In contrast, ambient light is light that has been reflected from other surfaces and comes from all directions. Ambient light is present in most scenes except for those located in outer space.

The reason that you cannot see the dark side of the moon is due to the fact that there is not enough ambient light present to illuminate it. In contrast, a scene with strong ambient light will have faint shadows. An example of illumination with a strong ambient component is lighting for portraiture photography.

When light strikes an object, some of it is reflected and the rest is absorbed as heat. An object that has a red surface is absorbing all of the light components except the red ones. The red ones are reflected and that is what your eyes see. While white objects reflect a great deal of light, black objects absorb it and turn it into heat. On a hot summer day, the white dividing lines of a highway feel cooler underfoot than the surrounding black asphalt. The lines reflect more light than the asphalt does.

When using a rendering package, what often is referred to as the "color" of an object is actually information about reflection. A common way of specifying an object's "color" is to list three numbers. These three numbers actually specify the reflectance of red, green, and blue light. For instance, a color of "1.00, 0.50, 0.00" means that this object reflects 100% of a light's red component, 50% of the light's green component, and 0% of the light's blue component. Even though these three numbers are commonly referred to as the color of the object, they actually specify information about what light components get reflected.

We can categorize reflected light into two types called *diffuse* and *specular*. Dull, matte surfaces such as ordinary writing paper and walls covered with flat paint are called diffuse reflectors because they exhibit diffuse reflection. When light hits a diffuse reflector, it scatters reflected light in every direction. Figure 4-4 demonstrates the interaction of direct light with a diffuse reflector. It is as if the impact of the incoming light raises a cloud of reflected light rays that fly out in all directions. Diffuse reflection is what gives an object its color. When we refer to an object as being black, white, or orange, we are actually referring to the object's diffuse reflection.

For diffuse reflectors, the brightness of the reflected light depends on

1. The components of white light that it reflects.
2. The strength of the ambient and direct light striking the surface.
3. The position of the direct light sources.
4. The orientation of the reflecting surface relative to the direct light source.

Suppose a surface reflects the red components of a light source. If the light source is intense, it will appear bright red. If the light source is dim, then it will be dark red.

Figure 4-4 Diffuse Reflection.

Figure 4-5 Morning and noonday sun.

The position of a direct light source also affects an object's reflectance. If you have two directional light sources with the same strength, the one closer to an object will be brighter than the one that is further away. If you have driven a car on a city street at night, you have experienced the effect that distance has on light intensity. If you are waiting at a stoplight, the red light at your intersection appears much brighter than the red lights located farther down the street.

A directional light's orientation relative to a surface affects the intensity of the light that strikes the surface. For example, safety experts caution us in the summer to avoid noontime sun because the rays are more intense when the sun is directly overhead. Instead, they advise us to go outdoors in the morning or evening when the intensity is much lower. Figure 4-5 illustrates how weaker rays from morning light form a small angle with the ground while intense rays from midday sun are perpendicular to the ground.

Figure 4-6 demonstrates the same principle with an object and a light source. Side B of the object receives the most intense light because the light is hitting it at right angles. Side D gets no light at all because it is on the far side of the object relative to the light source.

Figure 4-7 shows another way to think of this. Draw a vector from a polygon to the sun and compare it to the polygon normal. The light is most intense when the sun vector and the polygon normal point in the same direction. This corresponds to Figure 4-7a, where the sun is directly overhead, and the light received by the object is at maximum intensity. In Figure 4-7b, the polygon normal deviates slightly from the vector going to the sun, so the polygon receives light that is less intense. The polygon in Figure 4-7c receives even less light, and Figure 4-7d shows a polygon that receives no light at all. Its normal points away from the sun vector.

Surfaces having a dull finish exhibit only diffuse reflection, but surfaces that are shiny also have specular reflection. Specular reflection creates highlights on a shiny object and reflections in mirror-like objects. While shiny plastic exhibits both diffuse and specular reflection, a mirror is an example of a perfect specular reflector. Figure 4-8 shows an example of a light ray being reflected from a mirror. The reflected ray bounces off the surface at the same angle as the incoming ray struck it.

Figure 4-6 Polygon orientation.

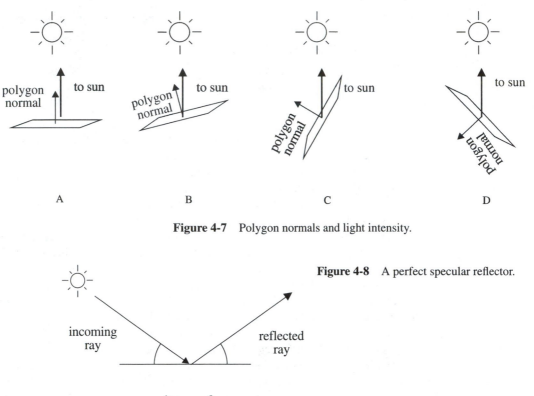

Figure 4-7 Polygon normals and light intensity.

Figure 4-8 A perfect specular reflector.

The following list itemizes the factors that affect specular reflection. Just as for diffuse reflection, the intensity of light striking an object will have an effect, so it should come as no surprise that the first three items on this list are shared in common with the list of influences on diffuse reflection.

 1. The strength of directional light source(s).
 2. The position of directional light source(s).
 3. Orientation of the surface with respect to the light source(s).
 4. Position of the viewer.
 5. Surface roughness.

Notice that the list of influences on specular reflection does not include color. In the basic Phong lighting model, a specular reflector reflects all light components equally. A mirror, which is a perfect specular reflector, reflects all colors.

 The two influences unique to specular reflection are viewer position and surface roughness. Have you ever noticed how highlights on a shiny object will change position as you move around it? Figure 4-9 explains why this happens. It shows the interaction of a reflected light ray and a viewer. One vector goes from the surface to the viewer, and a second one represents the reflected light ray. There is an angle between them. When the angle between

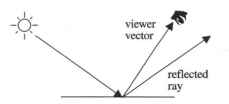

Figure 4-9 Ingredients for specular reflection.

the viewer vector and the reflected ray is small, the viewer will see a reflection of the light source, which is what creates the highlight on a shiny object.

A surface's roughness contributes to the size and brightness of a highlight. If an object's surface is smooth, then a viewer must be closely aligned with a reflection ray in order to see a specular reflection. The result is a small, tight bright highlight. If the surface is a little rougher, then the specular reflection will still be visible even if the viewer vector and the reflected ray are a little different. Up to a point, as the surface becomes rougher, specular reflection becomes visible for greater deviations between the directions of reflected ray and the viewer vector. This results in a highlight that is more spread out and a little less bright. If the surface becomes too rough, specular reflection disappears altogether. Figure 4-10 shows the relationship between surface roughness and highlight size.

Objects can exhibit both specular and diffuse reflection. Figure 4-11 gives examples of different mixes of specular and diffuse reflection.

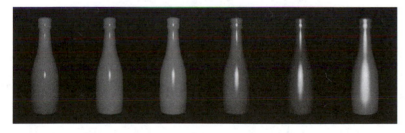

Smooth Rough

Figure 4-10 Surface roughness affects highlight size.

100% diffuse, 0% specular	Paper
	Semigloss paint
	Gloss paint
	Shiny plastic
	Colored Christmas tree ornaments
0% diffuse, 100% specular	Mirror

Figure 4-11 Examples of specular and diffuse reflection.

With the exception of constant shading, the shading algorithms in this chapter all use the Phong lighting model to perform their color computation. Where they differ is in how often they perform color computations and in how they determine surface orientation. The lighting model performs the color computation, and the shading algorithm dictates how often it is performed.

CONSTANT SHADING

This method is extremely simple. Instead of taking into consideration such things as color reflectance, light sources, surface orientation, and viewer position, this technique simply uses the color reflectance information as the color of the object. This does not lead to a realistic appearance because it gives the same color to every polygon in an object. For an example of constant shading, look at the upper left teapot in Figure 4-1.

FACETED SHADING

Faceted shading uses a polygon's normal to determine orientation and then performs a color computation. Since it performs only one color computation per polygon, all pixels inside a polygon will receive the same color. All pixels within a polygon may have the same color, but a different polygon may receive a different color. Take a look at teapot 2 in Figure 4-1 for an example of faceted shading.

GOURAUD SHADING

The Gouraud shading technique [GOUR71] performs a color computation once for each polygon vertex. Instead of using the polygon normal to determine surface orientation, Gouraud shading uses the vertex normal. Remember from Chapter 3 that a vertex normal is the average of the surrounding polygon normals. After the algorithm computes the vertex colors, it blends them along the polygon's edges. Look at the edge labeled "A" in Figure 4-12. Its upper vertex P1 has a dark color and the lower vertex P2 has a lighter one. The algorithm gradually changes the color from the dark shade at one endpoint to the light shade at the other. The technical term for this blending technique is *interpolation*.

Figure 4-13 demonstrates the last step, which fills interior pixels by means of the same interpolation technique that blends color along edges. To fill a row of interior pixels, the algorithm begins at the left end of the row and stores the color of the left edge. For each subsequent pixel in the row it changes the color a little bit until it reaches the rightmost pixel. The color of the last pixel matches the right edge. For examples of Gouraud shading, see teapot 3 of Figure 4-1 as well as all of the objects in Figure 4-3.

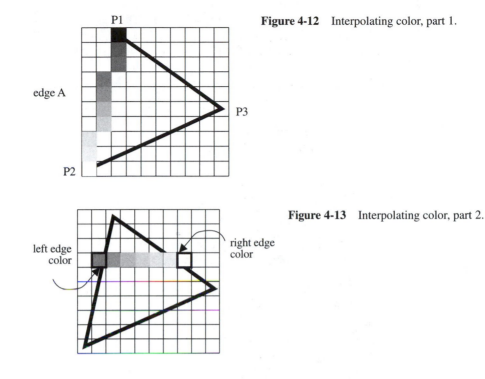

Figure 4-12 Interpolating color, part 1.

Figure 4-13 Interpolating color, part 2.

PHONG SHADING

In addition to creating a lighting model, Phong also developed a shader [BUIT75]. The Phong shading algorithm performs a color computation at each pixel. Instead of interpolating colors across the polygon, the Phong shading algorithm interpolates vertex normals across the face of the polygon and uses the interpolated normals in the color computations.

There are two steps to creating the interpolated normals. Using the vertex normals as a starting point, the first step creates a normal for each pixel on a polygon edge. Figure 4-14

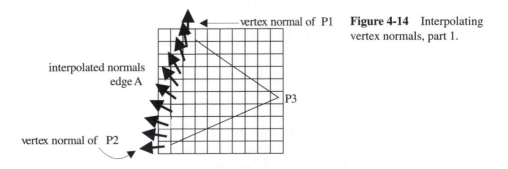

Figure 4-14 Interpolating vertex normals, part 1.

shows the process along one edge of a polygon. The edge pixel closest to vertex P1 has a normal whose direction is nearly the same as the vertex normal at P1. Traveling down the edge to vertex P2, notice that the directions of the pixel normals gradually change to match the direction of the vertex normal at P2.

The second step computes normals for each interior pixel. Figure 4-15 demonstrates normal interpolation across a row of pixels. Moving from left to right, the normals gradually change direction from the normal on the left edge to the direction of the normal on the right edge. Because the normal direction changes smoothly, the shades of color produced by the lighting model will change smoothly too. You can find examples of Phong shading in teapot 4 of Figure 4-1 and in the four objects in Figure 4-2.

CUES TO THE ALGORITHMS

After you have determined that the surface method is the z-buffer algorithm, focus your observation on one object. Use the following to identify the shading algorithm for that object.

1. If the object has a single color and looks "flat," then the shading algorithm is constant shading.
2. If each polygon has a single color, and the underlying polygon structure is apparent, then the shading algorithm is faceted.
3. If no light is present on a smoothly shaded object, then the shading algorithm is Gouraud or Phong. Without a highlight, it is usually impossible to distinguish between the two.
4. If the highlight is star-shaped or runs along a polygon edge, then the shading algorithm is Gouraud.
5. If the highlight is bright, compact, or elliptical, then the shading algorithm is Phong.

FURTHER READING

Chapter 16, "Illumination and Shading," from *Computer Graphics: Principles and Practice* [FOLE90] provides a detailed technical treatment of illumination and shading. Especially

interpolated normals

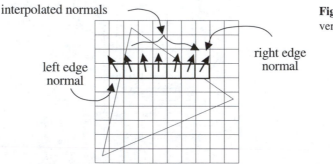

left edge normal

right edge normal

Figure 4-15 Interpolating vertex normals, part 2.

pertinent are the first two sections entitled "Illumination Models" and "Shading Models for Polygons." The first delves a littler deeper into the interaction of light and a reflecting surface, and the second presents the shading algorithms in enough detail that a programmer can implement them. Notice that Foley uses the term "constant shading" differently from how it is used here.

EXERCISES: z-BUFFER SHADING ALGORITHMS

Use TERA to answer the following questions. Choose the "z-Buffer Shading Algorithms" session, which is Option 5 for Unix users.

1. Begin with the "Tea Party."
 a. Which object has a star-shaped highlight? Which shading algorithm produced it?
 b. There are two objects whose appearance is extremely similar no matter what shading algorithm is used. Which two objects are they? Explain why their appearance does not change when switching between Gouraud and Phong shading.
2. Change to the "Lunch" scene, and answer the following:
 a. Which objects exhibit specular reflection?
 b. Suppose you have a large, smooth-shaded polygon whose surface is not shiny. The lightest shade is located in the polygon's interior. Which shading algorithm produces this effect? Why is this algorithm capable of putting the lightest color in the polygon's interior when the others cannot?
 c. Why would constant shading and faceted shading produce the same appearance on an object consisting of one polygon?
3. Select the "Table Top."
 a. Which algorithm creates the look of shiny plastic?
 b. Which algorithm creates highlight perimeters that follow polygon outlines?
 c. Which object has the same appearance no matter what the shading algorithm? Explain how this happened for this object.
4. Use the "Desk Closeup" images for these questions.
 a. Is it possible to know the location of the pencilholder's interior when using constant shading? Why or why not?
 b. Which shading algorithm allows you to see the underlying polygon structure of the pencil?
 c. What are the differences between the highlights on the Gouraud-shaded marker and the highlights on the Phong-shaded marker?
5. Switch to the "Things" scene.
 a. Which object looks the same no matter what shading algorithm is used? Why is that?

b. The YellowThing's shape has sharp corners. Do the smooth shaders produce a better appearance than faceted shading on this object? Can you think of a simple object for which you might choose faceted shading over Phong shading?

c. Use TERA to change the shading to "faceted" for all six Things. Which object has the largest polygons? Which object has the smallest polygons? As the polygons get smaller, what happens to the appearance of an object? Compare the appearance to other shading algorithms.

DOING IT YOURSELF: LIGHTS AND HIGHLIGHTS

This section will help you to

- Define colors
- Understand the interaction of light and surfaces
- Become familiar with the *finish* statement

Read Section 4.6.2, "The Point Light Source," and Section 7.6.3.3.2, "Specular Highlight," in your on-line POV-Ray documentation. The information in those sections will help you carry out the activities in this chapter.

Copy the file `lights.pov` and `pawns.inc` from `/yourself/ch4` on your CD to your computer's hard disk. When examining the file, notice that there are no color names mentioned. Instead, each color is specified in terms of its red, green, and blue components. By specifying red, green, and blue values, you can create your own colors and escape the limitations of POV-Ray's predefined colors.

1. Render the scene and answer the following questions.
 a. What are the red, green, and blue values for the color blue?
 b. What are the red, green. and blue values for the color green?
 c. What are the red, green, and blue values for the color white?

Think of the red, green and blue values of an object's color as reflection percentages. A color of "`red .5 green 0 blue 1`" can be interpreted as a color that reflects 50% of red light, zero percent of green light and 100% of blue light.

Remember that what you see as an object's color is the result of light reflecting from the object's surface. When an image is illuminated by white light, which is approximately the same color as natural light, you see the colors that you would expect. However, the color of a light source will strongly influence what you perceive as an object's color. At present, the two lights in the `lights.pov` file are both different strengths of white light. Change them to be red lights by setting their green and blue components to zero. Redraw the image.

2. Compare the appearance of the board in this version of the image to the appearance of the board in previous images. How do the colors red and white appear under red light? How do you account for this?

Change the lights back to their original colors for the remainder of the activities in this section.

Currently all of our scene's surfaces are diffuse reflectors, because the *finish* statement specifies diffuse reflection only. Consider the following finish statement:

```
finish {ambient 0 diffuse .8 }
```

This means that ambient reflection is at 0% strength and diffuse reflection is at 80% strength.

3. Increase the ambient reflection of the plane, board, and pawns to 20% and redraw the scene. What can you say about the shadows in this new version when you compare it to the first image you created? Which image has darker shadows?

To add specular highlights to an object, add the word "specular" to its finish statement:

```
finish {ambient .2 diffuse .8 specular 1}
```

A value of 1 for specular indicates that we want a specular highlight at 100% strength.

4. Change the three pawns to have a specular reflection and render the scene. How many highlights do you see on the spherical top of each pawn? How does the number of highlights on a sphere correspond to the number of light sources you have in a scene?

As you know, specular reflection depends not only on surface properties and the position of the light source but also on the position of the viewer. We are going to verify this in the following pair of activities.

5. At present, the camera location is on the left side of the checkerboard, which means that you are currently viewing the left sides of the pawns. On what sides of the pawns do you see specular highlights?

6. Change the camera position to be in front of the checkerboard. You can do this by changing the location to be

```
location <5, 5, -20>
```

Render the scene and make note of the highlights. Now move the camera to the right side of the board by changing the location to

```
location <15, 5, 0>
```

and redraw the image. Where are the highlights now? Compare this image to images where the camera was in front and to the left of the pawns. When the camera position moves, what happens to the highlights?

5 Shaders for Raytracing

You have already seen how raytracing can create visual excitement through the use of reflections, transparency, and shadow. Computer science students find raytracing programs easy to write because the basic operation that determines surface visibility forms the basis for adding shadows and creating reflections. This chapter examines the visual effects of raytracing in a little more detail and explains how they are created.

VISUAL CUES

As with any image, begin by identifying its surface algorithm. If you find raytracing, you will need to examine individual objects to determine their shader. As you know from Chapter 3, raytracing is capable of producing a rich assortment of visual effects, so you will need the following cues to help you:

- Opaque versus transparent
- Presence of a highlight
- Reflection

Raytracing can draw objects whose surfaces are reflective, shiny, or dull. The overturned coffee mug in Figure 5-1 (see color plate section) demonstrates how highlights on an otherwise nonreflective surface can create that shiny plastic look. Highlights can be fuzzy, dim, and have a tendency to spread out, but on very shiny objects, the highlights are sharp, tight, and bright. In fact, one commonly available raytracer (POV-Ray) uses the term *Phong_size* as a way to control the size and brightness of highlights. The higher the value of *Phong_size* the shinier the object. In Figure 5-1, which object has the highest *Phong_size*?

In the real world, the smoothness of a surface heavily influences highlights. Smoother surfaces appear shinier than rough ones. In your mind, compare the lacquered finish on a wooden table to the raw face of a piece of wood that has just been cut by a table saw. Which is smoother? Which is shinier? If a surface is very, very smooth, you will be able to see reflections in it. Look at Figure 5-1 in the color plate section. Which surface in the figure gives the appearance of being the most highly polished?

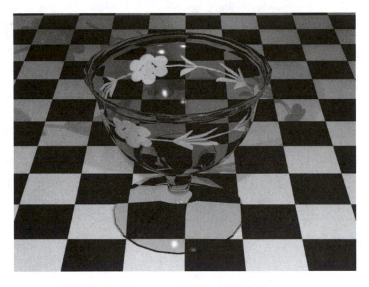

Figure 5-2 One material type, different roughness.

In the real world, surface smoothness also influences the overall transparency of an object. Surface roughness reduces an object's transparency. Think of a glass vase with a design etched or ground into it. In Figure 5-2 the entire vase is made from the same material, but the transparency of the design is different from the rest of the vase because it has a rougher surface. However, most raytracing programs do not take surface roughness into account when determining transparency. Instead, they give you an option to control the overall transparency of an object by specifying a value. A value of one specifies that an object is completely transparent and a value of zero indicates that the object will be opaque. Values between zero and one specify varying degrees of semitransparency.

EXERCISES: RAYTRACING SHADING CUES

You will need to run TERA to answer the following questions. Choose the session called "Ch. 5a: Raytracing Cues," which is Option 6 for Unix users.

1. In the images entitled "My Glass," what cues tell you that this image was raytraced?
2. In the "Trumpet" images, change the appearance of the trumpet from "Shiny" to "Mirrored" and back again.
 a. What did you notice about the highlights?
 b. Repeat this process with the mallets and the xylophone. Compare the changes in appearance.
 c. Do you see the same thing on all three objects or something different?

3. Once you have selected the "Candle" image, change the appearance of the champagne glasses from "Dull" to "Shiny" to "Mirrored." Each version's appearance suggests that a different material was used to manufacture the glasses. Suggest a real-world material that would make glasses with a dull surface. What material would make a shiny glass? A reflective glass? A transparent glass?

4. In the "Paperweight" image, what visual cues tell you that this is a raytraced scene? These objects have distinctive facets in their geometry, just as a cube does. Set the appearance of each object to be "Dull" or "Shiny." Even though each polygon has just a single color, why would we not call this faceted shading?

RAYTRACING REVISITED

The basic operation in raytracing is to shoot a ray and see what it hits. Raytracing fires a ray from the viewpoint through each pixel on the screen and checks to see if it hits anything. Once a raytracer calculates where a ray hits an object (sometimes called the "hit point"—ouch!), the fun begins. A shader will calculate the color, taking into account both lighting and surface properties. This section will explain four basic types of shaders, called *diffuse*, *specular*, *reflective*, and *transparent* [FOLE90].

To determine if the hit point is in a shadow, a raytracer fires a new ray toward the light source. If the new ray reaches the light source without running into any intervening objects, then the hit point is in direct light; otherwise it's in a shadow. Sometimes, the ray runs into the object itself! As you can see in Figure 5-3, if the ray passes through the object on its flight to the light, then the hit point is on the object's dark side.

If an object is opaque and nonreflective, a raytracer usually calculates the color at the hit point by using the same Phong lighting model that you first saw in Chapter 4. To compute the color of a hit point that is located in shadow, it uses only the ambient portion of the illumination and does not include any light coming from the direct light source. Because it is working with less light, it produces a darker color, which is appropriate for a shadow. In

Figure 5-3 An object's dark side.

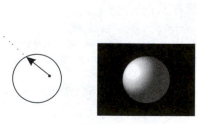

a scene lit by a single direct light source, you will never see a highlight in a shadow because specular reflection requires direct light.

Shiny surfaces in direct sunlight exhibit both specular and diffuse reflection, but dull surfaces exhibit diffuse reflection only. Diffuse shaders produce diffuse reflections. Adding a highlight is the job of a specular shader.

If there is only one light source and no highly reflective surfaces, then an object can cast at most one shadow. It may cast more in a scene containing multiple light sources. A raytracer will fire rays aimed at each light source to determine if a hit point is in direct line of sight of that light source. If the ray reaches the light source without hitting anything, then the light's contribution is added to the total illumination. The color computation uses the total illumination to compute its result.

Determining the color of reflective surfaces requires more work than for nonreflective surfaces. In the real world, highly polished surfaces like mirrors are so smooth that incoming light rays bounce off at the same angle that they came in, as you saw in Figure 4–8. The reflected light rays do not get jumbled as they bounce, so when they reach a viewer's eye, the viewer's brain will perceive an image very similar to the one that would be visible from the position of the mirror.

For any hit point on a reflective surface, a raytracer fires two rays. The first goes to the light source and the second one is a reflection ray. The reflection ray travels through space until it hits an object. The raytracer calculates the color where the reflection ray hits and uses the result to calculate the color back at the original (reflecting) object. If the reflection ray does not hit an object, the raytracer uses the background color for the reflecting object. In Figure 5-4 the reflection was the result of following hundreds of reflection rays as they bounced off the mirror and struck something.

Most rendering packages will allow you to adjust the reflectivity of an object. Some objects, like highly polished marble, have their own color and are not quite as reflective as a mirror. Reflections in such a surface are not as apparent as in a mirror, but they can still create a dramatic appearance as you can observe in Figure 5-5 (see color plate section).

Figure 5-4 A perfect specular reflector.

A raytracer creates this effect by combining the color from the Phong lighting calculation with the color from the reflection ray.

"What if," you may ask, "the object hit by the reflection ray is also reflective? Then what?" In this case, a raytracer bounces a new reflection ray from the second object. If this new reflection ray hits an object, the color from the third object is sent back to the second object for a color calculation and the result is sent to the original reflecting object. Figure 5-6 (see color plate section) demonstrates how a ray hitting one mirror bounces to a second mirror before striking an object. A viewer sees a reflection of a reflection. The color of the vase as seen in the reflection is not as vivid as on the vase itself because the mirror has a little color of its own and it is mixed with the color of the reflection.

Have you ever stood between two mirrors that faced each other? You see a reflection of a reflection of a reflection that goes on and on as light rays bounce back and forth between the two mirrors, as in Figure 5-7. You can simulate this effect by using a raytracer, but you may have to find out how to adjust the number of reflections that the raytracer will follow. Each reflected ray adds extra work for the raytracer, so creating an image of reflected reflections can take quite a bit of computer time.

A raytracer behaves in a different manner when it hits a transparent object. It spawns two new rays, just as for a reflective object, and as before, the first ray is aimed toward the light source. However, the second ray actually continues through the object. To calculate the direction of the second ray, a raytracer uses the same direction as the incoming ray but bends it a little bit based on the object's *index of refraction*. The index of refraction is a measure of how much light bends (refracts) as it enters a substance. When compared to air, the refractive index of water is 1.33; glass is 1.5 and a diamond is 2.4. The images in Figure 5-8 were rendered by POV-Ray and involved adjusting the value of "ior," which is short for index of refraction. As the refractive index increases, rays are bent more sharply and the distortion grows.

Transparent objects may have their own color and will alter the appearance of anything seen through them. Another way to say this is that they change the color of any light passing through them. Figure 5-9 (see color plate section) shows how light passing through a transparent object can change color. You can see the color pattern of the stained glass on the tabletop.

Figure 5-7 Reflections of reflections of

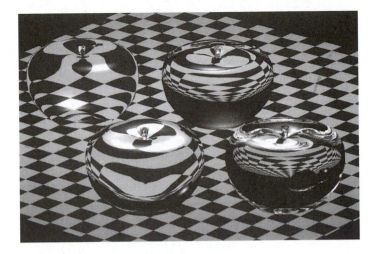

Figure 5-8 Index of Refraction.

Some exotic situations require both reflection and transparency. A real-life example of this occurs when glass reflects an image. Figure 5-10 (see color plate section) demonstrates how a painting situated behind glass can combine with a reflection of objects in front of the glass. To get this effect, a user will need to adjust both the "transparency" and "reflection" values for an object.

In summary, when a ray from the viewpoint hits a visible object, a raytracer determines if the hit point is in light or shadow by shooting a ray from the hit point to the light source. This determines the illumination that is used for computing the color of opaque nonreflective objects. If there is more than one light source, a separate ray is shot to each one and the results are combined in the final color calculation. In addition to generating a light ray, reflective objects cause a raytracer to generate a reflection ray that bounces off the hit point. Whatever the reflection ray finds will heavily influence the color of the hit point. Hitting a transparent object also requires the creation of two rays. Just as before, the first ray points at the light. The second follows a path similar to that of the incoming ray, but it is bent a little according to the object's index of refraction. An object that is both transparent and reflective will require that three rays be generated at the hit point.

CUES TO THE ALGORITHMS

As you know from the last chapter, you always decide on the surface algorithm before attempting to identify anything else. The thing about rendered images is that *one and only one surface algorithm creates the image*, so you can use cues from anywhere in the picture to help you make your decision. This point cannot be emphasized enough. If anyone asks you to determine the shading algorithm, figure out the surface algorithm first.

Once you do decide that the surface algorithm is indeed raytracing, then it is proper to proceed to study the shading technique. Here is a table summarizing the visual cues for the algorithms described in this chapter.

Visual Cues	Algorithm
Opaque; dull surface; no highlight	Diffuse shading
Opaque; highlights; "shiny plastic" look	Specular shading
Opaque; image of surrounding scene is visible in surface; mirror-like	Reflection
Scene behind object is visible	Transparency

Diffuse shaders create dull or matte surfaces. Specular shaders add specular reflection to create highlights on shiny surfaces. The terms diffuse, specular, and reflective all describe different types of opaque surfaces. If you find yourself in the position of viewing a portion of a scene through an object, then you know that the object is transparent.

FURTHER READING

You can find a detailed, in-depth discussion of raytracing in Section 16.12, "Recursive Raytracing," of *Computer Graphics: Principles and Practice* [FOLE90]. It covers the details of Whitted's illumination model and how it accounts for rendering shadows, reflections, and transparent objects. Subsequent sections in the chapter discuss variant raytracing algorithms that were tailored to address specific applications.

EXERCISES: RAYTRACING SHADING ALGORITHMS

Start TERA and choose the "Ch. 5b: Raytracing Algorithms" session, which is Option 7 for Unix users.

1. Select the "Chemistry" scene. Change the volumetric flask from "Specular" to "Reflective" to "Transparent." Check for highlights on the flask in all three cases.
 a. What do you observe?
 b. Check the highlights of other objects in the scene. Does what you observe confirm your findings?
 c. For a hit point on a specular object, how many rays are fired? How many are fired for a transparent object?
 d. Which ray is responsible for producing the highlights?
2. Once you have chosen the "Sky Vase" scene, find the algorithm that allows you to see the internal structure of objects. Why is it impossible to determine when the floor is transparent?
3. In the "Dinner" scene, contrast the effects of the "Specular" algorithm on the goblet and knife to effects on the plates.
 a. Which of these objects are in shadow?
 b. What can you conclude about shiny objects in shadow?

4. Select the "Garden" scene.
 a. If this were an actual outdoor setting, which algorithms would be inappropriate for the sky? Why?
 b. Which of these would be inappropriate for the ground?

DOING IT YOURSELF: REFLECTION AND REFRACTION

Now it's time to start harnessing some of the exciting visual effects that are the hallmark of raytracing. The activities in this chapter are designed to help you

- Use the finish statement to create transparency and reflection
- Become acquainted with the wealth of predefined materials available in POV-Ray

In your on-line documentation, read Section 7.6.3.3.2, "Specular Highlight," Section 7.6.3.5, "Refraction," and Section 4.8.4.3, "Using Reflection and Metallic." These discuss various refinements to the finish statement. When you're finished reading these, copy the file `simple.pov` from `/yourself/ch5` on your CD.

1. Render the scene and compare the image to the contents of the file.
 a. How many spheres do you see in the image?
 b. How many sphere statements do you see in the file?
 c. According to the documentation in the file, how can you account for the disparity between the number of spheres you see in the image and the number of sphere statements in the file?

You can control the size of a specular highlight by adding the *roughness* specification to a finish statement. Useful values for roughness range from 0.7 (very rough) to 0.0005 (extremely smooth). Smaller values will simulate smoother surfaces with smaller, tighter highlights. Just don't use zero as a value.

Adding a *reflection* specification to a finish statement will create a reflective surface. For a mirror surface, use the finish statement

```
finish {ambient 0 diffuse 0 reflection 1}
```

For a reflective surface that also has a color, use a mixture of diffuse, ambient, and reflective light:

```
finish {ambient .1 diffuse .4 reflection .5}
```

As a rule of thumb, the ambient, diffuse, and reflection values should add up to a value that is not much larger than one. As you increase an object's reflection, you will probably decrease its ambient and diffuse values.

Creating a transparent object requires changes to both the finish and color statements. For transparent objects you need to specify a *filter* value in the color statement:

```
color red 1 green 0 blue 0 filter 1
```

A filter value of one gives you maximum transparency. Forgetting the filter value will result in an opaque object no matter how you change the finish statement.

To complete the illusion that an object is made of glass or other refracting material, you must specify *refraction* and *ior* in the finish statement. You always give a value of 1 to refraction. The term *ior* stands for "index of refraction." If you are creating glass, the value of ior should be 1.5.

2. Change the specular highlights of `simple.pov` to be as tight as possible. Modify the cylinder to have a green reflective surface and the small sphere to be made of glass. In addition, add a little reflection to the tabletop. When you are finished, a rendering of your scene should look similar to Figure 5-11.
 a. What value did you use for roughness?
 b. What finish statement did you use for the cylinder?
 c. What modifications did you make to the small sphere?

In POV-Ray there are a wide variety of predefined materials that depict assorted glasses and metals. To see samples of these materials, look in your `povray` directory for a subdirectory called `texsamps`. You will see that `texsamps` has quite a few subdirectories, but at present we are interested in the `glass` and `metals` subdirectories. In these two subdirectories you will find the files `glasses.pov`, `golds.pov`, `coppers.pov`, `chromes.pov`, `silvers.pov`, and `brasses.pov`. Each of these files contains between 15 and 20 different variations on glass, gold, copper, and so on. Render them to see how they look.

If you want to use any of the glass materials, you must use the statement

```
#include "glass.inc"
```

in your `.pov` file. The sharp symbol (#) must be the first character on the line. Similarly, to use the metals, you must use the statement

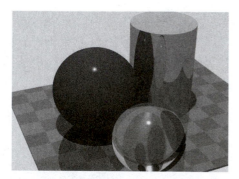

Figure 5-11 A Raytraced Image.

```
#include "metals.inc"
```

3. For fun, change the `simple.pov` file one more time. Change the material of the cylinder to be `T_Old_Glass`, the material of the large sphere to be `T_Copper_5C`, and the material of small sphere to be `T_Gold_2A`. The finished picture should look like Figure 5-12. You may want to examine the contents of one of the `.pov` files in the `texsamps` subdirectory to help you make these changes.

 a. In your new image, what is the texture statement for the cylinder?

 b. What is the texture statement for the small sphere?

 c. Compare predefined finishes to using finish statements that you create yourself. Which requires less typing?

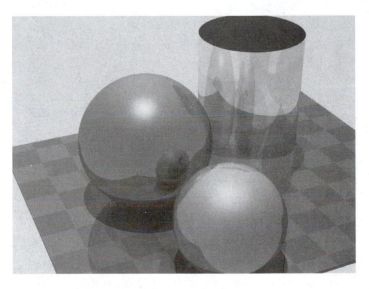

Figure 5-12 Fun with Raytracing.

6 Texture Mapping

Computer-synthesized images often look artificial because they lack the details of real life. For example, you have seen computer-synthesized rooms from an idealized house, and the walls in these rooms have been perfectly smooth and clean. Real walls in real houses are full of history, including fingerprints, scuff marks, grease spots, bulges in the plaster, and maybe even dents in the drywall. Texture mapping is a way of adding realism and interest to an otherwise sterile-looking scene.

Consider for a moment the task of creating a scene containing a lawn. Texture mapping gives us a way to make a believable lawn without having to create hundreds of thousands of tiny narrow polygons to represent blades of grass. The image on the right in Figure 6-1 portrays such a lawn as well as a brick wall and a summer sky. If the blades of grass in the lawn were actual polygons, imagine the time it would take for a person to create and position each one!

Luckily for us, texture mapping techniques add enough interest and detail that we don't have to do this. In fact, the entire scene in Figure 6-1 has a grand total of eight polygons in it. Texture mapping can simulate details that would be too difficult or time-consuming to create by using polygons.

Shaders that carry out texture mapping are available for both raytracing and z-buffering. Coupled with either surface algorithm, they produce convincing and attractive results.

Figure 6-1 Texture mapping.

without with

66

VISUAL CUES

Whenever you are looking at an image and find a lot of detail on an object's surface, there is a good possibility that texture mapping changed its appearance. Visual cues for texture mapping include the following:

1. Images or patterns "glued" onto an object. Such images or patterns might include paintings, lettering, or photographs. See Figure 6-2 in the color plate section.
2. Objects that appear to be made from wood or marble as in Figures 6-3 and 6-4 in the color plate section.
3. Any repeating pattern including stripes, checks, rings, or tile. See Figure 6-5 in the color plate section.
4. The presence of oil slicks or mottling, as can be seen in Figure 6-6 in the color plate section.

These effects can be categorized as *two-dimensional texture mapping* or *three-dimensional texture mapping*. Two-dimensional techniques place a flat (two-dimensional) image onto an object using methods similar to pasting wallpaper onto a wall, while three-dimensional techniques are analogous to carving an object from a block of material like marble or wood. Figure 6-7 visually contrasts two- and three-dimensional texture mapping.

TWO-DIMENSIONAL TEXTURE MAPPING

Two-dimensional techniques use preexisting images during the texture mapping process [CATM75]. These images, called "texture maps," come from a wide variety of sources and are limited in variety and scope only by the imagination of the person doing the texture mapping. Possible sources include scanned photographs, images created in a paint or drawing package, and captured video. Another rich source for images comes from computer rendering! Figure 6-8 in the color plate section shows several examples of both natural and rendered images. POV-Ray created the images on the right.

There are four main ways of wrapping an image on an object, and each of these gets its name from the *shape* it uses [BIER86]. The four most commonly used map shapes are planar, columnar, spherical, and box. Most rendering packages allow you to choose a map

Figure 6-7 Two-dimensional versus three-dimensional texture mapping.

shape when texture mapping an object. People tend to choose the shape that most closely resembles the geometry of the object that they are attempting to texture map. For example, a book is flat and more closely resembles a plane than a sphere or cylinder. A coffee mug is closer in appearance to a cylinder than to a plane or sphere, so a cylindrical map shape would be a good first choice. What would be a feasible choice for a basketball?

A *planar* map shape creates an effect that is similar to the one you would get by aiming a slide projector at an object. Consider the planar-mapped teapot in Figure 6-9. A conceptual slide projector was positioned somewhere behind the viewpoint and aimed along the z-axis so its image will reach the teapot. Notice how the color changes on the teapot as you move left or right along the x-axis and as you move up or down along the y-axis.

A *cylindrical* map shape wraps an image around an object. The texture map encircles it, as can be seen in Figure 6-10. Figure 6-11 shows an example of several objects with a cylindrical map shape. Notice that the cylinder's axis is parallel with the y-axis. In other words, the cylinder circles around the y-axis.

The *spherical* map shape will wrap an image around an object in a manner similar to cylindrical mapping, but as Figure 6-12 demonstrates, the top and bottom of the image get squeezed. Spherical mapping has an appearance similar to cylindrical mapping. Compare Figure 6-13, which demonstrates spherical mapping, to the image in Figure 6-11. In both cases the squares of color from the texture map become distorted into "pie slice" shapes at the apex or "North Pole" of an object. A spherical map shape pulls the texture toward the

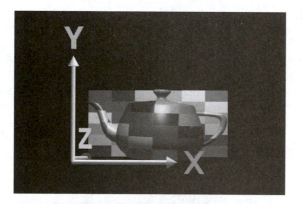

Figure 6-9 Planar map shape.

Figure 6-10 Cylindrical map.

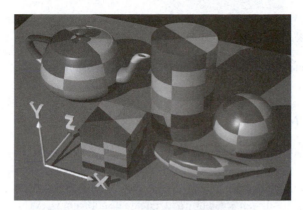

Figure 6-11 Cylindrical mapping.

Figure 6-12 Spherical map.

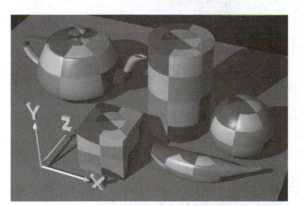

Figure 6-13 Spherical mapping.

North Pole rather like a child pulling the covers up and around her chin. What you cannot see in this picture is that the same pulling and squeezing occurs at the South Pole as well. Pulling causes the texture map to stretch at the equator. Compare the size of the squares located at the middle of the cylindrically mapped objects in Figure 6-11 to the size of the squares at the middle of spherically mapped shapes. The squares in the spherically mapped objects are taller.

Using a *box* as a map shape is similar to planar mapping, but instead of using one texture map, box mapping uses six maps—one each for the left, right, front, back, top, and bottom sides of an object. Figure 6-14 shows an example of box mapping, including the six texture maps, and Figure 6-15 shows the texture maps applied to various objects.

ALGORITHMS FOR 2D TEXTURE MAPPING

Two-dimensional mapping glues an image onto an object. In other words, for each pixel in an object, we encounter the question, "Where do I have to look in the texture map to find the right color?" To find an answer, the three-dimensional coordinate on the object is converted into a two-dimensional normalized device coordinate. As mentioned in Chapter 2, normalized device coordinates have values ranging from zero to one and represent a position in an image expressed as a percentage. Each algorithm uses a *map shape* to help convert a three-dimensional point from an object into a two-dimensional normalized device coordinate.

For a map shape that is planar, we take the (x, y, z)-coordinate from an object and throw away one of the x, y, or z, which leaves us with a two-dimensional coordinate, which is ultimately converted into a pixel location in the texture map. The action of removing one of the coordinates is called *projection*. In Figure 6-9 objects have a planar map shape. You

Figure 6-14 Six texture maps.

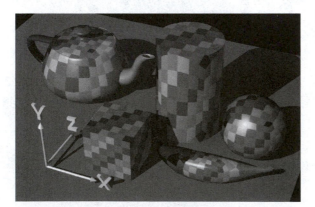

Figure 6-15 Box map.

can determine which of x, y, or z was projected during the mapping process by looking for color changes along the direction of each coordinate axis. If you do not see a change in color when moving in the direction of an axis, then you know that the corresponding coordinate was projected. In this case an object's color changes when moving parallel to the x- or y-axis. However, movement along the z-axis does not produce any change in color and from this you can conclude that the z-coordinate was the one that was eliminated.

A map shape of a cylinder will wrap an image around an object. Technically speaking, an (x, y, z) value is converted into cylindrical coordinates of $(r, theta, height)$, but you can think of *height* as "how far up" and *theta* as "how far around." For purposes of texture mapping, we only need *theta* and *height*. We scale *theta* and *height* to range from zero to one and treat the scaled version of *theta* as the x-coordinate and the scaled version of *height* as the y-coordinate. Voilà! We now have normalized device coordinates! From the normalized device coordinates we can find the correct pixel location in the texture map.

Using a sphere as a map shape involves converting each (x, y, z) coordinate from an object to spherical coordinates of $(r, theta, phi)$. Think of *phi* as latitude and *theta* as longitude. For purposes of texture mapping, we are only interested in the *phi* and *theta*. To find the color in the texture map, we scale *phi* and *theta* to range from zero to one. And use them as the x- and y-coordinates.

Box mapping is similar to planar mapping because you throw away one of x, y, or z, but first you have to determine which side of the object you are on. For the front and back sides, box mapping removes the z-coordinate and uses the remaining x- and y-coordinates to determine the pixel location in the front and back texture maps. For the top and bottom, it removes the y-coordinate and uses the x- and z-coordinates to determine the location in the texture map. For left and right, it removes the x-coordinate.

EXERCISES: 2D TEXTURE MAPPING

The success of a 2D texture mapping technique depends on how good it looks to a viewer. The shape of the 3D object being mapped will greatly influence the effectiveness of these techniques, as you will see in the next set of exercises. Choose "Ch. 6a: 2D Texture Mapping," which is Option 8 for Unix users.

While answering questions 1–4 you will see four sets of images, and all of them have a multicolor checkerboard as the texture map.

1. Choose the "Simple Shapes" image.
 a. Which mapping looks best on the sphere? Which looks best on the box? On the cylinder? Do you see any rationale for naming the map shapes? If so, what is it?
 b. Set the box and the square to planar mapping. Which side of the box resembles the square in appearance?
 c. Are there any geometric features that the square and matching box side have in common? Is there any connection to their appearance?

Without a reference set of coordinate axes in an image to guide you, it would be unreasonable to ask you to visually identify a texture map's orientation. However, the next group of images does have a set of axes, because their goal is to help you understand the interaction of map shape, map orientation, and object geometry.

2. Choose the "Planar/Box Map" scene.
 a. Use the "Coordinate Axes" object in the picture to determine the direction of the square's normal. What is it?
 b. What map orientation produces a checker pattern on the square?
 c. To see the pattern of the texture map with the least amount of distortion, what orientation should you choose with respect to a flat surface such as a wall or tabletop?

3. Choose the "Cylindrical Mapping" image. Click on various radio buttons and observe their effect on the box and the cylinder. No matter what option you choose, you will see checks of the texture map become distorted into wedges that are shaped like pie slices. The point where those pie slices come together marks one of the poles of the cylindrical map shape. These poles are analogous to the North and South Poles on earth. Similar to earth, a cylinder has an axis and it runs through the two poles. Once you have experimented with the choices, answer the following questions:
 a. When the poles of the texture map occur on the left and right sides of an object, which is the direction of the map axis? Refer to the coordinate axes to answer this question.
 b. When poles are on the front and back of an object, what is the direction of the map axis?
 c. Experiment with all available choices for the square. Has the pattern of the texture map been preserved?
 d. Would you recommend any of these choices for texture mapping a square or any other planar object? State your reason.

4. Choose the "Spherical Mapping" scene.
 a. Set all objects to "Around Y," which means that their map axis is parallel to the y-axis. On which object(s) do checks of the texture pattern seem equally spaced as you move up and down on the y-axis?
 b. Experiment with the choices for the "Coordinate Axes" object. Describe the appearance of the texture map as you work your way through the choices. Are you satisfied with the look of the texture map?
 c. Contrast the shape of the "Coordinate Axes" to the shapes of the other objects. What advice about mapping would you give to someone who is about to texture map an object whose geometry shares more in common with the "Coordinate Axes" than with the other objects in the scene?

The next three scenes are a little less abstract in composition and have some real-life objects in them.

5. Choose the "Executive" scene, which depicts some objects that might appear on a desk in a corporate suite.

 a. Select the "Coffee Mug" and look at all possible rendering algorithms. Which mapping algorithm causes a star to appear on both sides of the mug?

 b. For the algorithm that places a star on both sides of the mug, describe the map orientation in terms of the coffee mug's geometry.

 c. Which mapping choice looks best on the desktop?

 d. Experiment with choices for the "Duck Decoy." This object is *bilaterally symmetric*, which means that you can cut the object into two halves and the left and right halves are mirror images of each other. Most vertebrate life forms, including people are (nearly) bilaterally symmetric. Experiment with the choices for the "Duck Decoy." Which of the three map shapes looks best? Do you think this would apply to all objects with bilateral symmetry?

6. Move on to the "Bad Dog" scene.

 a. What sort of symmetry does the dog possess? Which map shape would be the best for him? Confirm this by looking at all possible rendering choices.

 b. Experiment with rendering choices for the "Dog Dish" until you find one that puts Fido's name on the outside and inside of the dish. Now mentally turn that dish 180 degrees so you can see its far side. Will the lettering have a satisfactory appearance?

 c. Which map shape leaves a visible seam on the carpet?

 d. What shape makes the most visual sense for the couch?

7. As you have observed in the last two exercises, some map shapes are more appropriate for a particular geometry than others. In the last scene, "Moo Review," you'll see only map shapes that look good.

 a. What map shape was used on the cow? Why?

 b. What possible map shapes could have produced the pattern on the "Barn Walls?"

 c. Do you have enough information to decide on the floor's map shape? What influenced your decision?

MORE ON 2D MAPPING

An effective way of creating complex textures from simpler ones is by using *layering* [PORT84]. The technique of layering is similar to the process that allows television viewers to see a weather forecaster standing in front of a map when in fact the forecaster is actually standing in front of a blue wall in a television studio. Video equipment substitutes the weather map for the blue background. (Have you ever noticed that forecasters never wear

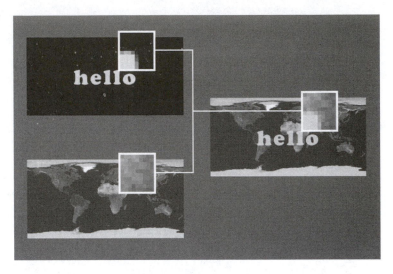

Figure 6-16 Layered textures.

blue?) Layering combines two or more images by designating a color or range of colors to be transparent. Look at Figure 6-16, where the word "hello" is written on a map of the earth. Each of the two simple images is treated as a layer, with the "hello" image being placed on top and its black background being designated as transparent. Creating a pixel in the final image requires finding the color in the corresponding pixel locations of the two simple images and combining them. If the pixel color from the "hello" image is black, then the pixel color in the final image will come from the earth image. The happy result is a "hello, world" image suitable for texture mapping.

Most commonly available rendering packages have options for all of the texture mapping techniques discussed here, but each of them do it a little differently. Most of them allow you to choose a map shape and orientation. You will need to check what happens when you attempt to position, scale, or orient the object that you are texture mapping. In most packages, you have to apply the same transformations to texture as you do to the object, or

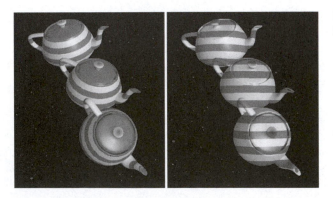

Figure 6-17 Texture positioning.

the texture will not "stick" to the object, as Figure 6-17 demonstrates. For most occasions, if your teapot starts with a yellow-tipped lid, you would like that teapot to continue having a yellow-tipped lid no matter what orientation the teapot takes. This corresponds to making sure that the texture map moves, grows, and turns the same way that the 3D object moves, grows, and turns. The right side of Figure 6-17 demonstrates what can happen if the object moves but the texture map stays put.

PROBLEMS WITH 2D MAPPING

As you witnessed in the last set of exercises, you have to pick an appropriate map shape for an object's geometry or the results can be unattractive. Even if you have picked the right map shape, you can still run into problems. With planar mapping, there is always one direction in which a pattern will degenerate into stripes. If the mapped object is not flat, you will always have to struggle with this.

With cylindrical and spherical mapping, you can have problems with a visible seam. Both approaches bend the left end of a texture map around an object so that it meets the right end of the texture map. Figure 6-18 (see color plate section) shows how the effect is really the same as what you get when two pieces of fabric are sewn together. Just as you would dislike a seam running down the middle front of your T-shirt, you would not like to see a visible seam in a prominent place on 3D objects. One solution is to rotate the texture so its seam is located on a side that is invisible to a viewer.

If you are using a rendering package to do your texture mapping, you do not have to worry about the next drawback, but if you are a programmer who is going to implement texture mapping, you will have to consider it. A major annoyance crops up when you try to write a program that implements cylindrical or spherical mapping, and that is the necessity of handling singularities. A singularity is a location where numbers can fluctuate so wildly that a program will crash. Both spherical and cylindrical mappings contain two singularities, one each at the North and South Poles. Just as it makes no sense to talk about the time zone at the North Pole, it is impossible to determine both texture coordinates by the usual mathematical conversion. A programmer has to anticipate singularities and handle them as special cases or the program will bomb.

3D TEXTURE MAPS

In three-dimensional texture mapping, each point on an object determines its color without the use of an intermediate map shape [EBER94]. This technique uses an (x, y, z)-coordinate to compute the color directly. It's equivalent to carving an object out of a solid substance. Most 3D mapping techniques do not explicitly store a value for each (x, y, z)-coordinate but use a procedure or algorithm to compute a value based on the coordinate, and thus are called *procedural textures*.

Stripes, rings, and checkers are basic examples of 3D texture maps. To produce stripes on the left teapot of Figure 6-19, we take the z-coordinate, throw away any fractional part of the value, and look at the integer part. If it is even we choose red, otherwise we choose white. How were the stripes produced in the other two teapots?

Figure 6-19 Stripes.

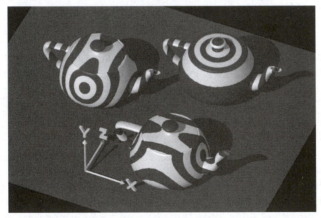

Figure 6-20 Rings.

To produce rings, we color a point by choosing two of the three coordinates, and use them to compute a distance from a reference point. We truncate the computed distance, which means we throw away any fractional part of the value and keep the integer part. If the truncated value is even, we give it one color; if it is odd, we give it another. Figure 6-20 shows some teapots with rings. A bull's eye effect, with rings radiating out from a central point, requires that when computing the distance, the reference point be at the center of the object.

A 3D checker pattern can produce more pleasing results than any 2D mapping technique. In Figure 6-21 the left teapot demonstrates the effect of using a planar mapping to apply a checker image. As you can see, the pattern degenerates into stripes along the top of the

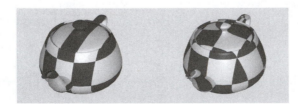

Figure 6-21 Checkers.

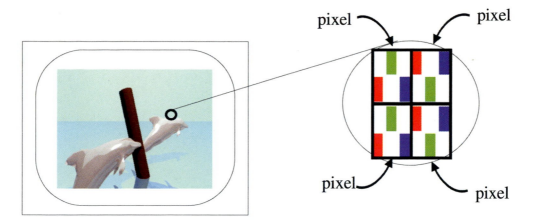

Figure 2.4 Color images on a television are created with phosphor dots that glow red, green, and blue.

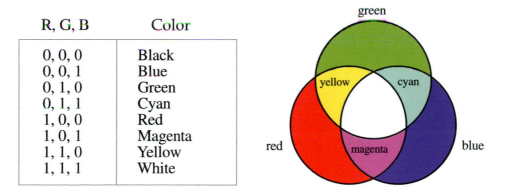

R, G, B	Color
0, 0, 0	Black
0, 0, 1	Blue
0, 1, 0	Green
0, 1, 1	Cyan
1, 0, 0	Red
1, 0, 1	Magenta
1, 1, 0	Yellow
1, 1, 1	White

Figure 2.5 The additive color system.

1,1,1	1,1,1	1,1,1	1,1,1	1,1,1	1,1,1	1,1,1	1,1,1	1,1,1	1,1,1
1,1,1	1,1,1	1,1,1	1,1,1	0,0,0	0,0,0	0,0,0	0,0,0	1,1,1	1,1,1
1,1,1	1,1,1	1,1,1	1,0,0	1,1,1	1,1,1	1,1,1	1,1,0	1,1,0	1,1,1
1,1,1	1,1,1	1,0,0	1,0,0	1,0,0	1,1,1	1,1,1	1,1,0	1,1,0	1,1,1
1,1,1	1,0,0	1,0,0	1,0,0	1,0,0	1,0,0	1,1,1	1,1,0	1,1,0	1,1,1
1,1,1	1,0,0	1,0,0	1,0,0	0,1,0	0,1,0	0,1,0	0,1,0	1,1,0	1,1,1
1,0,0	1,0,0	1,0,0	1,0,0	0,1,0	0,1,0	0,1,0	0,1,0	1,1,0	1,1,1
1,1,1	1,1,1	1,1,1	1,1,1	0,1,0	0,1,0	0,1,0	0,1,0	1,1,0	1,1,1
0,0,1	0,0,1	1,1,1	1,1,1	1,1,1	1,1,1	1,1,1	1,1,0	1,1,0	1,1,1
0,0,1	0,0,1	1,1,1	1,1,1	1,1,1	1,1,1	1,1,1	1,1,1	1,1,1	1,1,1

frame buffer on screen

Figure 2.6 A color image stored in a frame buffer.

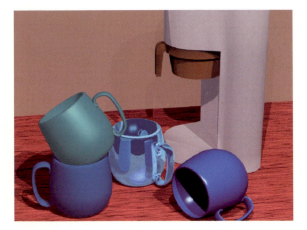

Figure 5.1 Raytracing effects.

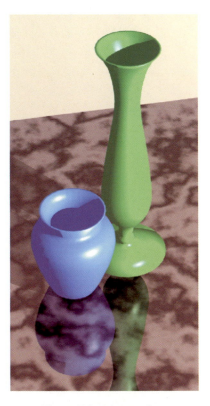

Figure 5.5 A less perfect specular reflector.

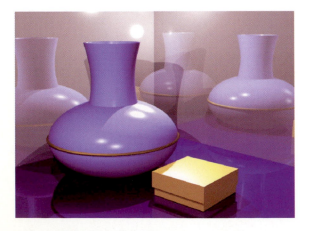

Figure 5.6 Two interreflecting mirrors.

Figure 5.9 A transparent object.

Figure 5.10 Transparency and reflection.

Figure 6.2 Patterns "glued" onto objects.

Figure 6.3 Objects made from wood. (Copyright ©1997 Ron Faulkner.)

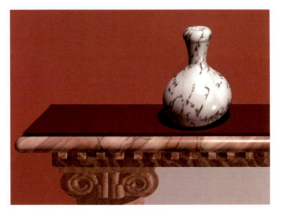

Figure 6.4 Objects made from marble.

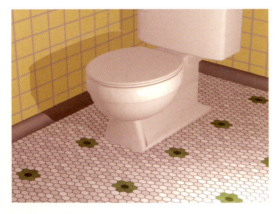

Figure 6.5 Repeating patterns.

Figure 6.6 Mottled surfaces.

Figure 6.8 Sample texture maps. (Texture maps on right by Steve van der Burg.)

Figure 6.18 Seams can appear with cylindrical or spherical texture mapping. (Texture ©1997, Kevin Ferguson.)

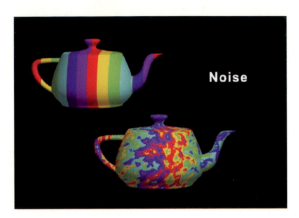

Figure 6.24 Noise.

Figure 6.29 2D texture mapping in POV-Ray.

Figure 8.2 Spotlight. (Copyright ©1997, John Schuchert.)

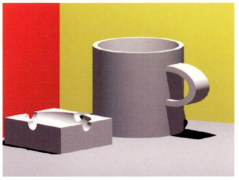

no radiosity

radiosity

Figure 8.4 Color bleeding.

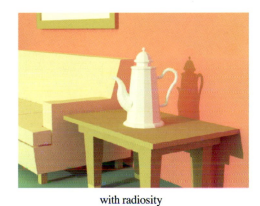

without radiosity

with radiosity

Figure 8.5 Deepness of shadow.

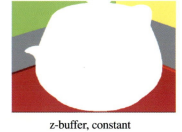

wireframe

hidden-line

z-buffer, constant

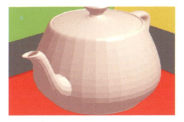
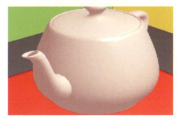

z-buffer, faceted

z-buffer, Gouraud

z-buffer, Phong

Figure 10.6, part 1 Rendering tests.

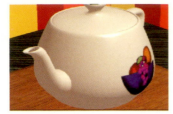

z-buffer, planar texture

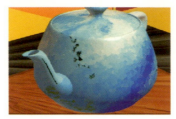

z-buffer, spherical texture

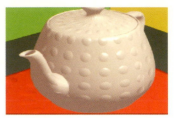

z-buffer, bump (rivets)

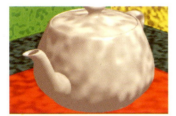

z-buffer, bump (dents)

z-buffer, environment map

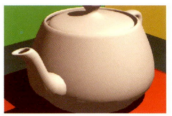

raytrace, diffuse only

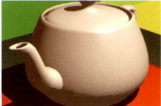

raytrace, diffuse and specular

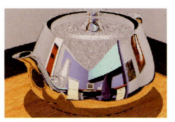

raytrace, texture map

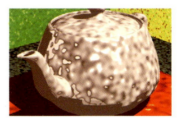

raytrace, bump map

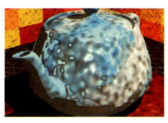

raytrace, texture and bump

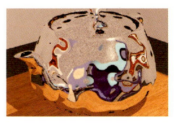

raytrace, reflection

raytrace, reflection and bump

raytrace, transparency

Figure 10.6, part 2 Rendering tests.

teapot. Compare this to the right teapot, which has a 3D texture map of checkers. The checkered pattern is visible in all three directions and is created using the following algorithm:

1. Sum the integer parts of x and y.
2. If the integer part of z is even, go to step 4.
3. If the sum of x and y is even, choose Red, otherwise White.
4. If the sum of x and y is even, choose White, otherwise Red.

The techniques for creating stripes, rings, and checkers involve throwing away the fractional part of a value and using the remaining integer part to decide on a color. A second group of techniques involves throwing away the integer part and keeping just the fraction. The left teapot in Figure 6-22 has a basic *ramp* texture. Throwing away the integer part of the x-coordinate and keeping just the fraction produces the repetitions in the pattern. The remaining fraction has a value that ranges from zero to one. The ramp texture assigns a dark color to the value zero and a light color to one. For intermediate values, it mixes the two colors. Values closer to zero are assigned colors that are closer in appearance to the dark color associated with zero. For a value of 0.5, the assigned color is a 50-50 mixture of the dark and light colors, and for a value of 0.25, the color is a mixture of 75% dark and 25% light. The result is a smoothly blended band of color that repeats itself over the surface of an object.

It is possible to change the size of the repetition by introducing the *modulo* function. The modulo (or mod) function gives you the remainder. For instance, $mod(1.75, 1)$ returns a value of 0.75, which is the remainder when you divide 1 into 1.75. In other words, $mod(x, 1)$ throws away the integer part of x and keeps only the fractional part. If we change the "1" to a "2" as in $mod(x, 2)$, we're keeping the remainder from a division by two. So $mod(3.5, 2)$ has a value of 1.5 because 2 goes into 3.5 once, which leaves a remainder of 1.5.

To make the size of the repetition twice as large, we begin by dividing by two and keeping the remainder. (How do you express this with the modulo function?) This remainder ranges between zero and two. What we really want is a range from zero to one, so we take the remainder and divide by two. With this result, we can use the same color-mixing scheme as we did for the original ramp texture. In general, the formula

$$mod(x, a)/a$$

Figure 6-22 Ramp.

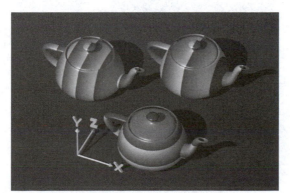

produces a range of values between zero and one. To increase the size of the pattern, increase the size of *a*. If you want to change the orientation of a texture, substitute another value for *x*. Compare the size of the pattern in the left and right teapots in Figure 6-22. Which teapot has the greater value of *a*? The *x*-coordinate was used in the left teapot. What coordinate created the pattern on the middle teapot?

Remember that the range of zero to one is also the range for normalized device coordinates. Since it generates values between zero and one, another way of thinking about *mod(x, a)/a* is that it produces normalized device coordinates. Once converted to device coordinates, the values of *mod(x, a)/a* can determine a pixel location in a texture map. In the example shown in Figure 6-23 the *x*-coordinate from each point on a teapot is converted into the *x*-component of a normalized device coordinate, which determines a pixel location in a texture map. The result is an interesting set of stripes. By changing the colors in the texture map, it is possible to create a rich assortment of striped patterns.

Noise

As you can see in Figure 6-24 (see color plate section), regular patterns are less interesting than patterns that have a little randomness added. To add randomness, texture mapping makes use of noise functions [PERL85]. A noise function accepts an (*x, y, z*)-coordinate of a point as input and produces a value that is somewhat random, but the nature of the randomness is well enough behaved that it is useful for computer graphics. Noise functions for computer graphics produce values that have a known range and a limited bandwidth. Having a known range means that a user knows ahead of time what the extreme values will be. It is akin to knowing the posted minimum and maximum speed limits on an interstate highway. Having a limited bandwidth means that while the noise function may produce wildly different values for two points spaced far apart, it will produce values that are close together for points located close together. Think of a weather map of the United States with the daily high temperatures listed on it. Temperatures may be extremely different in Phoenix, Arizona and International Falls, Minnesota, but temperatures for Saint Paul and Minneapolis will be similar.

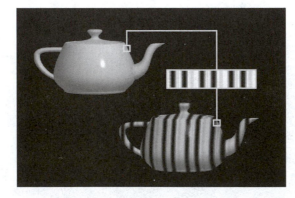

Figure 6-23 Other stripes.

Figure 6-25 Frequency and amplitude.

To create variety in textures, we would like to manipulate two aspects of a noise function, namely, amplitude and frequency. Amplitude is the range of values and frequency is a measure of how fast the noise function's value changes when the input changes. Figure 6-25 demonstrates these properties visually. In this representation, black represents the lowest possible value and white the highest. The middle image depicts the function

$$noise(x, y, z)$$

The noise in the two images on the right has higher amplitude than the middle one. Notice how the range of light to dark is more extreme in these images. Increasing the frequency increases the level of detail seen in the picture. The bottom two images have noise of a higher frequency. In general, if we have one noise function, we can vary its effect via the expression

$$a * noise(f_1 x, f_2 y, f_3 z)$$

where a controls the amplitude and f_1, f_2, and f_3 control the frequency. For a higher frequency in the x-direction, increase the value of f_1. To decrease the amplitude, decrease the value of a (but keep it above zero). Do any of the images in Figure 6-25 show the results of lowering the amplitude?

There is a special kind of noise, called $1/f$ *noise*, that can simulate many natural phenomena including turbulence. Figure 6-26 shows how it is created. It begins with a noise function, which is depicted in the left image. To this is added the same noise, but with twice the frequency and half the amplitude, which results in the second image. Noise at twice the frequency adds detail, while the lower amplitude guarantees that the original pattern is still visible. Adding noise at four times the frequency and one-quarter the amplitude results in the third image. In general, we start with a first term of noise:

$$noise(x, y, z)$$

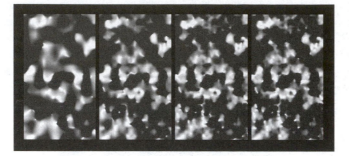

Figure 6-26 Adding higher frequencies.

and add to it a second term,

$$\tfrac{1}{2} * noise(2 * x, 2 * y, 2 * z)$$

and add to it a third term,

$$\tfrac{1}{4} * noise(4 * x, 4 * y, 4 * z)$$

and add to it a fourth term,

$$\tfrac{1}{8} * noise(8 * x, 8 * y, 8 * z)$$

and so on. The question arises, "When do we stop adding terms?" Figure 6-26 hints at the answer. Compare the two images on the right. The difference between these images, where a fourth term is added, is a lot less noticeable than the difference between the left two images, where the second term was added. Higher-frequency noise creates finer detail, but if the details are so small that they happen inside a pixel, then they will be invisible to a viewer. In conclusion, once the frequency is so high that it produces invisible detail, there is no need to add more terms to the 1/f noise.

In most rendering packages that offer texture mapping, you will be given options to control the size of a texture pattern, which corresponds to the idea of controlling the

Figure 6-27 Marble.

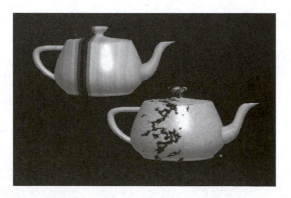

frequency. Controlling the extremity of a pattern will be different, depending on the pattern. For example, with a stone texture, you may be given an option to control the "crookedness" of the veins running through the stone. For wood, you may be allowed to control how "gnarly" the grain is. Some packages allow you to add "turbulence" to a texture, which is equivalent to using $1/f$ noise. Consult the documentation that accompanies your rendering package to find the options available in your software.

With noise, it is possible to create marble from stripes (Figure 6-27) or wood from rings (Figure 6-28). Making marble begins by taking one of the x-, y-, or z-components of a point, just as for making stripes. Suppose we choose x. Before using the modulo function, we add some noise to x to move it a little. Instead of using $mod(x, a)/a$ as a normalized device coordinate into an image map, as we did for stripes, we use

$$mod(x + noise(x, y, z), a)/a$$

Adding noise has the effect of adding a little randomness to the color we pick. As a result, straight, even stripes can turn into interesting veins of color snaking through stone.

Creating convincing wood textures involves adding some randomness to the simple ring texture discussed earlier. A ring texture is a set of concentric cylinders of alternating color, but tree rings in real wood are not perfect circles. To make the rings more irregular and more believable requires adding some eccentricity to make more irregular rings. A second addition of randomness is called *twist*. The name twist comes from the real-world effect that it simulates. Imagine that you are holding the ends of a rope in your left and right hands. If you hold the left end still and spin the right end between the thumb and forefingers of your right hand, you are adding twist to the rope. Twist causes the ring eccentricities to move left and right as you move up and down a tree trunk. The last addition is also rooted in the physical world. In real life, objects are not cut along a plane that is exactly parallel to the axis of a tree trunk because the center of a tree does not follow a perfectly straight line. Due to this fact, tilting a wood texture a little gives a more realistic look to a wood grain.

Figure 6-28 Wood.

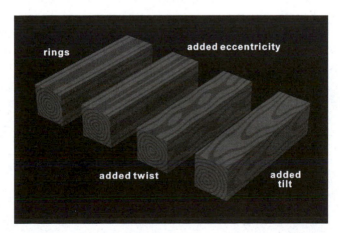

CONCLUSIONS

Texture mapping adds variety and interest to any object, even the simplest. Usable with z-buffer and raytracing surface algorithms, texture mapping helps alleviate the artificial, "shiny plastic" look of Phong shading. Compared to explicitly specifying thousands of tiny polygons, it is a cheaper way of adding detail, both in terms of the human time required to model a scene and in the computer time required for rendering.

Texture mapping techniques are categorized as being either two-dimensional or three-dimensional. Two-dimensional techniques make use of a preexisting image that is pasted onto an object. Three-dimensional techniques use the (x, y, z)-coordinate of a point to compute its color. While two-dimensional techniques have the advantage of allowing an artist to use scanned images or lettering, some unpleasant distortions may occur as an image is mapped into an object. From a programmer's perspective, many two-dimensional techniques have intrinsic singularities that require an extra program code that handles the singularities as special cases. Because it operates in three-dimensional space, 3D texture mapping does not introduce additional distortions into a pattern and can create convincing simulations of wood and stone. However, in general, three-dimensional techniques take up more computer time than 2D methods because a 3D technique computes the color directly from the position of a point, rather than referring to a preexisting image.

Noise can create variety in a texture map by adding randomness. Noise functions with well-behaved randomness allow a user to control the fineness of detail by varying the frequency and to control the extremity by varying amplitude.

FURTHER READING

To learn more about the specifics of 2D texture mapping, read Chapter 6, "Mapping Techniques: Texture and Environment Mapping," from the text *Advanced Animation and Rendering Techniques: Theory and Practice* by Watt and Watt [WATT92]. In this chapter they explain how to convert from 3D to 2D Cartesian coordinates via the coordinate system of a simple intermediate shape.

An excellent treatment of procedural texture mapping can be found in *Texturing and Modeling: A Procedural Approach*, edited by Ebert [EBER94]. It covers noise and turbulence and how to build your own procedural textures.

EXERCISES: 3D TEXTURE MAPPING

This set of exercises allows you to explore a wide variety of 3D texture mapping algorithms and to make some visual comparisons between 2D and 3D techniques. Start TERA and select the "3D Texture Mapping" session. This is Option 9 for Unix users.

1. Select the "Toys" scene, which is a collection of items that might have been found in a child's room a hundred years ago.
 a. What textures do you see?
 b. What texture(s) make the wall look good? What textures work well with the horse?
 c. Are there any objects that look better without texture maps? What are they?

2. Select the "Patches" scene. This scene was designed to give you a little more experience with frequency and amplitude.
 a. For a wide range of variation, what should you do to the amplitude?
 b. To control the amount of detail, which do you change—the amplitude or the frequency?

3. The "Archway" scene explores the effects of adding terms of noise that have higher and higher frequencies. Each rendering option allows you to control the number of terms that are present in the noise.
 a. Adjust the rendering of the front wall until you can see no differences between it and the rendering with the next higher term. This tells you how many terms are visible. Which rendering is it?
 b. Do the same thing with the back wall. Which rendering is it?
 c. Compare the number of visible terms in the front wall and in the back wall. Which has more visible terms? Which is closer?
 d. Each additional term tacks on an additional amount of rendering time. Can you think of any way of keeping the rendering time as low as possible when using noise?

4. Move to the "Fireplace" scene. All of the textures began as a simple stripe pattern.
 a. Which textures have visible veins in them?
 b. Besides stone, what other textures are possible by using the stripes-plus-noise approach?

5. You will see several wooden objects in the "Attic" scene. Experiment with the rendering options and answer the following questions:
 a. A cut perpendicular to a tree trunk reveals rings. What does a cut parallel to the trunk reveal?
 b. Set the rendering of the violin to "rings." In this rendering, the concentric rings are perfectly circular and equally spaced, but irregularities appear in the grain of the violin. What could account for this?

6. Examine the rendering options available in the "Bottle" scene.
 a. Which mapping technique can apply lettering onto objects?
 b. In addition to wood and stone, what other textures are possible using 3D techniques?
 c. (Optional!) Which rendering has entirely too many geeky references?

DOING IT YOURSELF: TEXTURES GALORE!

In this chapter, you will discover

- The subtleties of 2D texture mapping
- The bonanza of predefined 3D textures available in POV-Ray

As a prelude to the activities in this chapter, read Section 7.6.1.5, "Image Maps," and Section 4.10.2, "The Sky Sphere," in your on-line documentation. They contain reference material that will be useful to you.

For the first five activities covering 2D texture mapping, you will need the files `twodim.pov`, `earth.tga`, `dpumulti.tga`, and `cloud.tga` from the directory `/yourself/ch6` on your CD. Copy these files to your computer's hard disk and render `twodim.pov`.

As you read in your on-line documentation, an object's rotate, scale, and translate statements can affect the texture. If you place the rotate, scale, and translate statements after the texture statement like this:

```
sphere{ . . .
     texture{ . . . }
     rotate < . . . >
     scale < . . . >
     translate < . . . >
}
```

then the texture will move with the object as it is oriented, sized, and positioned in a scene. Sometimes, however, it is necessary to adjust the texture relative to the original object's shape before the ultimate sizing and positioning take place. One way of doing this is by adding rotate, scale, and translate statements *inside* a texture statement.

1. Find the cylinder in `twodim.pov` and take a look at its texture statement. There is a rotate command inside the texture statement. To see what it does, remove it temporarily by placing two slashes (//) in front of it like this:

 `// rotate <0, -60, 0>`

 This turns the line into a comment and POV-Ray will ignore it. Render the image.
 a. What is the difference between this image and the original?
 b. What was the purpose of the rotate command?
 c. This chapter discussed the problem of visible seams appearing on texture-mapped objects using a cylindrical or spherical map shape. What is one way to hide the seam?

When you are done with activity 1, remove the two slashes that you inserted in front of the rotate command.

2. Now you will examine the importance of the order of a texture statement relative to rotate, scale, and translate statements. At present, the front of the square block has a single dark blue "U" shape pattern on it. In the `twodim.pov` file, move the

block's scale and translate statements so that they come before the texture statement. Render the scene.

 a. How has the texture changed on the block?

 b. How do you account for the change?

When you are finished with activity 2, restore the block's scale and translate commands to their original positions in the file.

In the next three activities, you will make changes to the scene's texture commands. When you finish, you will have an image that looks like Figure 6-29, which is located in the color plate section.

 3. Include a rotate command that will put the dark-blue "U" shape on top of the square block.

 a. What rotate command did you use?

 b. Where you did place it?

 4. Texture map the sphere using the file `earth.tga`.

 a. What map type did you use?

 b. Where did you add a rotate command? What was it?

 c. What modifications did you make to the finish statement?

 5. Move the texture map on the cylinder so that the entire blue pattern is visible.

 a. What type of command did you use?

 b. What numeric values did you use?

 c. Where did you place the command?

There are an enormous number of intriguing predefined textures available in POV-Ray. While carrying out the next set of activities you will get a chance to experience them for yourself. Once you finish the remainder of the activities, you will have an impressive image whose use of texture is so extreme that it borders on bad taste. A preview of your image is depicted in Figure 6-30.

Look again in the `texsamps` directory of your POV-Ray installation. On this visit, we are interested in the contents of the `woods`, `stones`, and `skies` subdirectories. You will want to render `stones1.pov`, `stones2.pov`, `woods1.pov`, and the various cloud examples in the `skies` subdirectory. They are splendid to behold. If you want to use any of these textures in your scenes, you will have to use the appropriate `#include` statement in your file:

```
#include "stones.inc"          // Stone textures
#include "woods.inc"           // Wood textures
#include "skies.inc"           // Clouds
#include "stars.inc"           // Star fields
```

For the rest of the activities, you will need the file `threedim.pov` from your CD. It is located in `/yourself/ch6`. Copy it to your hard disk.

 6. Give a green stone texture to the square block, a red stone texture to the sphere, and a white stone texture to the tabletop. You can find examples of each of these in `stones1.pov` and `stones2.pov`.

Figure 6-30 A rich variety
of 3D textures.

 a. What texture did you use for the table top?
 b. What texture did you use for the block? ⌡
 c. What texture did you use for the sphere?
 7. Take another look at `threedim.pov`. Notice that the large sphere we used as a
background has been replaced by a sky sphere command. A sky sphere allows
you to use a realistic sky as a backdrop. In the current version of the image, the
background is very bright because the `S_Cloud2` texture is very bright. Change it
to a darker cloud texture. What texture did you choose?
 8. What rotate command will orient the wood texture on the cylinder so that the rings
radiate from the middle of its top face?

7 Bump Mapping

Bump mapping adds surface detail and interest to an object without the expense of using polygons to create the effect [BLIN78]. Figure 7-1 shows several examples of how bump mapping can change the shiny plastic look of Phong-shaded objects into pitted, rippled, or lumpy surfaces. Look again at Figure 7-1. While surfaces appear rough or uneven, notice that profiles of the teapots are still smooth. Bump mapping does not change the underlying geometry of a model, but "fools" the shading algorithm to produce an interesting surface. As long as the surface detail is small relative to the overall size of an object, bump mapping can create a convincing effect.

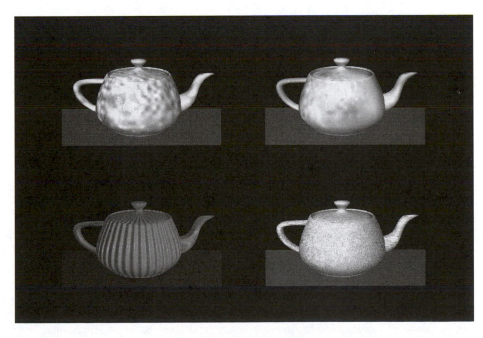

Figure 7-1 Bump mapping.

Embossing is a specialized form of bump mapping that creates the impression of a raised pattern, of the type that you have seen on embossed paper or wallpaper. When you see a raised pattern on an object's surface, it may have been created by embossing. The same technique can also produce an engraved look.

VISUAL CUES

Here are the cues that should lead you to consider bump mapping:

- A rough or pitted surface on an object having a smooth profile
- An embossed look, but with the embossing casting no shadows

HOW IT'S DONE

Remember from Chapter 4 that a polygon's orientation relative to a light source will determine the intensity of the illumination that hits it and is therefore responsible for the polygon's shading. Polygons facing toward a light source appear much brighter to an observer than polygons facing away from it. To find a polygon's orientation, we compare the direction of its normal to the direction of a ray heading toward the light source. If both are going in nearly the same direction, the polygon is receiving high-intensity light; if the direction of a normal is opposite that of the light ray, then the polygon receives no light at all, as you saw in Figure 4-7.

By changing the direction or magnitude of a normal, bump mapping can fool Phong shading into producing a shade that is different from the one that would be expected. In each of the four images of Figure 7-2, you see a line drawing of the normals located around the teapot's girth. In the upper left image, the normals are all the same size and they radiate out from the teapot's surface. The result is the classic shiny plastic appearance of Phong shading. The upper right image portrays an effect created by shortening selected surface normals. In the lower left image, the direction of some normals have been changed to create circular bumps that repeat over the teapot's surface. The last picture shows the effect of changing both the direction and magnitude of some of the surface normals. In all four images, the profile remains smooth while the surface changes appearance.

Bump mapping can create raised patterns that simulate the look of embossing, and Figure 7-3 illustrates the process. In the upper left corner of the figure is a 2D image called an *embossing mask*. We interpret colors in an embossing mask as heights, with brighter colors being higher elevations. In our embossing mask, there are two colors, so when considered as elevations, it is a flat area with the letter "D" rising out of it in a manner similar to a butte rising out of flat lowland. The picture on the right shows the elevations for one line across the embossing mask. As your eye travels from left to right across the mask, you begin in a low area, and about halfway across, there is a jump from low to high as you encounter the first part of the "D." Then there is a small plateau before you drop

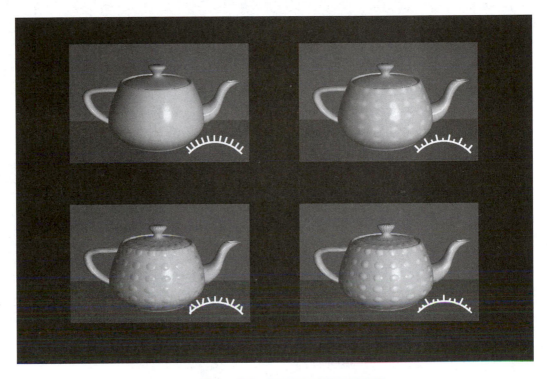

Figure 7-2 Altering surface normals.

down into the low area. There is a second set of transitions from low to high and from high to low before you reach the right side of the image.

The embossing process maps each point of the teapot to a pixel location in the embossing mask in the same way that 2D texture mapping does. Instead of using pixel values to change an object's color, we use them to alter an object's normals. When we land at a pixel location in the embossing mask, we look at the surrounding pixels to decide if we are at a transition. If there is a transition from dark (low) to light (high), we rotate the surface normal in one direction; if the transition is from light to dark, we rotate it in the opposite direction. If we land at a pixel location where there is no transition, we leave the normal alone. You can see this pattern of alteration in the upper right image of Figure 7-3. The result is a recognizable pattern in the teapot's surface.

While embossing can create an impression of a raised surface, the raised pattern cannot cast shadows. That is because polygons cast shadows, and embossing does not change the geometry of an object, so the shapes of individual polygons remain the same.

Embossing changes surface normals in a predictable manner based on the colors found in an embossing mask. Surface normals can also be changed in a random manner to create surfaces like stucco or sand, which appear rough, or surfaces that appear hammered or dented. Noise can add randomness to the direction of surface normals, and changing the frequency and amplitude of the noise will change the size and deepness of the resulting bumps.

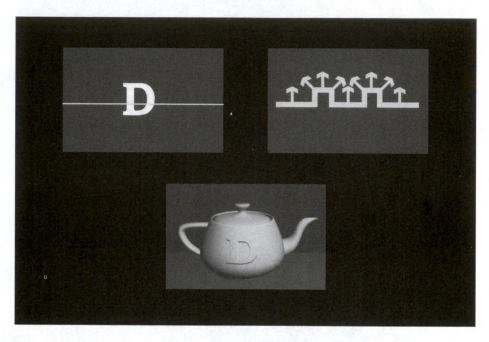

Figure 7-3 Embossing.

Bump mapping can be used with either the z-buffer or raytracing surface algorithms and, when combined with texture mapping, can create exciting and convincing visual effects. See Exercises 5 and 6 for examples of using bump and texture mapping at the same time.

CONCLUSIONS

Bump mapping, like texture mapping, adds visual interest and complexity to an image and helps eliminate the synthetic computer-generated perfection of simple Phong shading. Bump mapping alters an object's surface to make it appear wrinkled, scratched, or scuffed and thus more believable as a real object. It is most effective when the surface details are small relative to an object's overall size, because it does not affect the shape of an object's polygons.

FURTHER READING

Section 6.4, "Bump Mapping" from Watt and Watt's *Advanced Animation and Rendering Techniques: Theory and Practice* [WATT92] presents the mathematics required to perturb a surface normal and suggests several approaches to wrinkling a surface. The noise functions described in Ebert's *Texturing and Modeling: A Procedural Approach* [EBER94] can be used to control the size and frequency of the perturbations.

EXERCISES: BUMP MAPPING

To answer the following questions, use TERA to examine the "Bump Mapping" examples.

1. Choose the "Abstract" scene, and look at how the various bump mapping techniques interact with the objects' shapes. Answer the following questions.
 a. Which technique would simulate a single water drop falling onto a perfectly still pond?
 b. Which technique could create circular bumps along a seam on the side of an ocean liner?
 c. What technique most closely resembles burnished aluminum?
 d. Which techniques have a random element?
2. After you explore the "Demolition" scene, mentally compare the effect of dropping 5 pounds of golf balls from a height of 6 feet onto the top of a car to the effect of dropping 5 pounds of golf balls from a height of 50 feet onto that unfortunate car.
 a. Which of the two "bump maps" would have the greater amplitude?
 b. Think again about dropping things onto the car roof. What could you do to decrease the frequency of the resulting bump map?
3. In the "Camping" scene, compare the bump-mapped log to the texture-mapped log. When might a texture-mapped object look similar to a bump-mapped object?
4. In the "Icons" scene, you are viewing three sides of a cube.
 a. When you change to the "True Polygons" setting, is it clear that the icons protrude from the cube?
 b. Do you get the same effect when you use the "Embossed" setting?
 c. On which side does the embossing best simulate true polygons? Can you guess why?
5. Select the "More Toys" scene to complete the following questions.
 a. Compare the "Emboss" and the "Emboss and Shadow" settings for the BigBlock object. What do you see? How can you account for this?
 b. Select the RedBlocks. Switch back and forth between "Polygons& Shadow" and "Emboss&Shadow" while comparing the profile of the shadows. Which setting produces a shadow whose profiles are straight lines? Would you find this in nature? What accounts for the straight lines?
6. In the "Wall" scene, select the wall, and switch to the "Texture" algorithm. These colors were taken from an actual ceramic wall at a large Midwestern university.
 a. How apparent is the pattern?

 b. Compare this to the "Bump" and "Texture&Bump" settings. Which of the three most accurately represents the surface and color of a ceramic block wall?

 c. Which is the most visually convincing?

7. The "Stereos" scene consists of only four polygons! If you do not believe this, select each object and switch to the "Plain" setting.

 a. Select the amplifier and compare the "Texture," "Bump," and "Texture&Bump" settings. Which creates the most clearly visible detail?

 b. Select the CDshelf and compare the "Texture," "Bump," and "Texture&Bump" settings. Which of these is the most convincing rendering? Compare this answer to the answer you gave in part a.

 c. Can you make any generalization about which technique to choose based on the amount of detail you are attempting to simulate?

DOING IT YOURSELF: BUMPS

The purpose of these activities is to help you

- Become familiar with the variety of bump mapping available in POV-Ray
- Learn how the normal command alters surface properties
- Experiment with embossing

For background information, read Section 4.8.3, "Normals," and Section 7.6.2.3, "Bump Map," in your on-line documentation. As you read, notice that the creators of POV-Ray use the term "bump mapping" to describe what we call embossing.

The normal command, which controls the perturbation of surface normals, is placed inside a texture statement. Here is an example:

```
normal {bumps .75 scale 3}
```

The first numeric value controls the amplitude or the extremity of the bumps and the *scale* specification controls the frequency. A decrease in the scale value increases the frequency and causes the bumps to be smaller and to cluster more closely.

To carry out the following activities, you will need to copy all of the files in the directory /yourself/ch7 of your CD. This includes box.pov, barrel.inc, barrel.pov, emboss.pov, and cg.tga.

1. Render the file box.pov, which shows samples of available perturbation patterns. Which square displays ripples? Give your answer in terms of row (top or bottom) and column (left, middle, right).

Figure 7-4 A bump-mapped reflective surface.

2. Perturbing the normals of a reflective surface can produce an interesting and dramatic effect, as you can see in Figure 7-4.

 a. Compare the perturbation pattern of the reflection in Figure 7-4 to the patterns you saw in the image created from `box.pov`. Which two bump patterns could not possibly make the pattern in the reflection? Why?

 b. Render `barrel.pov`. Notice that there is no normal command in the plane object, and the resulting image has a perfect reflection that is less interesting than the one in Figure 7-4. Experiment with perturbing the plane's surface with the candidate patterns and attempt to replicate the effect. It does not have to be an exact match, but you can get close. What pattern did you choose?

The last set of activities covers embossing. An image determines the pattern of the embossing. It is similar to using an image to control the color of a 2D texture-mapped object. Many of the POV-Ray commands you learn for 2D texture mapping also apply to embossing.

3. Render `emboss.pov`.

 a. You should be able to read a message in the image. What is it?

 b. There is a rotate command in the box's texture statement. Why is it there?

 c. What is the name of the image that created the embossed look?

 d. Try substituting another image file as the embossing pattern and render the scene again.

8 Lighting

Lighting is an essential ingredient of any image and it is a major contributor to an image's overall mood or look. Light position, intensity, color, and type are as important to an image's appearance as the choice and positioning of shapes in the scene.

The first part of this chapter discusses simple lighting techniques, several of which you have already experienced while looking at pictures in previous chapters. The second part of the chapter covers *radiosity*, a sophisticated algorithm that creates a striking level of realism in computer-generated imagery.

LIGHT TYPES

The most commonly used types of light are *ambient, point light, spotlights*, and *area lights* [UPST90]. Each produces a characteristic effect when used to illuminate a scene.

Ambient light is uniformly distributed throughout a scene in all directions. Regardless of a surface's position or orientation, it receives exactly the same amount of ambient light as any other surface in a scene. In general, it is best to include a small amount of ambient light in any scene to prevent a shadowed object from being completely in the dark.

Ambient light fills in areas that are not directly lit and it lightens shadows. A good example of a lighting environment with a high ambient component is the setup for portrait photography, which evenly illuminates a person's face and prevents harsh, unflattering shadows from forming. In contrast, scenes with a low amount of ambient light have deep shadows. Consider the last time you were in a car at night and turned on the overhead ceiling light to read a road map. While you could probably read the map, it would have been difficult to see anything under the seat because there was not enough ambient light.

In a scene lit purely by ambient light, all surfaces receive exactly the same amount of light and as a result, color calculations produce exactly the same shade for every point on an object. In real life, environments with purely ambient lighting are extremely rare, as the appearance of Figure 8-1 would suggest. The image's unnatural appearance is due to a lack of transitions from light to dark, so what you see are flat-looking objects with no discernible contour.

Unlike ambient light, which is omnidirectional, a *point light source* radiates light outward from a single position and shines evenly in all directions. Examples of illumination

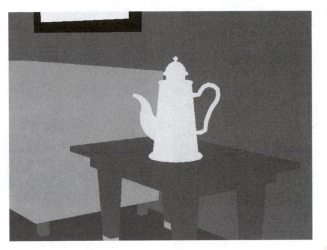

Figure 8-1 Ambient lighting only.

that can be simulated with a point source include a bare light bulb and the sun. The amount of point light reaching a surface will depend on the surface's orientation. Because the amount of incoming light varies over an object's surface, shading will vary over the surface too, and a viewer will see transitions from light to dark that reinforce the impression of three dimensions. Point sources are also responsible for creating highlights on shiny surfaces. However, a scene illuminated solely by a point source without the softening effects of ambient light will have harsh, dark shadows.

You have already seen many examples of illumination by point light. All the images in previous chapters were illuminated with a combination of ambient and point light.

Like a point light, a *spotlight* has position, but unlike a point source, whose light radiates in all directions, the illumination from a spotlight has a specific direction.

It creates a cone of light whose intensity falls off as you move from it. A spotlight creates a small area of illumination, just as its name suggests. In Figure 8-2 (see color plate section), you can see a circle of light, which heightens the theatric impact of the image.

Area lights are better than point lights for accurately simulating real-life light sources because most actual sources emit light over a surface area. For example, fluorescent lights can be tubes that are four feet long or more. An area light will illuminate a space more evenly than a point source and the resulting image will have shadows with blurred or soft edges, as Figure 8-3 demonstrates. The area of transition from full shadow to full illumination is called a penumbra.

COLOR

A light's color can be a powerful tool to enhance an atmosphere or mood that you are striving to create. Careful use of color can draw upon a viewer's lifetime of experiences to evoke a feeling. For instance, blue light can add a melancholy tinge while yellowish light can create feelings of warmth and cheerfulness. You should be aware of the fact that very few natural lighting sources are white. Sunlight is yellow-white on a summer day, but

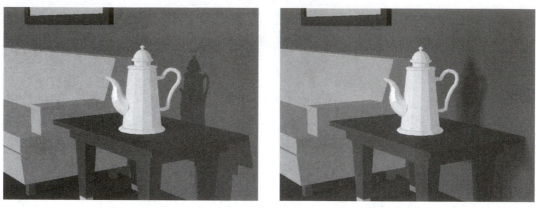

point source area light

Figure 8-3 Area lights create soft shadows.

bluish-white in winter months. At dawn or dusk, it can be rose hued or shot through with orange. Firelight has inviting tones of yellow-orange while a fluorescent bulb glows with a cold bluish light. In a computer-generated image, a white object illuminated by white light will be colored with nothing but shades of gray that have an unnatural look and betray the image's synthetic nature. If you change the light to be slightly tinged with color, the results are more pleasing.

VISUAL CUES

In general, if you see sharp shadows, or walls meeting in a sharp junction with abrupt changes of shade as you move from one wall to another, then you can be fairly sure that a point light source illuminates the scene. If you see a circle of brightness that has a distinct transition to darkness, then most likely it was made with a spotlight; if it is a bright area that gradually fades away, then you are probably experiencing a point light. The presence of shadows with a penumbra suggests that area lights illuminate the scene.

EXERCISES: SIMPLE LIGHTING

In order to answer the following questions, start TERA and choose the "Ch. 8a: Simple Lighting" session, which is Option 11 for Unix users.

1. When you begin, you will be looking at a scene of a peach and a knife. Observe the effects of various combinations of ambient and point light by clicking on the different options.
 a. Which setting is the darkest? The second darkest?

 b. When are the contours of the peach least noticeable?

 c. Which setting most resembles the effect you experience when turning on a ceiling light in a car at night?

2. Select the "Auction" scene, and compare the appearance of the "Low Ambient/Low Point Light" to "Low Ambient/High Point Light". What type of light illuminates those areas that are in shadow? How does this account for the appearance of the shadows?

3. Move on to the "Dresser Top" scene, and observe the appearance of the "Right Light," "Left Light," and "Overhead Light" settings, and look at the shadows created by each light source.

 a. Which light has the lowest position? How do you know?

 b. Which of the right, left or overhead lights are participating in the "Two Lights" setting? How do you know?

 c. Which setting gives you the brightest lighting? Is this what you expected?

4. In the "House" scene, the settings are labeled by the light color(s) used to illuminate various renderings of the white house that comprises the scene. Answer the following questions:

 a. Which setting looks most like a black-and-white photograph?

 b. Which lighting most closely simulates late evening? Noon? Dusk?

 c. Do any of the renderings use more than one light? Which one?

5. In the "Office" scene, which picture has an area light? Justify your answer.

TOWARD GREATER REALISM

In real life, every surface in an environment receives illumination from a combination of direct light and reflected or indirect light. Direct light is energy that comes directly from a light source, but reflected light is energy that has been reflected from one or more surfaces that are not light sources. Consider the pleasant situation of sitting in a sunny, light-walled room on a bright autumn day. Sun rays stream through windows to form rectangular areas of brightness. Only a small portion of the room receives direct sunlight yet the entire room is bright because sunlight reflects from the wall and hits the ceiling. From there it may strike another wall and then the floor. Much of the room's illumination comes from reflected or indirect light.

In computer graphics, simple illumination schemes use constant ambient light to simulate reflected light, and the result is an acceptable, but clearly synthetic image. I doubt that any of the images you have seen in the book could be mistaken for a photograph. Greater realism demands a better simulation of indirect light, and that is what radiosity does.

In fact, radiosity simulates actual conditions so well that architects use it to carry out lighting studies.

VISUAL CUES

Whenever you see an image that has soft shadows, consider radiosity as a possible lighting technique. However, you will have to look for additional cues to confirm its presence. One of them is called *color bleeding*, which only radiosity can produce.

In real life, when a light-colored object is placed near a boldly colored one, the light-colored object will "pick up" some color and this effect is called color bleeding. Objects in a room with red walls will pick up a little extra warm color. Figure 8-4 (see color plate section) demonstrates how radiosity can create this effect. In the right image, radiosity helps a white cup pick up red and yellow shades from the walls. Another way of saying this is that the walls "bleed" their color onto the white cup and tabletop. Contrast this with the left image, which portrays the same scene but has constant ambient light. The gray shades visible on this version of the cup look cold and artificial.

Another cue comes from examining shadows on large flat diffuse reflectors such as walls and ceilings. Radiosity creates variations in shade across the surfaces and produces a darkening as walls meet in a corner. Without radiosity, corners look artificially "clean." Also examine the relative deepness of various shadows. Figure 8-5 (see color plate section) shows a side-by-side comparison that demonstrates this effect. In most real-life situations, shadows under a table will be deeper than shadows on the tabletop because less light finds its way to the table's underside. Radiosity simulates this effect.

THE RADIOSITY ALGORITHM

The radiosity algorithm has its basis in the field of thermal heat transfer, which describes *radiation* as the transfer of energy from a surface after it has been thermally excited [GORA84]. Such surfaces include both surfaces that are basic emitters of energy, such as light sources, and the more commonly occurring surfaces that reflect energy.

The *radiosity equation* describes the amount of energy emitted from a surface as the sum of energy inherent in the surface itself plus all the energy that strikes it. This incoming energy comes from other surfaces, including both light sources and reflecting surfaces. When one goes to determine the amount of light coming from a contributing surface, one has to find out how much light is striking the contributing surface! Such complex interrelationships require information about how energy leaving one surface will be distributed among all the others. A *form factor* supplies this information by taking into account distances between surfaces and their orientation relative to each other.

It is possible to use a brute-force approach, called the full matrix radiosity algorithm, to determine the amount of light striking a surface, but it requires so much computation that researchers looked for another approach. They found it in the progressive radiosity algorithm [COHE88]. It begins by guessing the amount of energy arriving at each surface and then refines the guess through a series of calculations. Each successive refinement yields a more accurate approximation and eventually the progressive approach will yield the same results as the full matrix method. With this method, it is possible to render an image after each step and a viewer can decide if the approximation is acceptable or not. The progressive algorithm saves time because in most cases a viewer will be satisfied with an image long

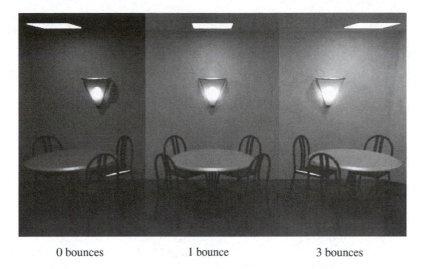

| 0 bounces | 1 bounce | 3 bounces |

Figure 8-6 Progressive radiosity. (By Stephen Spencer, Virginia Weinhold, and Kevin Simon.)

before the algorithm reaches the refinement step that would yield the same results as the full matrix method. Figure 8-6 shows three different images that were taken after one, two, and three steps of progressive refinement.

SUMMARY

Using radiosity in place of constant ambient light will create an image of extremely high quality, rivaling the realism of a photograph. Visual characteristics of radiosity include the appearance of color bleeding, a natural variation of shade over large diffusely reflecting surfaces, soft shadows, and a realistic depth to shadows. Radiosity is so accurate in its simulation of lighting behavior that it can be used for illumination studies. The only deterrent to using radiosity is the enormous computational cost. Even with the progressive method, creating an image of a moderately complex scene can literally take days on current computers.

FURTHER READING

Chapter 16, "Illumination and Shading," of *Computer Graphics: Principles and Practice* [FOLE90] presents a comprehensive theoretical discussion of light sources and radiosity. Ian Ashdown has written an entire book devoted to radiosity, entitled *Radiosity: A Programmer's Perspective* [ASHD94]. The book contains a floppy with a rendering program (including source code) that implements radiosity.

For an explanation of lighting couched in terms of traditional cinematography, refer to Ben de Leeuw's *Digital Cinematography* [DELE97]. It is a nonmathematical treatment and provides a rich resource of example images and animation.

EXERCISES: RADIOSITY

Start TERA and choose the "Ch. 8b: Radiosity" session. This is Option 12 for Unix users.

1. Begin with the scene depicting a set of empty shelves.
 a. Which two options have both red and yellow walls?
 b. Compare the two options that you identified in part 1a. What differences do you observe?
 c. Select the "All 3 Colors" option. From where is the planter picking up color? From where is the right side of the shelving getting its color? Is it from the same place where the left side is getting its color? How can you tell?
2. Select the "Living Room" scene, which demonstrates the effects of progressive radiosity.
 a. Compare the appearance of the "NoBounce" and "FourBounce" options. Consider the front faces of the white furniture, the sharpness of shadow, the appearance of the two walls, and any variations of shade within shadowed areas.
 b. Beginning with the "NoBounce" setting, compare the visual differences between successive options. Between which two settings do the differences disappear?
3. In the "Church" scene, compare the shadows under the pews with and without radiosity.
 a. Which have more "depth" or variation of shade? Which corresponds more closely with reality?
 b. Compare the number of radio buttons you have in this scene to the number of choices you had in the "Living Room" scene. Would it have been useful to have additional radio buttons in this scene? Why?

DOING IT YOURSELF: LIGHTING

Raytraced images created with point light sources have a hard-edged, overly clean look, but by experimenting with radiosity and various lighting types, you can achieve a more realistic look. This chapter's activities focus on lighting issues and will

- Acquaint you with the effects of ambient lighting
- Familiarize you with the salient differences of point, spot, and area lights
- Introduce you to radiosity

To prepare for this chapter's activities, read Section 4.6, "The Light Source," Section 6.2.6.2, "Radiosity Setting," and Section 7.8.9, "Radiosity," in your on-line documentation. You will also want to copy files `corner.pov` and `mug.inc` from the directory `/yourself/ch8` on your CD.

The first activity involves changing the ambient settings in a scene. As you know, in POV-Ray the ambient light level is specified in the finish statement. Searching through a file to find and change every ambient value can be tedious and time consuming. Fortunately, there is a better way. Inspect the contents of `corner.pov` and find the following statement:

```
#declare ambient_light_level = 0.0
```

This is an example of the *declare* statement, which associates a value with a name. In this case `ambient_light_level` has a value of 0.0. Now look for a finish statement in `corner.pov`. You will notice that they all look similar to this:

```
finish {diffuse 0.6 ambient ambient_light_level }
```

POV-Ray substitutes the value 0.0 for any occurrence of the name `ambient_light_level` before rendering the scene.

1. At present there is no ambient light in the scene, which makes it look very dark. To add ambient light, all you have to do is to change the value in the `#declare` statement that defines `ambient_light_level`. Adjust its value until your image looks similar to the left image of Figure 8-7. What ambient level did you choose?

Spotlights can make a dramatic impact as the right image of Figure 8-7 demonstrates. To create this image, begin by setting the ambient light close to zero. Follow this by converting the point light into a spotlight. It should be located at the same position as the point light

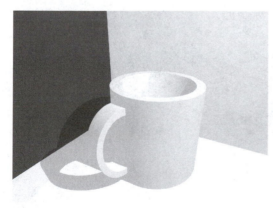
high ambient light

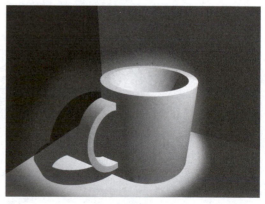
spotlight

Figure 8-7 Lighting effects.

and should receive a value of 15 for the *radius* and 20 for the *falloff*. Do not forget to add the word *spotlight*. For the *point_at* value, begin with a position that corresponds to the mug's location and adjust it accordingly until you get a result similar to the right image of Figure 8-7.

2. Give the `light_source` statement that you used to create your image.

In your last image, the spotlight perimeter softens gradually into darkness, but the shadow from the mug has knife-sharp edges. To create soft shadows, you can use an area light. Convert the light source into an area light that is 3 units long in *x* and 3 units long in *z*. Experiment with the statement until you create an image that is similar to the left image of Figure 8-8.

3. Give the `light_source` statement you used to create your image.

The last activity involves radiosity. Radiosity replaces the constant ambient light with a simulation of indirect light and thus produces more realistic results. When you tell POV-Ray to use radiosity, it uses the value of the ambient setting to determine the intensity of the indirect light. So you will set the ambient level as usual and use the "+qr" option to tell POV-Ray to turn on radiosity. As you raise the ambient level, you may want to reduce the intensity of other light because the image will become too bright and look washed out.

Beginning with the original version of `corner.pov`, adjust the ambient level and the point light source until the resulting image resembles the right image of Figure 8-8. For a full-color version of this image, you can refer to `fig8b.tga` in `/yourself/ch8` on your CD.

4. What modifications did you make to the `light_source` statement and the ambient level to produce your image?

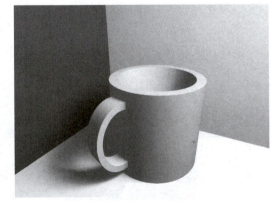

area lighting radiosity

Figure 8-8 More lighting effects.

9 Foolers

You have seen how raytraced images contain exciting visual effects such as shadows, transparency, and reflection, while images created with the z-buffer algorithm may have appeared a little dull by comparison. Unfortunately, raytracing has a big drawback in that it requires a lot more time to create an image than z-buffering does. In fact, it is so slow that, for large projects, computer animators choose rendering software that relies on the z-buffer algorithm. All 114,240 frames of Disney's *Toy Story* were imaged with Pixar's Renderman, which uses the z-buffer algorithm [LASS95].

"Wait a minute," you may be thinking, "there are shadows in *Toy Story*. Buzz Light-year's helmet is transparent, and you can see Slinky Dog's reflection on the floor." With some extra effort, a z-buffer algorithm can be extended to produce shadows, transparency, and reflections, and for many applications, it can substitute for raytracing and almost no one will notice.

SHADOWS

With the addition of a shadow buffer, a z-buffer algorithm can create shadows that are as convincing as those produced by raytracing [WILL78]. Before creating an image, the *shadow buffer algorithm* draws a version of the scene from the viewpoint of the light source and stores the depth information from this rendering in an extra memory called a *shadow buffer*. Figure 9-1 uses shades of gray to represent values in the depth buffer. Lighter shades occur on surfaces that are closer to the light source. During the second phase, the algorithm draws the image from the viewpoint of the observer, just as in the original z-buffer algorithm. When it determines that a point is visible to the observer, it uses the information in the shadow buffer to determine if the point is also visible from the position of the light source. If so, the point is in direct light, otherwise it is in shadow. Shading calculations for a shadowed surface use only ambient light while calculations for a surface in direct "view" of the point source use both the point source and ambient light. For an example of an image rendered with the shadow buffer algorithm, look at the right image in Figure 9-1.

Figure 9-1 Shadow buffer and z-buffer rendering with shadows.

TRANSPARENCY

A different type of modification allows a z-buffer algorithm to render transparent objects [MAMM89]. If a transparent object occurs in the foreground of a scene, then the algorithm renders all the opaque objects as usual. Then it sorts the polygons of the transparent object from back to front and draws them starting with the one farthest from the viewer. If a point on a transparent surface is closer to the viewer than anything previously rendered, the corresponding location in the z-buffer is updated, just as in the original z-buffer algorithm, but updating the color in the frame buffer is handled differently. Instead of using an object's color to replace the value in the frame buffer, its color is mixed with the current frame buffer value, and the result is stored as the new value in the frame buffer.

If there are opaque objects in front of the transparent one, then things get a little messier. First, all opaque objects in the background are rendered, followed by the transparent object. Finally, all the opaque objects in front of the transparent one are rendered in the conventional manner.

A scene containing an opaque object inside a transparent one, such as a fish in a fishbowl, requires yet more processing. The algorithm first renders opaque objects in the background, as before. Then it splits the transparent object into two parts—one part behind and the other in front of the opaque object. It renders the back half first, followed by the opaque object, and finally the front half of the transparent object.

While a z-buffer algorithm can render transparent objects in this manner, it cannot simulate refraction. When you see a transparent object, always check to see if it is bending the light passing through it. If you ascertain that the object refracts light, you can be absolutely sure that you are viewing a raytraced image.

ENVIRONMENT MAPPING

Environment mapping allows a z-buffer algorithm to create reflections and is similar to texture mapping with a box shape [BLIN76]. Suppose we wanted to use environment mapping to create a mirror-like teapot that is sitting on a dining room table. To begin, we render six images of the room, each with a viewpoint located where the center of the teapot will be. Although all six images will have the same viewpoint, each will have a different camera direction and together they cover the entire area of the room. Figure 9-2 shows that by aiming the camera up, down, left, right, to the back, and to the front of the teapot, one gets views of the entire room. These six views are used as six separate maps, called "environment maps," for the teapot.

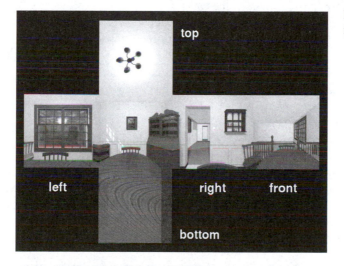

Figure 9-2 Six environment maps (van der Burg).

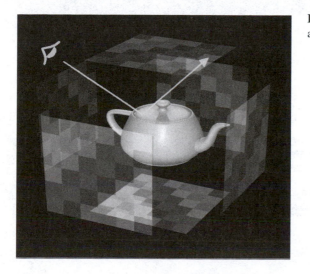

Figure 9-3 Environment mapping algorithm.

After creating the six environment maps, the algorithm renders an image of the teapot itself. Once it determines that a point on the teapot is visible, it bounces a reflection ray. The reflection ray first determines which environment map should be used and then it finds the pixel within the chosen map. The color of the pixel becomes the color for the visible point on the teapot. Figure 9-3 demonstrates the algorithm and Figure 9-4 offers a side-by-side comparison of reflections created by environment mapping and by raytracing.

Even though environment mapping required the creation of six additional images to render a scene, it is still useful for animation because there are many occasions where the six environment maps can be reused in subsequent renderings. As long as the reflective object does not change position radically, one set of environment maps will suffice. Of course, if our example teapot decides to fly away, we would need to compute new environment maps when it flies past the edge of the table.

Environment mapping works best when there is only one reflective object in a scene and that object is convex or flat. With nonconvex objects, there is a possibility that some part of the object will be reflected by another part of the same object. For example, in the raytraced image of Figure 9-4, the knob on the teapot lid is visible in the lid's surface. Unfortunately, environment mapping cannot create these types of interreflections, but it does work well for simulating mirrors and reflections that occur in tabletops or floors.

From your experience with raytracing, you also know that two mirror-like objects set in close proximity can create reflections within reflections. Environment mapping cannot do this either.

When creating images, if you exercise some care in choosing and positioning reflective objects, environment mapping can save you an enormous amount of rendering time. Because of the speed advantages, it is well worth considering environment mapping as an alternative to raytracing.

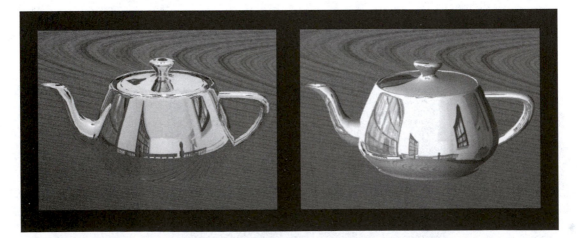

Figure 9-4 Raytracing compared to environment mapping.

CONCLUSIONS

Images that exhibit shadows but no reflective or transparent objects can be created with a z-buffer algorithm that has a shadow buffer added to it. Images with flat, reflective objects may also be created via z-buffer rendering that was enhanced by environment mapping. In fact, the only effects that are beyond the capabilities of an extended z-buffer algorithm are refraction and multiple interobject reflections.

When you examine an image, look carefully at any reflections or transparencies that may occur. Check carefully for refraction and multiple reflective objects. These are the only sure ways of distinguishing an enhanced z-buffer algorithm from raytracing.

FURTHER READING

Details of the shadow buffer algorithm are presented in Chapter 16, "Illumination and Shading," of *Computer Graphics: Principles and Practice* [FOLE90]. Also discussed in the same chapter are environment mapping (called reflection mapping) and nonrefractive transparency.

EXERCISES: FOOLERS

Start TERA and select "Foolers," which is Option 13 for Unix users.

1. Look at the "Choo-Choo" and "Beach" scenes and compare the shadows created with raytracing to those created with z-buffering.
 a. Are they similar?
 b. What shading is being used on the train?
 c. What techniques are being used in the "Beach" scene?
2. Select the "Teapot" scene and compare the raytraced and z-buffer versions.
 a. In which version(s) of the scene can you see reflections of the teapot's spout and lid handle?
 b. Two of the images have a ceiling with obvious parallel lines. Which surface algorithm does the better job of creating them in the teapot's reflection?
 c. The teapot casts a shadow that is visible in its reflection. Compare the appearance of the reflection in the z-buffered and raytraced versions. Which is more true to real life?
3. Move to the "Mirror" scene.
 a. Select the raytraced version that has lines in the ceiling, and look at the lines as they appear on the ceiling itself and as they are reflected in the mirror. How are they related?

b. Select the z-buffered version that has lines in the ceiling and look at them in the ceiling and in the mirror's reflection. Do these lines enjoy the same relationship as you observed in the raytraced version? Which version more accurately simulates reality?

c. Compare versions that have the obvious parallel lines in the ceiling to those that do not. In this chapter, it was mentioned that environment mapping does not work well with nonconvex reflective objects or with scenes having multiple reflective objects. Is there anything else you need to avoid if you are planning on using environment mapping?

4. In the "Magnify" scene, you see two renderings of a magnifying glass. Which of the renderings demonstrates refraction? How did you know?

5. For purposes of CAD/CAM (Computer-Aided Design/Computer-Aided Manufacturing), transparency can be a very useful way of displaying the internal structure of an object. In the "Gears" scene, which version gives a clearer idea of the internal structure of the machinery? Is refraction always desirable when rendering transparent objects?

DOING IT YOURSELF: CONSTRUCTIVE SOLID GEOMETRY

There really are no POV-Ray commands that are relevant to the first part of this chapter. After all, this chapter covers different ways of faking a raytraced look with z-buffer rendering and, as you know, POV-Ray is a true raytracer. However, there is a set of POV-Ray commands that are so useful that you need to know about them, and this is the perfect opportunity to learn about them.

This "Doing It Yourself" session covers Constructive Solid Geometry or CSG. It is a powerful tool that allows you to create complex and interesting objects from simpler ones. The following activities will give you an opportunity to

- Learn the four CSG operators available in POV-Ray

- Analyze complex objects in terms of their simpler components

- Experiment with creating your own CSG objects

Read Section 4.5, "CSG Objects," in your on-line documentation. It discusses the four CSG operators, which are union, intersection, difference, and merge.

The *union* operator groups objects together and treats them as a single entity. This is very helpful when building scenes with a number of complex objects. When you want to place a complex object, you can refer to it as a single entity instead of needing to specify all of its component parts explicitly. The *intersection* operator creates an object out of the space shared in common by its component objects. Take a look at Figure 9-5. The left image shows two spheres and the middle image is their intersection. The

intersection retains the overlapping parts of the two spheres. The *difference* operator subtracts or punches out a volume. The right image of Figure 9-5 shows the result of taking the difference of a box and a cylinder. A cylinder volume is drilled out of the box, leaving a hole. The *merge* operator is similar to the union operator. If you are planning to make a transparent object, use merge instead of union to eliminate unwanted internal surfaces.

1. You have actually used CSG operators already but may not be aware of it. Look at the file `pawn.inc` in `/yourself/ch3` on your CD.
 a. What CSG operator creates the pawn?
 b. How many objects are in a pawn? Name them.

Many everyday objects in our physical world can be constructed from CSG operations. Consider a drinking glass. Its outside shape can be made from an intersection of a cone and a box. The box trims off the point of the cone so it has a flat base, as you can see in Figure 9-6. We will call this new shape a "trimmed cone."

The diagram on the right side of the figure is an example of a special notation we use to represent CSG operations. The upside down "U" stands for intersection, and the diagram shows that we are taking the intersection of a cone and a box. The symbol we use for union is a right side up "U" and the symbol for difference is a minus sign.

2. Create a CSG diagram for
 a. the middle image of Figure 9-5.
 b. the right image of Figure 9-5.

Unfortunately, our trimmed cone is not very useful as a drinking glass because it is solid. Creating the cavity for liquids requires taking a difference of two trimmed cones. We make one trimmed cone a little smaller than the other and position it a little higher. Figure 9-7 gives you two visualizations of the process. As you can see, the CSG diagram is now a little more complex.

3. Examine the objects in Figure 9-8. Everything except the tabletop was constructed using CSG. All of the objects were constructed from spheres, cylinders, and boxes.

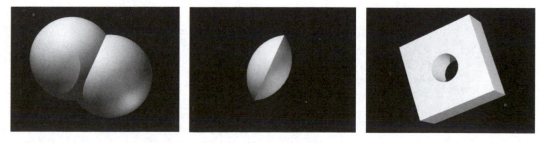

union intersection difference

Figure 9-5 A Demonstration of CSG operations.

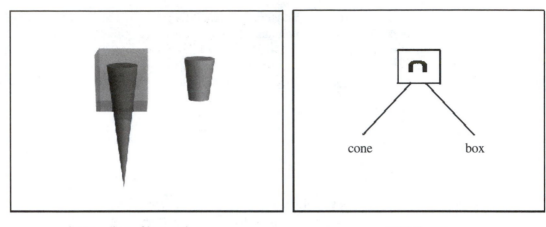

intersection of box and cone CSf diagram

Fgure 9-6 A trimmed cone.

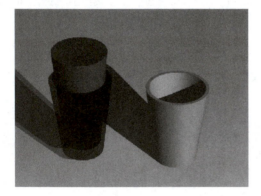

difference operation CSG diagram

Figure 9-7 Creating a drinking glass.

 a. What object uses only the union operator?
 b. What object is constructed solely with the difference operator? What shapes are being subtracted?
 c. Write a CSG diagram that describes the pencil holder.
 d. What is the CSG diagram that describes the coffee mug?
 4. Try creating one or more of the objects in Figure 9-8. To begin, copy `cup.inc` and `csg.pov` from the directory `/yourself/ch9` on your CD. The `cup.inc` file contains a definition for the drinking glass that we discussed, and the `csg.pov` file contains the basic lighting and table that you see in Figure 9-8.

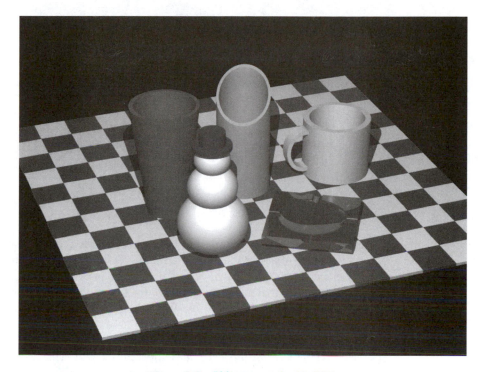

Figure 9-8 Objects created with CSG.

10 Cost and Effect

Having traveled through the first nine chapters of this book, you should now be quite familiar with the visual effects of rendering algorithms. However, if you plan to put this knowledge to practical use, you need to know a little about the performance of these algorithms. While the saying, "Looks are everything and you get what you pay for," may not constitute the healthiest philosophy for conducting one's life, it certainly holds true for computer graphics. When looking at a synthetic image, a good rule of thumb is "The better it looks, the more it costs."

In a very real sense this is the most important chapter in the book because it familiarizes you with the cost of rendering effects. Whether you are an artist, animator, or computer scientist, you will find that your supervisor will always ask, "How much is this going to cost?" or the closely related question, "How long is this going to take?" Some student animators do not understand why they ran out of time trying to render an animation before an assignment deadline. After all, they left it to render all night! A crucial aspect to the success of any computer graphics project is your ability to estimate the resources and time you will need to complete it, and the goal of this chapter is to give you some qualitative insights into that process.

Because this book is about rendering effects, the emphasis of this chapter will be on the cost of rendering. In addition to rendering costs, you will need to account for the time it takes to set up a scene (modeling) and the time required for a programmer to develop custom software. Estimating these would involve evaluating an artist's or programmer's ability and experience, and such topics are beyond the scope of this text.

Since programs are based on algorithms, computer scientists traditionally examine the underlying algorithm to predict performance. Algorithm cost is usually calculated in terms of time and computer resources. If this were a traditional computer science text, we would characterize computer resource usage in terms of memory and time requirements, but this chapter will concentrate mostly on the time issues. The old phrase, "Time is money," applies here.

Those of you who are computer scientists will find the following discussion extremely informal and lacking in such things as proofs for upper limits on run times. However, its purpose is to serve not as a formal analysis of time and space requirements, but as a reasonably reliable basis for examining the feasibility of a particular approach for a project.

There are many factors that influence rendering speed, and to incorporate all of them into a formal analysis would be a daunting task. However, it is possible to organize them into a short list and examine each of them in turn to get a sense of how they affect the overall process. Here is the list:

1. Scene composition.
2. Resolution of final image.
3. Lighting choices.
4. Computer speed.
5. Surface algorithm.
6. Shader.

The first part of this chapter examines these influences, and the discussion should give you an intuitive feel for the aspects you need to take into consideration when making estimates. Following this are the results from some actual timing tests, and the concluding portion shows you how this information can be put to good use when creating an animation.

Scene Composition

An aspect that will affect overall rendering speed regardless of surface and shading algorithms is the number and complexity of objects in your scene. The more objects you have, the longer it will take to render. For all surface techniques other than raytracing, objects are described as a group of polygons, and the more polygons an object has, the longer it will take the surface algorithm to determine what is visible. In fact, some manufacturers of specialty graphics equipment will describe the speed or performance of their hardware in terms of the number of polygons it can draw in a second. So if you know how many polygons you have in your scene, you can make a good guess at how long their hardware will take to draw your scene.

Raytracing has more flexibility than the other surface algorithms because it lets you use geometric shapes that are more sophisticated than a polygon. For example, a raytracer will allow you to use a cylinder to describe a chair leg and a box to describe a brick. The beauty of this feature is that you will be saving yourself some time. It takes a raytracer just about as long to test the visibility of a shape like a cone or a cylinder as it does to test the visibility of a single polygon. When you are using z-buffering, you have no choice but to use polygons to approximate a sphere, and you will need about 500 triangles to make one that looks convincing. However, if you are using a raytracer, you can replace the gang of triangles with a single sphere and you will save your raytracer the additional work of managing 500 polygons. You will see that raytracing is slow enough already—why make it slower?

Resolution and Antialiasing

As you can imagine, specifying a high resolution will lengthen rendering time. When you increase the resolution of your image, you are going to impact rendering speed dramatically.

Suppose you have been rendering an image with a resolution of 100×100 pixels, and now you choose to double the width and height. While your original image had 10,000 pixels (100×100), the higher resolution version will have 40,000 pixels (200×200). If you double the width and height of an image, you have not doubled the amount of work, you have increased it by a factor of four, and it will take four times as long to render.

Antialiasing also affects the speed of a renderer. Antialiasing describes a group of techniques designed to prevent a phenomenon known as *aliasing* [FOLE90]. Aliasing occurs when a renderer attempts to draw the small details in your scene and, as a result, visible errors will crop up in your finished image. These errors include staircasing or *jaggies* (Figure 10-1), missing or malformed polygons (Figure 10-2), and disintegrating textures (Figure 10-3). None of these are desirable in a finished image, and you will want to employ antialiasing to get rid of them.

Antialiasing divides a pixel into several regions and computes a color for each one. These colors, called samples, are averaged together to determine the pixel's color, as is demonstrated in Figure 10-4. Antialiasing softens the visible edges in an image and the human eye is more pleased with the final result, as you can see for yourself in Figure 10-5.

Figure 10-1 Aliasing creates staircasing or "jaggies."

Figure 10-2 Aliasing causes missing or malformed polygons.

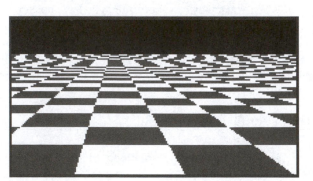

Figure 10-3 Aliasing causes textures to disinegrate.

Figure 10-4 Taking samples to compute pixel color.

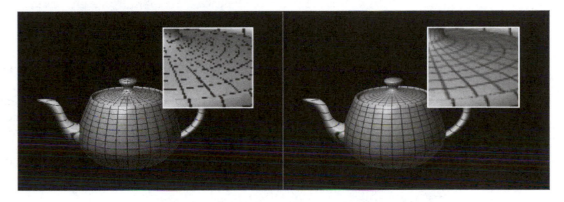

Figure 10-5 Benefits of antialiasing.

Most decent rendering packages will allow you to turn antialiasing on and off, and they will also allow you to specify the number of samples per pixel. When you decide to use antialiasing, always start with the lowest possible number of samples, which is probably four. View the resulting image, and if you are still seeing jaggies or other evidence of aliasing, increase the number of samples. Be aware, however, that computing multiple samples per pixel has the same effect on speed as does increasing the resolution. In fact, until you are ready to create your final image, you might consider turning off antialiasing altogether.

LIGHTING

Your choice of lighting will affect the amount of time it takes for a program to complete an image. Remember that to determine a color, the basic Phong lighting model must complete two tasks—one to compute the color based on ambient light and the other to compute the color based on the point light source. This is fine when you only have one point light source in a scene, but using multiple lights requires an extension to the basic model. If your scene has two point light sources, the extended lighting model will complete three tasks. The first is to compute the ambient contribution while the second and third tasks are to compute the contribution from each of the two point sources. Because calculating a point light's contribution is far more expensive than computing the ambient portion, the act of adding a second light nearly doubles the cost of calculating a color.

While spotlights are only a little more costly than point sources, area lights are by far the most expensive of all light sources. In addition, if you decide to use radiosity instead of a constant ambient component, you will incur a huge additional expense. It is best to hold off on using radiosity until you set up your scene and you are satisfied with the choice and positioning of your scene's objects, lights, and camera.

Computer Speed

As far as a computer is concerned, the faster it is, the better we like it! Check the processor clock speed—the "500 MHz" you see listed in a computer advertisement is the processor's clock speed and is a crude but effective estimate of the power of a desktop computer. For graphics, you will also want a lot (32 MB or more) of RAM and a large hard disk for storing all those pictures you are going to make. A really nice enhancement to a general-purpose computer is a special-purpose graphics card that is designed specifically for rendering. All it does is render polygons and it does so at a rate much faster than a general-purpose CPU. If shopping for a rendering package and you have a little extra money, it never hurts to ask if the software is capable of harnessing a graphics accelerator card to speed up the rendering process. By purchasing such a card, you can increase your computer's rendering power significantly.

Surface Algorithm

Determining surface visibility and color are the two most time-consuming things that a rendering algorithm does. Because these two activities dictate the overall expense of an algorithm, the next three sections will look at them in detail and present a qualitative comparison. By the time you are finished reading these sections, you will know the relative performance of surface algorithms and shaders.

The fundamental question that a surface algorithm answers is: "What is visible at this pixel?" This book has examined four different surface algorithms and each of them has its own way of answering that question. As you know, the wireframe algorithm does not bother answering this question at all and just draws every polygon it finds in a scene. When an algorithm does not spend any time performing tests to answer a question, it can finish up pretty quickly. It should come as no surprise then that wireframe is the fastest surface algorithm. Of course, the results are not very realistic either, so you can appreciate the trade-off. It is similar to skipping the hardest question of a homework set. A student taking this option will finish quickly, but the quality of the resulting grade will be less than optimal.

Coming in at second place in the speed department is the hidden-line algorithm. It does carry out some visibility testing but since it only has to draw outlines and does not concern itself with filling in areas, it is still fast. In third place is the z-buffer algorithm, because it has to process not only a polygon's perimeter but also every point in the polygon's interior.

While the z-buffer algorithm discards a polygon after determining its visibility, ray-tracing takes a less efficient approach. For each pixel in an image, it examines each and

every object and polygon in the scene. This means that each object and each polygon get processed many, many times. While researchers have developed several methods to make raytracing faster, its basic approach of drawing a pixel only after examining every object is very slow and puts it in last place for speed. But then, in terms of visual quality, it produces the most exciting effects, so you get what you pay for.

Z-Buffer Shaders

An effective way of determining the relative cost of basic z-buffer shaders is to examine how often they calculate color. For instance, constant shading uses the same color for an entire object, so a color calculation occurs only once per object. From past observations, you know that faceted shading produces multiple colors on an object, but each polygon will have only one color. From this we can deduce that a color calculation occurs once per polygon. The star-shaped highlights indicative of Gouraud shading are due to the fact that color calculation occurs only at polygon vertices and the resulting colors are blended along connecting edges. On the other hand, creating the elliptical highlights of Phong shading requires a color calculation at every pixel. From this examination, we can build a table that summarizes color calculation for each of the basic shaders:

Shader	Color Calculation
Constant	Once per object
Faceted	Once per polygon
Gouraud	Once per vertex
Phong	Once per pixel

While this list tells us how often each shader calculates a color, it does not specify which shader is the speediest. To determine this, we analyze the relative numbers of objects, polygons, vertices, and pixels in a scene. Most objects are composed of multiple polygons, and every polygon has at least three vertices. Furthermore, all but the smallest polygons occupy numerous pixels. In the vast majority of cases, there are more polygons than objects, more vertices than polygons, and more pixels than vertices. So in addition to summarizing occurrences of color calculation, this table actually lists the algorithms in order from fastest to slowest.

Bump mapping, 2D texture mapping, and environment mapping generally occur as enhancements to Phong shading and so require more rendering time. In general, 2D texture mapping is a little cheaper than bump mapping, but that should be taken only as a rule of thumb. Since there are so many ways of altering a surface normal or selecting a color from a texture map, it is not straightforward to determine which is faster without knowing the specifics of the particular technique. However, it is safe to say that using both bump and texture mapping is more costly than using just one of them. On the other hand, environment mapping does have an added cost of creating the six additional renderings that comprise the environment maps. Because of this, it is a little more expensive than basic 2D texture mapping. The following list is a summary of relative speeds:

Speed	Algorithm
Faster	2D texture mapping
	Bump mapping
	Bump and 2D texture mapping
	Environment mapping
	Bump and environment mapping or 2D texture and environment mapping
Slower	Bump, 2D texture, and environment mapping

A combination of bump and environment mapping would be useful for portraying a dramatic reflecting object that had a lot of surface detail on it, like the Wimbledon tennis cup or the basketball on the NBA championship trophy. Another application would be to create the surface of a reflecting pond where someone has just dropped a pebble into an otherwise still surface.

Texture and environment mapping would be appropriate for any reflective object that also has a color pattern on it. For example, this pair would create Christmas tree ornaments or highly polished marble surfaces.

Combining all three is a costly and exotic effect. If that Christmas tree ornament also had an embossed pattern and featured prominently in the foreground of a scene, then perhaps you would consider using all three, but in general, circumstances requiring this are extremely rare.

You probably noticed that the list did not mention 3D texturing. That is because the expense of 3D texturing is even more unpredictable than that of bump or 2D texturing. It can be as cheap as 2D texturing but often it can be more expensive than bump, 2D texturing, and environment mapping combined. Unless you know the researcher or programmer who created the texture, you will have to run a test of your own to check its speed.

SHADERS FOR RAYTRACING

For each pixel in an image, a raytracer first determines the visible surface and then calculates the color, so we can conclude that a color calculation occurs once per pixel. And while raytracing is more expensive than z-buffering, there is still a wide range in the performance of the available shaders. Here is a list that summarizes the relative speeds:

Speed	Shader
Faster	Diffuse shading
	Diffuse shading with specular reflection (shiny plastic)
	2D texture mapping
	Bump mapping
	Bump and 2D texture mapping
	Reflection
	Reflection with bump or 2D texture mapping
	Transparency
Slower	Transparency with bump or 2D texture mapping

A shiny plastic object requires a calculation for the specular highlight in addition to a calculation to determine the diffuse (colored) reflection. As in z-buffering, the more exotic shaders are enhancements to the basic "shiny plastic" shaders and require more time.

Reflection is more expensive than bump mapping because the raytracer has to chase the reflection rays that bounce off the surface. The raytracer must now answer the question, "What object does this reflection ray hit?" and this requires examining all the objects in the scene *again*. If the intersecting object is also reflective, then the raytracer has yet another reflection ray to follow. With a nonreflective surface, there are no reflection rays to chase.

If the process of creating a reflective object seems time-consuming, calculating the color seen through a transparent object is even more so. First, a raytracer must follow the ray as it passes into a transparent object, then it has to follow a new ray that exits the object. Finally, it has to find the surface that the exiting ray will strike. Of course, if there is another object *inside* the transparent one, there is even more work to do.

It makes sense that any enhancement of a transparent or reflective shader will incur still more expense. Bump mapping a reflective surface can create a stunning effect, but creating the image will take a lot of time.

Rendering Speed

Until now, we have discussed only the qualitative differences in algorithm performance. You know that a wireframe renderer is faster than a raytracer, but you do not know *how much* faster. An effective way of gathering this information is to run a benchmark, which is a measure of performance. In a benchmark, a person tests software or hardware by using a carefully specified set of data and then reports the result.

The data for our benchmarks are based on a single scene of 3409 polygons that depict a teapot located in the corner of a room. The lighting is simple, consisting of a single point source plus a constant ambient component. No radiosity was used because the computational demands would have been so great that the poor little computer would still be rendering as you read this text! Each technique used the scene to create an image with a resolution of 750 × 500. No antialiasing was used. The computer that performed the renderings is a 100 MHz Pentium-based PC with 32 MB of RAM running the Linux operating system (kernel 1.2.3). The algorithms were implemented solely in software and no special graphics accelerators were used. If you want to know more about how the benchmarks were carried out, feel free to contact the author (wolfe@cs.depaul.edu) for additional specifics.

Table 10-1 lists the time it took to complete each rendering, and Figure 10-6 (see color plate section) shows thumbnails of the resulting images. In all but the reflective and transparent cases, all objects in a scene were rendered with the specified technique. The timings are given in both seconds and minutes. Notice that the most expensive rendering took almost an hour!

There is a bit of variation in the performance of bump and texture shaders for z-buffering. Spherical texture mapping is more expensive than planar because it requires some trigonometry, and the bump mapper making the dents is using noise to make the random indentations. Adding noise adds expense.

Numbers are nice, but it often helps to look at data graphically to see trends. Table 10-2 is a graph of the timings. The cheapest (fastest) shader for raytracing still takes nearly

TABLE 10-1
Rendering speeds

Surface algorithm	Shader	Time (seconds)	Time (minutes)
Raytracing	Transparent	3286.81	54.78
	Reflection and bump	1386.39	23.11
	Reflection	1339.56	22.33
	Texture and bump	971.57	16.19
	Bump	966.39	16.11
	Texture	934.39	15.57
	Diffuse, specular	871.38	14.52
	Diffuse only	857.47	14.29
z-Buffer	Environment map	315.19	5.25
	Bump (dents)	150.72	2.50
	Bump (rivets)	82.03	1.37
	Spherical texture	85.23	1.33
	Planar texture	66.38	1.10
	Phong	41.05	.68
	Gouraud	10.29	.17
	Faceted	9.36	.16
	Constant	9.2	.15
Hidden-line		4.4	.07
Wireframe		3.4	.06

three times as long as the most expensive z-buffer shader. Does it come as any surprise that real-time applications such as virtual reality and training simulators use the z-buffer algorithm? Furthermore, notice the difference between the very fastest z-buffer shader and wireframe rendering. The wireframe technique is almost three times faster.

ANIMATION

Armed with the insight gained from the previous sections, consider the rendering costs involved in making an animation. In a movie house or cinema, animated films are displayed at a rate of 24 frames (images) per second, while at home, your VCR displays videotape at an even faster rate of 30 frames per second. Since animators need to create at least 24 images just to show one second of motion, it is no wonder that the computing needs of animation far outstrip the demands of rendering a single image. Imagine the amount of rendering it would take to make an hour-long animation!

In a process having much in common with image creation, animation is developed through trial and error. While an animator has a clear idea about how a shot should appear, working out the details is still a matter of experimentation. Thus an animator will need to set up a scene, view the resulting motion, and then make adjustments. Most likely an animator will look at many, many animation tests before seeing a version that is satisfactory.

As important as it is to use the speediest approach to create an image, it is crucial when creating animations. We will look at the six items mentioned at the beginning of this chapter and see how knowledge about each of them can help speed the development process.

TABLE 10-2
Rendering speeds in graphical form.

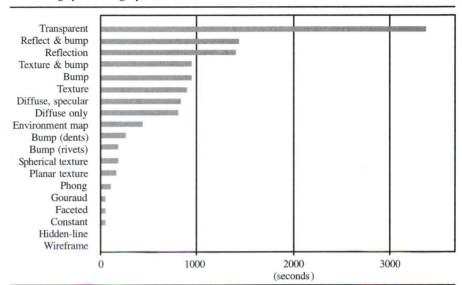

When setting up a scene, remember that the number and complexity of objects affect rendering speed. You can temporarily delete objects that you are not actively using when your work is focusing on another portion of the scene. With fewer polygons, a renderer can create an image more quickly and you will see the results that much faster. If you cannot remove a complex object, try substituting an object that has a lot fewer polygons but still retains the same size and approximately the same shape.

Choose wireframe for your initial renderings. It will give you a good idea of the position, size, and orientation of your scene's objects. In addition, it places so little computational load on a computer than even a 386-based computer can create real-time wireframe animations of scenes having 2000 polygons. Some packages based on raytracing and z-buffering will include a wireframe option for viewing rough drafts of your work. Take advantage of it.

If you move on to z-buffering, make an initial rendering with faceted or Gouraud shading to check your lighting. If your goal is to position a highlight "just so" on an object, you will need to make lots of test renderings, and you will not want to be held up by waiting for a texture mapping to complete. Another way to keep rendering time low while checking the lights is to use low-resolution images. The fewer the pixels you need to render, the faster you will see the results.

Once you have progressed to the stage where you want to apply textures to your objects, you have arrived at the realm of expensive shaders and time-consuming renderers. To compensate for this, use a very low resolution for your draft image. Even a resolution of 100×75 will tell you a lot about texture placement. In the author's experience, anything that looks like an error in a low-resolution image still looks like an error at a higher resolution. While perfecting your textures, there is no need to have all your lights turned on. In

fact, you can do a lot of useful work with all the light sources turned off except for the ambient component.

CONCLUSION

Although the benchmarks were a little on the informal side, they do lend some insight into the performance issues of rendering algorithms. You now know that bump and texture mapping are more time-consuming than making shiny plastic, and while reflection and refraction are exciting effects, they come with a heavy price tag attached. You also know why software for rendering movies would use z-buffering and why animators spend a lot of time looking at wireframe renderings.

I hope this book will prove useful when you decide to take an idea that inspires you and use it as an impetus for developing a reality that you can share with others. If you create imagery or animation that you are proud of, e-mail me the URL. It is always nice to get good news.

Best wishes in your graphics endeavors!

EXERCISES: REVIEW

After you fire up TERA one last time, look at your list of options for the title "Review," which is Option 14 for Unix users. This set of images is a reprise of all the effects covered by this book. Help yourself to them.

1. Look at "Home Rehab" and "Viking."
 a. Which objects did the most expensive rendering algorithm render?
 b. Is there any effect present in either scene that can only be handled with raytracing? Justify your answer.
2. Select the "Baseball" scene.
 a. For the baseball bat, which of the shaders are classified as producing a visual effect so similar that you are not obliged to tell them apart?
 b. Given the visual equivalence that you identified in the previous question, which shader would you choose to render the bat? Why?
 c. How many polygons are in the baseball bat? (*Hint*: You will find this in the same place where you would look to find out who created it.)
 d. The baseball in the scene is a sphere of 512 polygons and the baseball cap has 342. Do either of these objects have renderings that are visually equivalent?
 e. Compare the number of polygons in the baseball bat to the number in the baseball and the cap. What is the relationship between the polygon count and the likelihood of a group of z-buffer shaders producing a visual equivalence?

3. Select "A Barnyard Scene" and examine the bump-mapped and texture-mapped versions of the front wall.
 a. What can you say about the range of colors that are present in each one?
 b. Suppose you create a scene consisting of nothing except a single bump-mapped rectangle that fills the entire view of the camera. What will you see in the resulting image?
 c. It turns out that this particular type of bump mapping takes almost twice as long to render as the texture mapping does. Suppose you are confronted with the task of creating an animated flythrough of this pleasant scene. Your supervisor chooses the bump-mapped look but has not given you enough time to render the images. You have shown him the rendering estimates you made; you have pleaded with him, but he will not budge. (Perhaps he has pointy hair.) Do you have an alternative that will give him a barn that looks bump mapped but also allows you to bring this project in on time? What is it?
 d. (Bonus). Find the scene's geeky reference.
4. Look at "Hello," "Platonic," and "Halloween." What surface algorithm created these? (No fair peeking.) Are you sure? Why?
5. Which versions of these scenes could just as easily have been rendered via z-buffering?

The rest of the questions are paper-and-pencil exercises.

6. How many images would it take to create a five-minute animated film? Use the rate of 24 frames per second in your calculations.
7. Suppose the rendering time for each image is six minutes. How long will it take to render the entire animation? Express your answer in hours and minutes.
8. Suppose that the scene of your animation had the same complexity as the scene used for the timing benchmarks. What is the most exciting visual effect you could create? What surface algorithm and shader will you use to do it? What restrictions, if any, will this place on your animation?
9. Refer to the table of rendering times.
 a. How much faster is Gouraud shading when compared to Phong?
 b. In your experience, are there any circumstances where you can replace Phong shading with Gouraud shading and get away with it? (*Hint*: There is more than one.)
10. There is a way to extend Gouraud shading so you can use it as a replacement for Phong more often.
 a. In terms of a percentage, what is the speed of planar texture mapping when compared to Phong shading? To find this answer, divide the rendering time for planar mapping by the rendering time for Phong and multiply by 100.

b. Given how much faster Gouraud is when compared to Phong, some researchers have developed a system of using texture mapping to extend Gouraud shading. Color is still calculated only at polygon vertices, but instead of using a constant base color, the Gouraud-based texture mapper will get the base color from a texture map. We know that a basic Gouraud shader will render the test scene in 10.29 seconds. Given the percentage difference in basic Phong versus planar mapping, calculate the amount of time that a Gouraud-based texture mapper would need to render the scene.

c. Compare the rendering time you calculated for a Gouraud-based texture mapper to the rendering time of a Phong shader. Which is faster? By how much?

d. What is it that Phong can do really, really well that Gouraud shading cannot do?

e. Suppose there is an image of a solid background color with a circular highlight on it. (See Figure 10-7.) How would such an image help Gouraud shading to compete with Phong?

Figure 10-7 An image of a highlight.

DOING IT YOURSELF: HAVE FUN!

In the activities from the first nine chapters you have learned to choose and place objects to create your own virtual world; you now know a wide range of color, texture, and surface effects that add visual interest, and you have experimented in positioning lights and camera. You are prepared to create your own exciting images.

To help you with your projects, the CD in this book contains a library of over a hundred POV-Ray object definitions in the directory /yourself/ch10/incs. Each file in that directory has a name suggestive of the object it contains and ends with the dot extension ".inc." To see what each object looks like, use your favorite Web browser to display the file /yourself/ch10/library.htm. To see a picture of an object, click on its name. To access the object definition file, click on its picture.

All objects in this library have a minimum y-value of zero. Furthermore, they are centered at $x = 0$ and $z = 0$, and they are two units long. Figure 10-8 may help you visualize this. Since all objects are located in the same position and are roughly the same size, they may help you when you are in the process of setting up a scene.

There is another technique that will help you create a scene. For the activities in this book, you have used a text editor to create or modify files for POV-Ray. While it is certainly possible to make great-looking images by relying solely on this method, you may want to consider finding a modeling program. Interactive modeling programs or *modelers* allow you to position, size, and orient objects visually rather than having to guess at numbers

Figure 10-8 Position and orientation of objects in the POV-Ray library.

that you hope will represent your intent. When you are done creating your scene, you can instruct the modeler to produce a file that POV-Ray can render. In other words, it makes the ".pov" file for you. Most people find that it is *much faster* to use a modeler and well worth the time it takes to learn how to use it.

You may find yourself thinking, "Hey, if it's so much easier to use a modeler, why didn't we use one in this book?" That is understandable, because it makes sense to save as much time as possible. It is still crucial that you know the underlying rendering language (like POV-Ray), because on many occasions a modeler will not produce exactly what you want, and you will be forced to edit the .pov file it produced. This is why people who use modelers still find it essential to know the underlying rendering language.

The following paragraphs describe three modelers that are available for free or at low cost via the Internet. All of them produce input files for POV-Ray.

Sced

Created by Steve Chenney, Sced is a modeling program that makes use of geometric constraints to edit objects in a virtual world [CHEN98]. Sced uses constraints to facilitate the accurate placement of objects and provides a maintenance system for keeping constraints satisfied as the scene is modified. For example, once you can constrain a teapot to the center of a tabletop, you can move the table and the teapot will move along with it. Constraints make it easy to create and position jointed figures. Moving a hand will cause a constrained arm and shoulder to move appropriately.

Sced provides a variety of simple primitive objects and can import Digital Equipment Corporation's OFF format. There is full support for Constructive Solid Geometry (CSG) operations as well as provisions for lighting and camera parameters. Sced saves modeling information in its native format (".scn") for future editing and can export to a wide variety of rendering formats, including POV-Ray, Renderman's RIB, Rayshade, Radiance, and VRML among others.

Sced runs on almost any Unix platform with X Window System and is available at http://www.cs.berkeley.edu/~schenney/sced/sced.html. There you will find tutorials, example scenes, and binaries for several popular platforms. Unique to the modelers discussed in this column, the source code for Sced is available for download. One offspring of Sced is Sceda, which provides support for splined keyframe animation. Created by Denis McLaughlin, Sceda allows you to check your animations as wireframes before exporting them. Look for Sceda at http://www.cyberus.ca/~denism/sceda/sceda.html.

Breeze Designer

Neville Richards created Breeze Designer primarily to work with POV-Ray, but it also exports to other popular rendering formats including RIB, VRML, and AutoCAD's DXF [RICH98]. In addition to the simple modeling primitives and CSG support, Breeze Designer provides text objects using True Type fonts, blobs (metaballs), and heightfields. A user can also create surfaces using bicubic Bezier patches or sweeps (surface of revolution).

Breeze Designer imports objects in Autodesk's popular 3DS format as well as DXF. Objects can be grouped and manipulated as a single entity.

Users can preview textures from the built-in library based on POV-Ray's textures or can choose to create their own. An option exists within the program that will automatically hand off rendering to POV-Ray without having to leave Breeze Designer.

A notable feature of Breeze Designer is its support for third party plug-ins. One plug-in, based on Keith Rule's Crossroads library, imports a huge variety of file formats, including TrueSpace (COB), World Toolkit (WTK), Wavefront (OBJ), and VRML. Others create a variety of complex objects (trees) and animated effects. The plug-in feature is well documented, allowing students a chance to write their own modules.

Breeze Designer runs on Windows 95/NT and is available free of charge at http:// www.imagoes.fl.net.au. The full installation has been broken into a number of smaller zip files and is mirrored in several locations around the world.

Rhino

Rhino is a versatile modeling tool for creating shapes in addition to creating worlds. Quoting Robert McNeel & Associates, the creators, "Rhino is a conceptual design and modeling tool for industrial, product and scene designers. Whether you build heart valves or ship hulls, packaging or gears, Rhino is an easy-to-learn-and-use flexible and accurate modeler."

One of the strengths of Rhino is that it allows the user to create and edit combinations of freeform curves, surfaces, and solids. Rhino utilizes trimmed NURBS surfaces to represent curved shapes, including shapes with holes in them. Users can create a solid by joining surfaces together at their edges. This flexibility facilitates great expressiveness in creating shapes. Rhino's Web site contains tutorials for creating human figures, faces, and hands.

With its system of constraint-based modeling, Rhino provides the accuracy of traditional CAD packages. Users have access to a wide variety of snap options and can choose the orientation and precision of the Construction Plane, a 2D grid where data points are entered.

Rhino supports a blizzard of formats, including 3DS, DXF, RIB, POV, OBJ, and VRML. Unique among the modelers discussed here is its 3D digitizing support. Users can connect and use either a MicroScribe digitizing arm or the Faro SpaceArm.

Rhino runs on Windows 95/NT. The release price of Rhino is quite reasonable for students, instructors, and educational site licenses. For more information, visit their Web site at http://www.rhino3d.com.

Have fun!

VISUAL CUES

- Polygon appearance: Outlined
 See-through polygons
 Opaque polygons

- Solid polygons
 Single-color polygons: Object looks as if cut from paper
 Single-color polygons: Object has contours, but polygon structure is visible
 Smooth-shaded polygons: Compact, elliptical highlights
 Smooth-shaded polygons: Smeary, star-shaped, or polygonally shaped highlights
 Smooth-shaded polygons: Rough, pitted, or dented surface; object has smooth profile

- Objects
 Pattern appears to be painted on object surface
 Object appears to be made from wood or stone
 Object appears to be made from glass; light bends as it passes through object
 Mirror-like surface

- Transparency
 Refraction present; light bends as it passes through object
 Refraction absent; background undistorted when viewed through object

- Reflection
 Interreflections in reflective object; interreflections among multiple reflective objects
 Single reflective object; no interreflections, even if object is nonconvex

- Shadows
 Shadows absent
 Shadows present: Sharply-defined boundary
 Shadows present: Soft boundary (penumbra) present

- Diffuse surface interaction
 Objects "pick up" color from neighboring objects (color bleeding)
 Shadows have multiple colors as well as shades
 Shadows deepen gradually in room corners and where wall and ceiling meet

APPENDIX B
VISUAL IDENTIFICATION

The following is a summary of some of the salient visual effects created by various rendering algorithms. For a more thorough explanation, consult the text.

1. **Surface algorithm**
 Always attempt to determine surface algorithm first. Since there will be only one surface algorithm employed in an image, look for cues throughout the entire image.
 a. Outlined polygons
 i. See-through: **Wireframe**
 ii. Opaque: **Hidden-line**
 b. Solid (filled-in) polygons
 i. Refraction: **Raytracing**
 ii. Interreflections: **Raytracing**
 iii. Shadows, reflections: Probably **Raytracing**
 iv. No shadows, reflections or transparency: Probably **z-Buffer**
2. **Shading**
 Before determining the shading, you must determine the surface algorithm.
 a. Basic z-buffer shaders
 Only one of these will be present on an object.
 i. One color per object: **Constant shading**
 ii. Contoured object, one color per polygon: **Faceted shading**
 iii. Smooth shaded object, no highlights: **Gouraud** or **Phong**
 iv. Compact, elliptical, well-formed highlight: **Phong**
 v. Smeary, star-shaped, or polygonally-shaped highlight: **Gouraud**
 b. Additional z-buffer shaders
 These may be used in combination with each other or with Gouraud or Phong shading.
 i. Background is visible through object: **Transparency**
 ii. Reflective surface: **Environment Mapping**
 c. Basic Raytracing shaders
 These shaders may be used in combination.
 i. Matte surface, no highlight: **Diffuse shading**
 ii. Highlight present: **Specular shading**

 iii. Mirror-like surface: **Reflection**

 iv. Objects appear to be made from glass or crystal: **Transparency**

 d. Additional interest

 Any of the following can be used in conjunction with z-buffer or raytracing. If the object is raytraced, then any of the following can be combined with the basic raytracing shaders. If the z-buffer algorithm rendered the object, examine the highlight (if present) to determine if the basic shader is Gouraud or Phong.

 i. Patterns appear to be painted onto object: **2D Texture Mapping**

 ii. Objects appear to be made from a material such as wood or stone: **3D Texture Mapping**

 iii. Rough, pitted, dented, or embossed surface, but object profile is still smooth: **Bump Mapping**

3. Lighting

 a. Ambient portion

 i. Color bleeding; deepening shadows in corners; different colors (as opposed to different shades) in shadows and object contours: **Radiosity**

 ii. No color bleeding; shadows and contours composed of different shades of same color: **Constant Ambient Portion**

 b. Point, area light

 i. Sharp shadows: **Point Light**

 ii. Soft shadows (penumbra): **Area Light**

 c. Single, multiple light sources

 i. Object casts multiple shadows: **Multiple lights**

 ii. Convex objects exhibit multiple highlights: **Multiple lights**

ANSWERS TO SELECTED EXERCISES

CHAPTER 1: GETTING STARTED

1a. A guitar resting on a chair. The objects in the scene are the Floor, a Left Wall, a Right Wall, a Chair, and a Guitar.

1b. The two radio buttons are labeled "light" and "dark."

1c. The two images are "Guitar" and "Discussion."

3a. James Grogan created the chair and the guitar.

3b. POV-Ray created the image.

3c. "The Chairs" (chair5, chair8, chair3) are available as 3DS objects on Dino Panozzo's Reflectually site http://sunserver1.rz.uni-duesselfdorf.de/~pannozzo.

CHAPTER 2: BASICS

1. Instructions on how to use your VCR; directions to your friend's apartment

3. A rendering algorithm is a method of creating an *image* from a *model*.

5a. Graphics board

5b. Graphics controller

5c. Memory

5d. Frame buffer

7. Scenario B shows the viewer closer to the objects. The wider field of view is in scenario B. If the viewer gets closer to the objects, the field of view has to get wider in order for the viewer to still see the objects.

CHAPTER 3: EXERCISES ON SURFACE CUES

1a. SeeThrough image

1b. OpaqueOutline image

1c. FilledPolys and Reflection

1d. Reflection

3a. OpaqueOutline

3b. Reflection

3c. The table and the biggest sphere exhibit reflection.

3d. The smallest sphere exhibits refraction when the Reflection radio button is selected.

3e. The Reflection image allows you to verify that the smallest sphere is farthest forward because you can see the reflections of the other two spheres in the floor, and you can see that in the big sphere's reflection, the little sphere is much smaller than the medium size sphere. This indicates that it is farther away from the big sphere and thus closer to the viewer.

5a. The brown diagonal line is visible inside the sphere flake.

5b. Reflections and shadows are visible in the Reflections image.

CHAPTER 3: EXERCISES ON SURFACE ALGORITHMS

1a. The floor and table are reflective, and the table, books, and chair cast shadows. There are no transparent objects.

1b. The wallpaper is visible in the table: raytracing.
The tabletop is solid brown: z-buffer.
The tabletop is made from two triangles: hidden-line.
You can see through the table: wireframe.

1c. The books look pretty similar in the z-buffer and raytraced versions. That is because they are not reflective or transparent. Based on their appearance alone, it would be extremely difficult to identify the surface algorithm, but there are plenty of visual cues in the rest of the image to make a definitive identification.

3a. Opaque objects occur in the hidden-line, z-buffer, and raytraced versions of the image.

3b. Hidden-line

3c. Wireframe: outlined polygons; can see entire cup
Hidden-line: outlined polygons; spoon hides part of saucer
z-Buffer: solid polygons; no shadows
Raytracing: shadows, reflections

5a. Hidden-line

5b. Wireframe

5c. The table is reflective in the raytraced version but is not reflective in the z-buffer version. The bananas, apples, pear, and bowl cast shadows. In the raytraced version there are no refractive objects, but the table is reflective.

CHAPTER 4: EXERCISES ON Z-BUFFER SHADING CUES

1a. OneColorOnly

1b. OneColorPolys

1c. SmoothShading

3a. All four ducks

3b. In the "SmoothShading" version, highlights are polygon-shaped. In the "Good-Highlights" version, the highlights have curved perimeters and are more compact.

CHAPTER 4: EXERCISES ON z-BUFFER SHADING ALGORITHMS

1a. The teapot has a star-shaped highlight when rendered with Gouraud shading.

1b. Both the table and the mat appear the same under constant, faceted, Gouraud, and Phong shading. First, their geometry is flat, and the light is positioned relatively far away, which means that the light hits each spot on the two surfaces at roughly the same angle. This leads to even lighting over the surface of the object. If the lighting is even over a flat surface, it is difficult to distinguish smooth shaders like Gouraud and Phong from faceted shading. When an object is made up of one polygon, then faceted shading's "one color per polygon" is equivalent to constant shading's "one color per object."

3a. Phong shading

3b. Gouraud shading

3c. The wall looks pretty much the same under all four shaders. First, the walls have a flat geometry and are not shiny so there are no highlights. Second, the light is quite far away, which means that the lighting is very even. When the lighting is very even over a flat, dull surface, all four shading algorithms can produce similar results.

5a. The black background always looks the same. There is actually nothing there, so light does not bounce off anything and thus there is no reflection at all.

5b. Smooth shaders blend the meeting of two polygons. In the physical world, if polygons meet at an acute angle, you see a distinct edge where they meet. For this case, faceted shading produces a more acceptable result. A cube would look better with faceted shading.

5c. The YellowThing has the largest polygons and the BlueThing has the smallest. As polygons get smaller, the visual effect begins to resemble that of Phong shading. Remember that Phong shading calculates color once per pixel, and faceted shading calculates color once per polygon. If the polygons become small and approach the size of a pixel, then the visual appearance of faceted and Phong shading will coincide.

CHAPTER 5: EXERCISES ON RAYTRACING SHADING CUES

1. Reflections, shadows, transparency

3. Materials for dull glasses: unglazed porcelain, plastic with a rough surface

Material for shiny glasses: smooth plastic
Materials for reflective glasses: smoothly polished metal, opaque glass
Material for transparent glasses: glass

Chapter 5: Exercises on Raytracing Shading Algorithms

1a. The highlights are different in each case.

1b. It is sometimes difficult to pick out the highlights in a highly reflective surface because there is competition due to the reflections of the surrounding scene. Transparent objects may exhibit highlights on their far sides. If the objects were opaque, their far sides would be invisible.

1c. On an opaque object with specular reflection, a raytracer will fire one ray toward the light source. On a transparent object with specular reflection, a raytracer will fire one ray toward the light source and an additional ray going through the object.

1d. The ray being fired toward the light source is responsible for determining the highlight.

3a. Both the goblet and the knife are in shadow.

3b. Specular highlights are visible only in direct light. They are not present in shadowed areas.

Chapter 6: Exercises on 2D Texture Mapping

1a. Spherical mapping looks best on the sphere. Box mapping looks best on the box. Cylindrical mapping looks best on the cylinder. The map names comes from their shapes.

1b. The top side of the box

1c. The orientation of the box's top side is the same as the orientation of the square. Furthermore, they are both rectangles with approximately the same proportions.

3a. Around X

3b. Around Z

3c. No. It has been distorted into wedges or transformed into two sets of stripes.

3d. If you want to make the pattern from the original texture visible to a viewer, do not use a cylindrical map shape on a planar object.

5a. Planar

5b. The texture map has the same orientation as a plane that would slice the mug into two mirror halves.

5c. Planar

5d. Planar mapping looks best. Of the choices, planar mapping would look best on most bilaterally symmetric objects as long as the normal of the map matched the

normal of the plane that cuts the object into two mirrored pieces. There is an exception to this: See Exercise 6 in Chapter 6.

7a. Planar mapping was used because the cow is bilaterally symmetric.

7b. Planar or box mapping

7c. The map shape of the floor is probably planar. The pattern is easily discernable and not distorted on this flat surface.

CHAPTER 6: EXERCISES ON 3D TEXTURE MAPPING

1a. Checkers, Stripes, Brick, Wood, Marble

1b. All of the textures look pretty good on the wall. All of the textures are okay on the horse, but the brick texture may be a little goofy.

1c. My personal opinion is that the textures interfere with seeing the letters on the side of the Block.

3a. 4Terms

3b. 2Terms (maybe 3Terms)

3c. The front wall, which is closer to the viewer, has more visible terms.

3d. Be aware of an object's distance from the viewer when deciding on the number of terms. Minimizing the number that you request will speed rendering times.

5a. Parallel lines

5b. The geometry of the violin itself

CHAPTER 7: BUMP MAPPING

1a. Ripples

1b. Rivets

1c. Scratches

1d. Dents, rough

3. When the texture map consists of various shades of the same hue

5a. There is not a lot of difference in the raised patterns when switching between "Emboss" and "Emboss&Shadow" versions. That is because embossing does not actually change the geometry of a flat surface, and without protruding polygons, there is nothing to block the light that strikes the object's surface.

5b. The Emboss&Shadow version produces the straight-line shadow perimeters. No, this would not be found in nature, because in the physical world, protruding polygons would cast a shadow. Because embossing does not actually raise the surface, there are no protruding polygons to cast shadows.

7a. Texture&Bump

7b. The change between the Texture&Bump and the Texture settings for the CDshelf is not as dramatic as it was for the amplifier. There are fewer protuberances on the CDshelf than there are on the amplifier, which explains why adding bump mapping to the texture mapping was not as helpful as it was for amplifier.

CHAPTER 8: EXERCISES ON SIMPLE LIGHTING

1a. Darkest: Low Ambient, Low Point Light. Second darkest: Low Ambient, High Point Light

1b. High Ambient, Low Point Light

1c. Low Ambient, High Point Light

3a. The right light has the lowest position, which is discernible by looking at the length of the shadows it creates.

3b. You can see that the shadows created by the left and the right lights are present in the "Two Lights" version, so you know that the two lights being used are the left and the right ones.

3c. As expected, having all three lights on creates the most brightly lit scene.

5. The "Penumbra" setting was created with an area light. Notice the soft shadow stretching out to the right from the overhead cabinets.

CHAPTER 8: EXERCISES ON RADIOSITY

1a. "No Radiosity" and "All3Colors"

1b. In "No Radiosity," the different shades and shadows on the white shelves are all gray. In "All3Colors," the color bleeding, which is the hallmark of radiosity, is readily apparent. The left side of the shelving has a yellowish cast while the lower portion nearest the base has picked up the floor's blue color. The right side of the shelving is distinctly pink.

1c. The planter is picking up both red and yellow, but the majority of its color comes from the blue in the floor. The yellow shades appear on the left side of the planter, which is the side where the yellow wall is positioned.

3a. With radiosity, shadows have more variation in shade. From your experience with the physical world, it makes sense that the shadows under the pews should be deeper than the shadows at the rafters. The area near the rafters receives more ambient light.

3b. As it is, there is not much difference between "One Bounce" and "Two Bounces," so adding more bounces would not have improved the image's appearance, but surely would increase the overall rendering time.

CHAPTER 9: FOOLERS

1a. The placement is different, but the quality of their appearance is similar.

1b. In the z-buffer version, it is probably faceted, and quite a few of the polygons are quite small. The raytraced version is using a combination of diffuse and specular shading.

1c. There is a lot of texture mapping. The beachball has a spherical map shape, while the sky and beach blanket have a planar map shape. The sand is bump mapped.

3a. The reflected lines continue in the same direction and align with the actual lines in the ceiling. Perspective is preserved.

3b. The reflected lines in the z-buffer version do not align with the actual lines in the ceiling, in contrast to the raytraced version. The raytraced version more closely simulates the reality of the physical world.

3c. If you anticipate having parallel lines in a reflection, choose raytracing. Environment mapping coupled with the z-buffer algorithm will not give you satisfactory results.

5. The z-buffer version of the image gives a clearer indication of the internal workings of this particular piece of machinery. For situations where you are trying to communicate internal structure, refraction can interfere with the presentation by adding distortions.

CHAPTER 10: COST AND EFFECT

1a. The floor in the "Home Rehab" scene was rendered with a combination of reflection and texture mapping, which is more expensive than either reflection or texture mapping by itself. The most expensive object to render from the "Viking" scene was the bump-mapped reflective water.

1b. For the "Home Rehab" scene, only the hammer and the floor would need the six environment maps, so that would create some work for a graphicist. However, the parallel lines on the wall most likely would cause your z-buffer program some problems. There are only about 500 polygons in this image, so I would choose raytracing unless this was part of an animation. If this were an animation, I'd deep-six the lines on the wall and go with z-buffer. In the "Viking" scene, you could definitely get away with an environment map for the water. Go for z-buffer.

As a bonus here, I am going to mention the "Bicycle" scene that is also in this session of TERA. There are no reflections of reflections in the "Bicycle" scene, and the reflections of the bicycle spokes in the chrome rim are not too apparent, so you might be able to get away with environment mapping. However, you would have to prepare environment maps for each of the three reflective objects, which might constitute enough work that you might consider using raytracing. The helmet does have about 3000 polygons in it, which would really slow down a raytracing package. If you were making just the one picutre, you should probably use raytracing to avoid making all those (6×3) environment maps.

3a. They are similar.

3b. Nothing but bumps

3c. Make a rendering of a single polygon that fills the entire viewing area. Bump-map that polygon. Save the image and use it as a texture map.

3d. During the Great Depression of the 1930s, farmers struggling with a seven-year drought were so poor that they did not have money to buy paint for their houses, let alone their barns. The Mail Pouch Tobacco Company hit upon a cheap way to advertise—they offered to paint barns for free. What they painted was the phrase "Chew Mail Pouch Tobacco" in yellow lettering on a black background. The farmer received a protective coat of paint for his barn and the Mail Pouch Company got advertising for the cost of paint. If you travel any country roads in the Midwest, you may still see one of these ads, faded from age, yet still faintly apparent on the side of an old barn. Our image carries a message that has been updated for our present time.

5. A z-buffer program could easily have produced the diffuse, specular, bump-mapped, and texture-mapped versions. If it is a little more sophisticated, it could create the transparent versions of the "Hello" and "Platonic" images. It would take a sophisticated z-buffer program and patience on the part of the graphicist to create the reflective versions.

7. 7200 images × 6 minutes = 43,200 minutes. Divide this by 60 minutes to get 720 hours. To get the number of *days*, divide this by 24, which gives you *30 days*. Bet you didn't think it'd take that long!

9a. Gouraud shading is a little over four times faster than Phong.

9b. You can substitute Gouraud shading for Phong shading for any matte or dull surface. If a shiny object is in shadow, you can substitute Gouraud shading. And if your viewer is positioned so he or she will not see a highlight from the shiny object, you can still use Gouraud instead of Phong shading.

APPENDIX D
INSTALLING TERA

TERA is easy to install. Read the section that pertains to your computer system.

WINDOWS 95 AND WINDOWS 98

TERA runs on any Windows 95 or Windows 98 system that has a display capable of 256 colors and a resolution of at least 640 × 480.

INSTALLING TERA:
1. The name of your setup program is `win95\setup.exe` on the CD-ROM.
2. Start your computer and insert the TERA CD into your drive.
3. Use "My Computer" to locate `setup.exe` in the `win95` directory on the TERA CD. Double-click on `setup.exe` to activate it.
4. Setup will ask you for the letter of your CD drive. Change the letter if necessary and click on "install."
5. If asked if you are running Win 3.1, click on "no."

That's it!

RUNNING TERA

1. Insert the TERA CD into your drive.
2. From the "Start" menu, select "Programs." From the menu that appears, select "Tera." In the Tera menu, select the session or chapter you want to explore.

WINDOWS NT

TERA runs on any Windows NT system that has a display capable of 256 colors and a resolution of at least 640 × 480.

INSTALLING TERA:

1. The name of your setup program is `winnt\setup.exe` on the CD-ROM.
2. Start your computer and insert the TERA CD into your drive.
3. Use "My Computer" to locate `setup.exe` in the `winnt` directory on the TERA CD. Double-click on `setup.exe` to activate it.
4. Setup will ask you for the letter of your CD drive. Change the letter if necessary and click on "install."
5. If asked if you are running Win 3.1, click on "no."

That's it!

RUNNING TERA

1. Insert the TERA CD into your drive.
2. From the "Start" menu, select "Programs." From the menu that appears, select "Tera." In the Tera menu, select the session or chapter you want to explore.

Macintosh Power PC

TERA requires SoftWindows on Mac platforms and a configuration of 256 colors and a resolution of at least 640 × 480, which is the default for SoftWindows.

INSTALLING TERA:

1. If you have already put the TERA CD into your CD drive, remove it.
2. Run SoftWindows.
3. At the prompt, type
 WIN
 followed by the enter key.
4. Insert the CD.
5. Activate the File Manager, and select the drive letter corresponding to your CD drive. Click on "mac," and then double-click on "setup.exe."
6. Setup will ask you for the letter of your CD drive. Change the default letter if necessary and click on "install."
7. Click "yes" when asked to install WIN32S support. You do not have to install the FreeCell game if you do not want to.

That's it!

RUNNING TERA

1. Make sure that your CD drive is empty.
2. Run "SoftWindows" and at the prompt, type
 WIN
 followed by the enter key.
3. Insert the TERA CD into your drive.
4. Double-click on the TERA program group. Double-click on the icon corresponding to the session you want to explore.

Newer versions of SoftWindows are capable of running Windows 95 applications. If you wish, you can attempt installing the Windows 95 version of TERA instead.

WINDOWS 3.1

TERA runs on Windows 3.1 systems that have a display capable of 256 colors and a resolution of at least 640×480.

INSTALLING TERA

1. Insert the TERA CD into your drive.
2. Start a Windows session.
3. In the File Manager select the letter corresponding to your CD drive. Click on "win31," and then double-click on "setup.exe."
4. Setup will ask you for the letter of your CD drive. Change the letter if necessary and click on "install."
5. Click "yes" when asked to install WIN32S support. You do not have to install the FreeCell game if you do not want to.

That's it!

RUNNING TERA

1. Insert the TERA CD into your drive and start a Windows session.
2. Double-click on the TERA program group. Double-click on the icon corresponding to the session you want to explore.

IRIX, SUN, LINUX

TERA requires X11 with a Pseudocolor Visual with 256 colors or more and a display resolution of at least 640 × 480.

INSTALLING TERA

The TERA CD uses an ISO 9660 level 1 format. All you have to do is to mount the CD and you are done with the installation! Consult your "man" pages on "mount" for the particulars of your system. For example, on a Linux system, the mount command looks like this:

```
mount -t iso9660 /dev/cdrom /cdrom
```

RUNNING TERA

1. Insert the TERA CD into your drive, mount the CD, and fire up X Window System.
2. Type
    ```
    cd /cdrom
    ```
 Substitute your CD-ROM mount point for `/cdrom` in the above path name.
3. Change into the directory appropriate for your system. Choices are `irix5_3`, `irix6_3`, `sun`, and `linux`.
4. Type
    ```
    tera
    ```
 You will get a list of choices. Type the number corresponding to the session you want to explore. You will see the TERA window appear. Have fun!

Bibliography

[APPE67] A. Appel. The Notion of Quantitative Invisibility and the Machine Rendering of Solids. *Proceedings of the ACM National Conference*. Washington, DC: Thompson Books, 1967, pp. 387–393.

[ASHD94] I. Ashdown. *Radiosity: A Programmer's Perspective*. New York: Wiley, 1994.

[BIER86] E. Bier and K. Sloan. Two-Part Texture Mapping. *IEEE Computer Graphics and Applications* **6(9)**, September 1986, 40–53.

[BLIN76] J. Blinn and M. Newell. Texture and Reflection in Computer Generated Images. *Communications of the ACM*, **19(10)**, October 1976, 542–547.

[BLIN78] J. Blinn. Simulation of Wrinkled Surfaces. *Proceedings of SIGGRAPH '78*. July 1978. *Computer Graphics*, **12(3)**, 1978, 286–292.

[BUIT75] B. Phong. Illumination for Computer Generated Pictures. *Communications of the ACM*, **18(6)**, June 1975, 311–317.

[CHEN98] S. Chenney. Sced. http://www.cs.berkeley.edu/~schenney/sced/sced.html.

[CATM75] E. Catmull. Computer Display of Curved Surfaces. *Proceedings of the IEEE Conference on Computer Graphics, Pattern Recognition and Data Structure*. May 1975, pp. 11–17.

[COHE88] M. Cohen, S. Chen, J. Wallace, and D. Greenberg. A Progressive Refinement Approach to Fast Radiosity Image Generation. *Proceedings of SIGGRAPH '88*. August 1988. *Computer Graphics*, **22(4)**, 1988, 75–84.

[DELE97] B. de Leeuw. *Digital Cinematography*. Boston: AP Professional, 1997.

[EBER94] D. Ebert, F. Musgrave, D. Peachey, K. Perlin, and S. Worley. *Texturing and Modeling: A Procedural Approach*. Boston: AP Professional, 1994.

[FOLE90] J. Foley, A. van Dam, S. Feiner, and J. Hughes. *Computer Graphics: Principles and Practice*, 2nd ed. Reading, MA: Addison-Wesley, 1990.

[GORA84] C. Goral, K. Torrance, D. Greenberg, and B. Battaile. Modeling the Interaction of Light Between Diffuse Surfaces. *Proceedings of SIGGRAPH '84*. July 1984. *Computer Graphics*, **18(3)**, 1984, 213–222.

[GOUR71] H. Gouraud. Continuous Shading of Curved Surfaces. *IEEE Transactions on Computers*, **C-20(6)**, June 1971, 623–629.

[GRIT98] L. Gritz. Blue Moon Rendering Tools Home Page. http://www.seas.gwu.edu/student/gritz/bmrt.html.

[KOLB98] C. Kolb. The Rayshade Homepage. http://www-graphics.stanford.edu/~cek/rayshade.

[LASS95] J. Lassiter and S. Daly. *Toy Story: The Art and Making of the Animated Film*. New York: Hyperion, 1995.

[MAMM89] A. Mammen. Transparency and Antialiasing Algorithms Implemented with the Virtual Pixel Maps Technique. *IEEE Computer Graphics and Applications*, **9(4)**, July 1989, 43–55.

[MURR96] J. Murray and W. van Ryper. *Encyclopedia of Graphics File Formats*. 2nd ed. Sebastopol, CA: O'Reilly and Associates, 1996.

[PERL85] K. Perlin. An Image Synthesizer. *Proceedings of SIGGRAPH '85*. July 1985. *Computer Graphics*, **19(3)**, 1985, 287–296.

[PORT84] T. Porter and T. Duff. Compositing Digital Images. *Proceedings of SIGGRAPH '84*. July 1984. *Computer Graphics*, **18(3)**, 1984, 253–259.

[POVR98] POV Team. Persistence of Vision Raytracer. http://www.povray.org.

[RICH98] N. Richards. Breeze Designer. http://www.imagoes.fl.net.au.

[UPST90] S. Upstill. *The Renderman Companion*. Reading, MA: Addison-Wesley, 1990.

[WARD98] G. Ward. Radiance WWW Server. http://radsite.lbl.gov/radiance/HOME.html.

[WATT92] A. Watt and M. Watt. *Advanced Animation and Rendering Techniques: Theory and Practice*. Reading, MA: Addison-Wesley, 1992.

[WHIT80] T. Whitted. An Improved Illumination Model for Shaded Display. *Communications of the ACM*, **23(6)**, June 1980, 343–349.

[WILL78] L. Willams. Casting Curved Shadows on Curved Surfaces. *Proceedings of SIGGRAPH '78*. August 1978. *Computer Graphics*, **12(3)**, 1978, 270–274.

Index

directional light, 47
DXF, 15

E

Eber, Dena, xvi
Egbert, Parris, xvi
embossing, 88
 visual cue, 88
embossing mask, 88
environment mapping, 105
 cost, 117, 120

F

faceted shading, 42, 50
 cost, 120
 visual cue, 52
Faulkner, Ronald, xvi
Ferguson, Kevin, xvi
form factor, 98
frame buffer, 12
frequency, 79

G

GIF, 15
Gouraud shading, 42, 50
 cost, 117, 120
 visual cue, 52
Graham, Jim, xvii
graphics controller, 12
Grissom, Scott, xv
Gritz, Larry, xvi, 11

H

hidden-line, 28, 32
 cost, 117, 120
 visual cues, 37
hit point, 56
Horsthemke, Bill, xv

I

index of refraction, 60
interpolation, 50
interreflection, 60

J

jaggies, 114
Jones, William B., xvi
JPEG 15

K

Kambhamettu, Chandra, xvi
Kolb, Craig, xvi, 11

L

layering, 73
Li, Hui-Lin, xvi
light
 ambient, 94
 area, 95
 color, 95
 point, 95
 spot, 95
Luetscher, Dwight, xv

M

map shape. *See* two-dimensional texture
 mapping: map shape
marble texture, 81
Mickelsen, Robert A., xvi
mod. See modulo
model, 10
modeler, 16
modulo, 77
multiple light sources, 59
 cost, 115

specular shading, 58, 62
 cost, 120
 visual cues, 62
Spencer, Stephen, xv, xvi
spherical mapping, 68
spotlight , 95
Stanczak, Alicja, xv
stripes, 75

T

Targa, 15
TERA, 2
 appearance menu, 4
 Close Enough, 5
 image selection, 4
 installing on Macintosh, 142
 installing on Unix platforms, 144
 installing on Windows 3.1, 143
 installing on Windows 95, 140
 installing on Windows NT, 141
 on a MacIntosh, 3
 on a Unix workstation, 3
 on Windows 95 or NT, 3
 running TERA, 3
 Self Quiz, 5
 Tell Me More, 5
 using TERA, 4
texture mapping
 advantages of, 66
 three-dimensional. *See* three-dimensional
 texture mapping
 two-dimensional. *See* two-dimensional
 texture mapping
 visual cues, 67
texture maps, 67
three-dimensional texture mapping, 75
 checker texture, 76
 marble, 81
 noise, 78
 procedural textures, 75
 ramp, 77
 rings, 76
 stripes, 75
 wood texture, 81
TIFF, 15
transparency, 60, 64
 cost, 118, 120
 visual cues, 62
 with reflection, 61
 with z-buffer algorithm, 105

turbulence, 81
twist, 81
two-dimensional texture mapping, 67
 box mapping, 70
 cost, 118, 120 121
 cylindrical mapping, 68
 disadvantages, 75
 layering, 73
 map shape, 68, 70
 planar mapping, 68
 projection, 70
 spherical mapping, 70
 and bump mapping, cost, 118, 120

V

van der Burg, Steve, xvi
vector, 29
vertex, 16
vertex normal, 30
visual analysis, 1
visual cues
 summary, 129
visual literacy, 1
VMRL, xvi

W

Ward, Greg, xvi, 11
Weinhold, Virginia, xvii
wireframe, 28, 31
 cost, 120,121
 visual cues, 37
Wolfe, Alain, xvii
wood texture, 81
world coordinates, 15

Z

z-buffer, 28, 33
 and reflections, 105
 and shadows, 103
 and transparency, 104
 cost, 120, 121
 visual cues, 37